THIS WAY

THIS WAY

Signage Design for Public Spaces

James Grayson Trulove

Connie Sprague

Steel Colony

GLOUCESTER MASSACHUSETTS

ROCKPORT PUBLISHERS

First published in the United States of America by
Rockport Publishers, Inc.
33 Commercial Street
Gloucester, Massachusetts 01930-5089
Telephone: (978) 282-9590
Facsimile: (978) 283-2742
www.rockpub.com

ISBN 1-56496-752-2

10 9 8 7 6 5 4 3 2 1

Design: Cathy Kelley Graphic Design
Cover Image: [ie] design

Printed in China.

acknowledgments

Our thanks to the principals and staff of the firms featured in *This Way: Signage Design for Public Spaces* for their help and persistence in gathering the images and information we needed.

My gratitude and thanks to Judy Schurger, project manager for this book, who skillfully and enthusiastically pulled together the many elements involved and gave us a firm direction, and to Cathy Kelley, our art director, who helped in many ways to expand our scope and to give the book its identity.

>

contents

Second star to the right, straight on 'til morning...

...so directed Peter Pan as he and his friends embarked on their unforgettable journey to Never Never Land.

Indeed, celestial bodies and natural phenomena have guided humankind to their destinations over the millenia. When the ancient Polynesians set out from Tahiti across the uncharted Pacific in search of a new home, they plotted their course from signs in the waves. The ability to read such signs was called wayfinding. In modern times, the world we inhabit has become inundated with signs, logos, and directional and informational graphics. Despite the multitude of signage, finding directions through the maze of modern life can sometimes be a daunting task as the overabundance of information creates only more confusion. The need for tools to enhance our ability to navigate an increasingly complex world has inspired a new take on wayfinding. Modern designers, architects, and graphic artists use their skills to incorporate wayfinding tools into the daily environment—from work-places and malls to parks and museums.

Modern wayfinding differs from the arcane practices of ancient cultures in the diversity of its applications and the sophistication of its technology. In addition, the concept of creating an identity for corporations and other establishments as a means of increasing public awareness has expanded the sense of place to include room for thought. By devising arresting images, appealing typography, and memorable arrangements of space, graphic designers and architects working together produce spaces that attract and retain public interest.

A stunning example of the power of persuasive graphic design can be seen at The Block at Orange in Orange County, California. This 811,000-square-foot outdoor retail and entertainment complex could have been perceived as just another monster mall. But CommArts worked to give the complex a high-energy atmosphere, sparked by the unusual design element of 90-foot-tall graphic stylons, whose imagery is designed to be changed on a regular basis, thus staying fresh and "cool," a vital component for success in California. The complex, with its hundreds of stores, restaurants, and a skateboard park, could have been overwhelming, but the designers' intelligent use of wayfinding signage keeps visitors from feeling lost or confused.

On a smaller scale, the Cineplex 8 Theater in Hiratsuka, Japan, illustrates the cutting edge of international wayfinding techniques that transcend simple text. Using abstract shapes of neon, painted aluminum, brushed steel, and holographic fabric, Koryn Rolstad Studios/ Bannerworks created an impressionistic ocean environment that leads theatergoers almost intuitively to their destinations. The system relies upon artful directional signals that transcend the limitations of language.

With modern technology, graphic designers can overcome problems that baffled earlier eras. Thus, using specially designed Braille and audio railing, Coco Raynes and Associates was able to design an art exhibit at the Musee des Beaux Arts in Calais, France that can be appreciated even by blind visitors.

As the appreciation of intelligently planned graphic design and signage grows, so will the demand for taking wayfinding, in its modern sense, to new levels of expression.

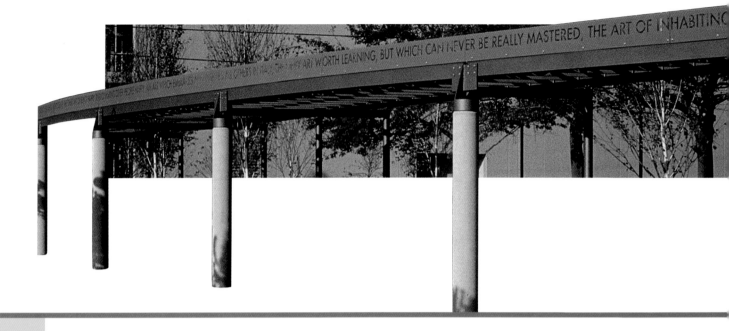

CREATING A
LEARNING EXPERIENCE

by Lee Skolnick

Architecture and design have the potential to convey meaning as well as information.

This powerful trait is often overlooked in the rush to approach, as well as to analyze, these disciplines in terms of their functional and purely aesthetic imperatives. The fact is that all design interprets as well as informs. What characterizes the best design is that it consciously utilizes this challenging and transcendent potential.

In creating learning experiences, designers are confronted with the perfect opportunity to actually employ design as interpretation. Signs, labels, written directives, and environmental graphics serve a wide array of purposes when employed in public places. Graphic design may

be used to move people through space, to identify objects or places, to provide warning or welcome, to explain, or to convey context. Often in our experience, we encounter a cacophony of messages through the random combination of these varied graphic and three-dimensional elements. However, as the examples provided in this section demonstrate, when a coherent, multi-layered design strategy is employed, the result can be an experience that envelops the visitor in meaning and promotes deeper understanding.

A well-crafted design seeks to develop a consistent visual vocabulary that is a seamless expression of the themes and concepts it embodies and communicates.

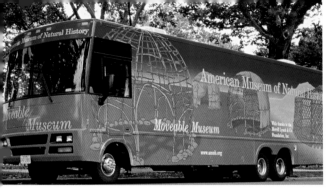
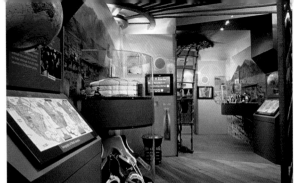

> When a coherent, multi-layered design strategy is employed, the result can be an experience that envelops the visitor in meaning and promotes deeper understanding. <

Issues of space, form, structure, organization, light, color, texture, imagery, and circulation are combined in much the way a composer arranges the instruments of an orchestra to create a symphony. The result resonates in a clear, harmonious, and consistent voice. In the case of educational environments and displays, this approach is essential if interpretation is to become learning.

On the largest scale of creating public sites, buildings, and environments, key questions must be asked at the onset of the design process: Is there an existing context or site condition to which the design will need to respond? What is the nature of this context in relation to the themes and concepts that the project seeks to interpret? Is there a consonance between container and contained, or would a stark contrast between the two create a more effective mode of expression? How best will people be moved through the procession of ideas and spaces? Can a narrative or chronology act as an organizing device and interpretive anchor, or does the subject lend itself to a more freeform, organic, or random sense of order?

Of course, most interpretive experiences are subject to a host of other criteria that help define a meaningful and appropriate design response and that must be satisfied if real learning is to occur. Most important is the keying of subject matter to audience. Although there may be no subject that is absolutely inappropriate to present to any given audience, the interpretion of a topic can determine whether or not it works for a particular group.

A thorough examination of the learning styles and capabilities of the target audience is, therefore, a crucial first step in determining both the right aspects of a topic to present and the means of interpretation to employ. The best ways to get to know the audience, other than through one's own intuition and experiences, are to study the developmental norms for specific age groups, to understand demographic differences, and to actually test ideas and approaches through formative evaluations and/or focus groups. The resulting data can greatly influence the relative degrees by which communication is accomplished through written, visual, environmental, or more actively participatory elements.

Additionally, issues of multi-generational, intergenerational, multicultural, and universally accessible interpretation can only be effectively addressed by taking

 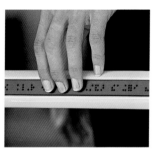

> Development of multi-sensory devices as well as keying differentiated interpretation to visitors with varying levels of education, expertise, and interest can ensure a more widely inclusive experience. <

a comprehensive look at potential visitors and their varied needs. Development of multi-sensory devices as well as keying differentiated interpretation to visitors with varying levels of education, expertise, and interest can ensure a more widely inclusive experience.

Once a designer is armed with enough information about the potential users, then the more intellectually challenging task of meaningful and engaging interpretation can be tackled. Designers must immerse themselves in the subject at hand if they are to come up with truly effective ways of communicating it to the public. A thorough understanding of a topic's underlying ideas facilitates insights which can be translated into design strategies. For instance, for certain subjects the creation of contextual and/or immersion environments can create powerful vicarious experiences which help focus the visitor's attention and enhance the power of suggestion. Others might lend themselves to a more detached or

abstracted visual atmosphere. Certain topics can benefit from interpretation made possible by the incredible advances in interactive media technologies. However, the increasingly ubiquitous use—and occasional overuse—of these learning aids has led designers to re-discover the evocative power of stories told through the display and interpretation of real artifacts. These objects have an inherent uniqueness and authenticity, which can not be delivered by any other means. Between these two extremes lies the broad array of interpretive strategies, which includes environmental graphics and murals, varying types of signage, audio/video, and "hands-on" (non-electronic) interactive displays.

Interestingly, for designers today, the lines between these formerly distinct elements are blurring more and more. Not only are practitioners with different skills collaborating on the conceptualization and design of projects at an earlier stage in their development, but

they are also sustaining that collaboration longer in order to ensure a seamless visitor experience. In addition, it has become increasingly important for people with expertise in specific fields to be thoroughly conversant in the issues involved in other, related ones.

As is evident in the projects highlighted in this section, this cross-disciplinary effort is crucial to the creation of effective learning experiences, for when all interpretive elements are skillfully composed and integrated, designers can take ideas and transform them into a vividly told story. In so doing, we can differentiate passive learning from active learning. in which understanding is gained through experiences and discovery.

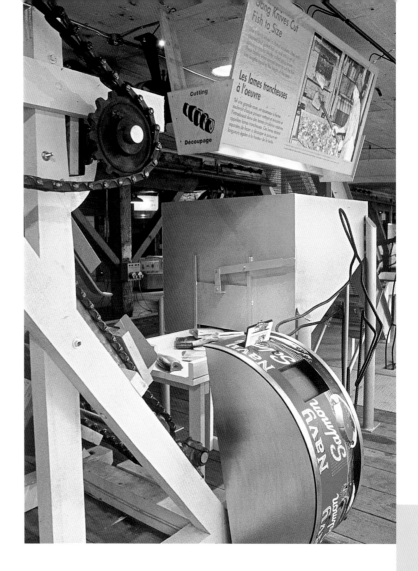

Lee Skolnick, principal of Lee H. Skolnick Architecture + Design Partnership, is an architect, designer, and educator based in New York City. He has created award-winning projects, in both the public and private sectors, which have been published in books and periodicals worldwide.

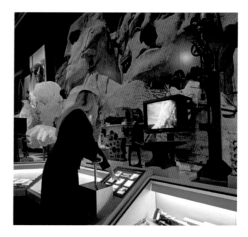

THIS PAGE: The interactive blasting exhibit has proven to be the big hit of the show. Visitors select from images of the four presidents' faces by touching one of the images on the control panel. The selected image appears on the video monitor as a still photograph. When the detonator plunger is pressed, a simulated blast occurs and the still image becomes the first frame of a video that documents actual blasting. Large, low-frequency speakers located under the platform send the vibration and sound of the blast through the area. *National Park Service photo.*

LINCOLN BORGLUM VISITOR CENTER

At the Mount Rushmore National Museum, information taken from the museum's archives has been reformatted into multi-layered graphics. A variety of presentations, from wall murals and video displays to interactive media, offer visitors a taste of history.

To give visitors to Mount Rushmore National Memorial a better understanding of the story behind the awesome monument, the National Park Service asked Albert Woods Design Associates, Inc. to create an interpretative exhibit as part of a $56 million redesign of the overall visitor facilities at the memorial. The major goals of the new exhibit were to explain how the mountain was carved and to tell the human story of the people involved in the creation of the memorial.

The exhibit draws heavily on the Park's archives, including collections of artifacts, memorabilia, photographs, documentary films, and oral history. The 5200 square foot exhibit is arranged in two parts. A windowed gallery overlooking the memorial holds exhibits and film that directly support the view of the carvings. The films include footage on preservation efforts, fund raising, and Mount Rushmore in popular culture. The main exhibition hall covers the geology of the mountain and the techniques used in carving. A huge photomural showing the work in progress serves as a backdrop

for the tools and hardware, with action film showing them in use. A highpoint of this exhibit is an interactive program that allows visitors to touch-select one of the faces and then "detonate" a blast in that area using an authentic plunger.

Enclosures focusing on the workers and sculptor, Gutzon Borglum, allow visitors to select film sequences featuring the sculptor and the men who worked on the mountain. The area also contains a chronology of the memorial and a topographical relief model showing the working facilities used during the carving.

In a separate space, a large, porcelain enamel mural presents the 150-year history of the United States during which the four presidents served. The latest techniques of digital image composition were used to blend the many historical images into the final composition.

The visitor center is named after Lincoln Borglum, the son of the sculptor, who worked on the carvings and later became the first National Park Service superintendent at the memorial.

DESIGN FIRM
Albert Woods Design Associates, Inc.

PROJECT DESIGN
Albert Woods

FABRICATION
Universal Exhibits,
Los Angeles, Ca.

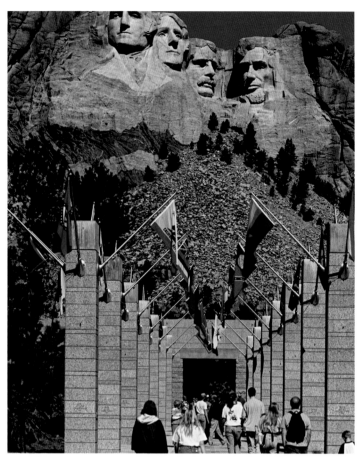

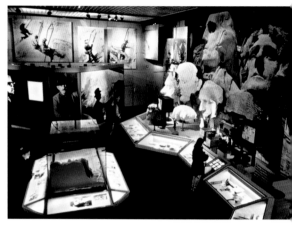

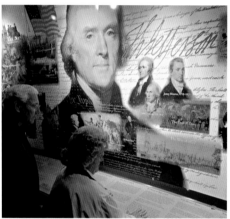

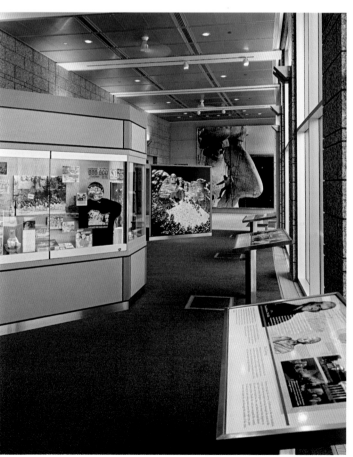

TOP LEFT: Visitors arriving at the park pass through the Avenue of Flags, which provides a fitting wayfinding directional leading them directly to the Grand View Terrace, a plaza that provides an unobstructed view of the sculpture. Elevators and stairs from the terrace lead visitors into the visitor center. *Photo by Bill Groethe, First Photo.*

BOTTOM LEFT: Inside the gallery overlooking the memorial, horizontal porcelain enamel panels give background information on each of the four presidents. At the far end of the gallery, a large photograph of sculptor Gutzon Borglum, suspended in front of Lincoln's nose, gives visitors a sense of the carving's enormity. *Photo by Greg Hursley.*

TOP RIGHT: The centerpiece exhibit explains the carving process. The backdrop is a 48-foot-long mural enlarged from photographs of workers taken one day in 1938. Video screens present film clips edited from many sources that were taken at various times during the carving. The display also includes plaster models used for measurements, wooden dynamite crates, and other tools used in the process. A lighted display case contains artifacts used in the carving and text explaining the process. *National Park Service photo.*

BOTTOM RIGHT: Within the large exhibit hall, a quiet space devoted to the meaning of the memorial includes a 30-foot mural of American history, which incorporates two hundred paintings and illustrations, all digitized and photocomposed into a continuous image. Below the mural, a continuous panel contains historical text and maps. *National Park Service photo.*

THE FRANKLIN DELANO ROOSEVELT MEMORIAL

The truest partnership of form and function is demonstrated when graphics literally become part of the architecture, and the structures and space themselves carry meaning. The FDR Memorial is a prime example of this harmony of information and site. For Biesek Design, signage is most successful when it fits seamlessly into surrounding environments, does its job quietly, and mostly goes unnoticed.

The FDR Memorial depicts twelve pivotal years of American history through a series of outdoor rooms, each devoted to one of FDR's four terms in office. The 7.5-acre park includes commissioned bronze sculptures as well as inspirational quotes from Roosevelt chiseled into massive red granite walls. As the FDR project was several decades in the making, some of the sign planning and design was in place when Biesek Design joined the effort. However, the design team was responsible for final sign planning, typographic layouts, specifications of material and finishes, and project construction drawings.

The somewhat divergent project objectives included the creation of a venerable appearance with classic regional vernacular; ADA-compliant signage components; movement patterns conducive to pedestrian and disabled access; limited signage, constructed of durable, low-maintenance materials; and reasonably priced fabrication and installation.

This task of implementing a circulation sign system to help guide the thousands of daily visitors began with a needs assessment of the pedestrian traffic. Since the park had four entrances, there were four circulation patterns to consider. Fortunately, the park was under construction at

the time, so this situation afforded designers an opportunity to look at the site lines and conditions that would shape the program. This, in turn, allowed exact control of sign placement and an opportunity to walk the site with the landscape architect to discuss sign system goals.

For the signage, designers chose solid bronze with a verdigris finish for the letters, antique bronze background panels, and statuary rubbed bronze for the frames. Porcelain enamel on steel also was used on several signs. These materials were harmonious with the sculptures and stonework on the site. In addition, bronze, venerable and elegant, lasts for centuries, and requires little or no maintenance. Syntax, a classic sons serif font, lends a delicate, understated touch; narrow letterforms provide excellent legibility when rendered as dimensional letters.

Stone walls guide visitors through the memorial while chiseled text in the granite walls guides them through history. The lettering artist who hand chiseled some twenty inscriptions throughout the park wisely suggested not using the same typeface on the walls as had been chosen for the signage. As a result, the signage does not compete with the art or sculpture of the memorial.

DESIGN FIRM
Biesek Design

PROJECT DESIGN
Jack Biesek
Mark Panelli

FABRICATION
Karman, Ltd.

PHOTOGRAPHY
Robert Creamer
Jack Biesek

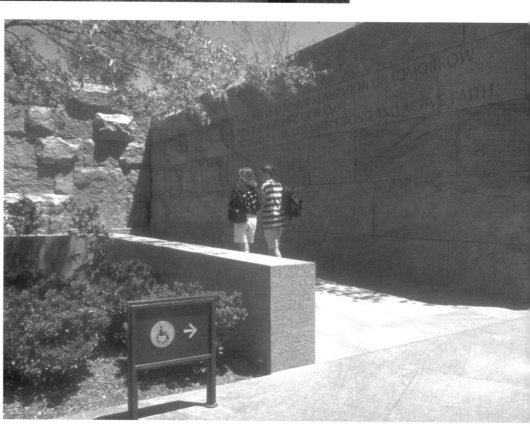

OPPOSITE PAGE: The signage emphasizes clear, simple graphics rather than text, especially helpful for international tourists. Signs utilize the classic bronze theme; attention was given even to simple details like the bronze hardware of the entrance door, creating visual continuity.

TOP: Verdigris letters, antique background and statuary bronze frame harmonize with the stone and sculpture in the outdoor setting.

BOTTOM: Strategically placed directional signs help provide circulation cues.

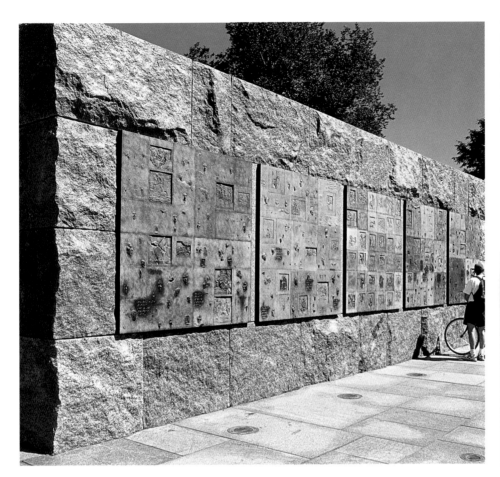

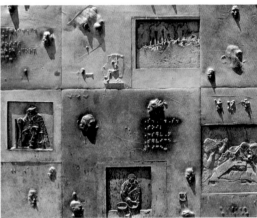

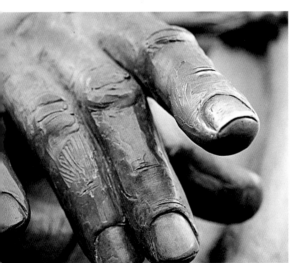

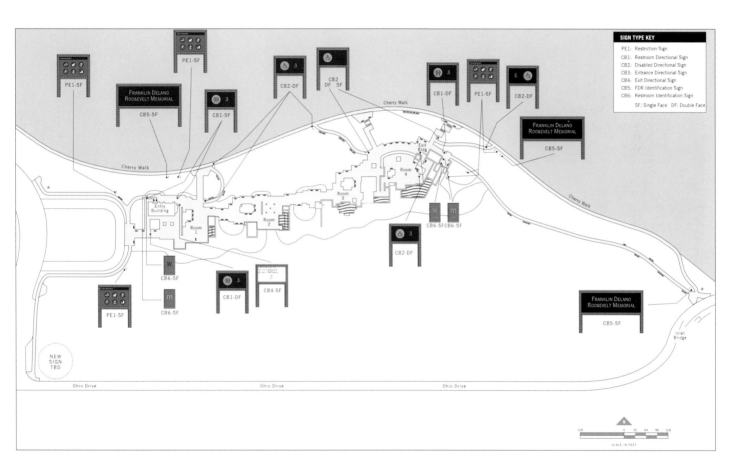

THIS PAGE: A location plan for
the signage at the FDR Memorial
illustrates the comprehensive
scope of the project.

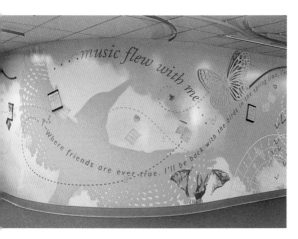

ROBERT CRAWFORD ELEMENTARY SCHOOL

As an alternative to more traditional forms of signage, environmental graphics can be an effective tool in an educational institution. At the Robert Crawford Elementary School, an otherwise straightforward school setting is transformed into a dynamic environment. Learning is made more colorful and enticing through graphics created for the space. While text is woven into the mural, most of the meaning is derived from visual forms.

Koryn Roldstad Studios/Bannerworks, Inc. created an installation that transformed a central meeting area at the Robert Crawford Elementary School into an environment that expresses the creativity of Major Robert Crawford's life and inspires young children. Major Crawford, who composed the Army Air Corps theme, "Off We Go into the Wild Blue Yonder," was a native Alaskan musician and aviator. The project had to tell the story of a significant historical figure and the installation had to be easy to clean, durable, and immune to the tugs of inquisitive hands and fingers.

Students' drawings of flying machines and whirling creatures are incorporated into the graphics. Digital images of Major Crawford's life as well as other images of flight and music are printed on durable wallpaper (kid and crayon proof). The walls have become blue sky and clouds, with scattered imagery of sheet music, historical photographs, newspaper articles, and natural and manmade forms of flight. The design incorporates several sculptural metal forms, including toy airplanes, a butterfly, and musical wind bars of enameled aluminum flat bar, that sweep the ceiling and walls. Musical sheets of past compositions float behind three-dimensional piano keys and Plexiglas covers, reminding viewers of the importance of the creative process. The sculptures and archival elements are attached and constructed in such a way that they are protected from a child's inquisitive touch. All images are bright and colorful to help weather Alaska's long, dark winters and to provide a child-friendly educational atmosphere.

DESIGN FIRM
**Koryn Rolstad
Studios/Bannerworks, Inc.**

PROJECT DESIGN
**Koryn Rolstad
Luci Goodman
Megan Adcock
Ryan Rosenberg**

FABRICATION:
**Bannerworks, Inc.
Ross Technologies
Reliance
Vision International
Pro Lab**

PHOTOGRAPHY
Brian Allen

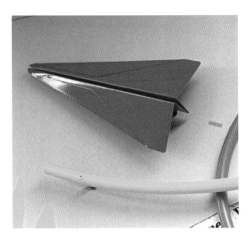

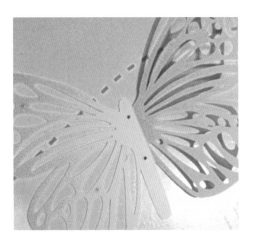

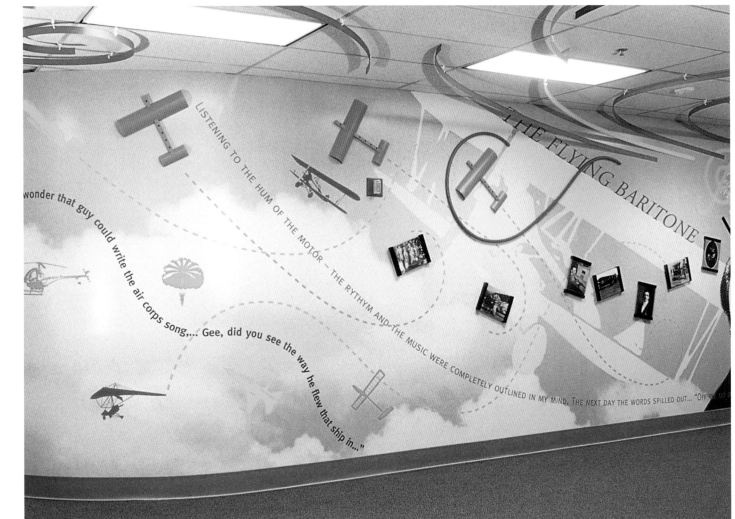

OPPOSITE PAGE: Colorful wind bars lighten the mood at the Alaskan elementary school.

TOP: A whimsical paper plane is one of the many three-dimensional elements of flight. To make the project interactive with the student body, children's drawings of flying creatures of nature were incorporated into the design. The largest three-dimensional piece attached to the walls is the hydro-cut steel butterfly, whose fluttering wings cast an intricate shadow on the wall.

BOTTOM: With a creative force equal to Crawford's accomplishments, the design aims to tell the story of a significant historical figure. At the same time, the installation had to be easy to clean, child-friendly, and durable.

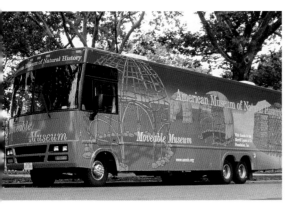
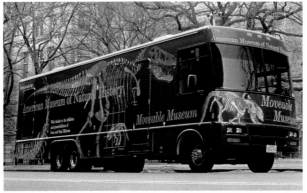

MOVABLE MUSEUM

Education has changed from rote memorization to active, experiential learning. Graphic design plays an important role in helping teachers find new ways to facilitate this process. At the Movable Museum of Paleontology, interactive exhibits bring this science to life. Displays, organized into microenvironments to maximize immersion, successfully encourage and inspire active learning.

Designed for the American Museum of Natural History in New York, the Movable Museum of Paleontology addresses two primary objectives: institutionally, to introduce the public to the museum's role in paleontological research and, educationally, to provide students and educators, grades K-6, with a unique resource. The program dictated that the completed design function both as an interactive learning environment and as a comprehensive public walk-in with state-of-the-art techniques and interactive technologies.

The primary design challenge for Lee H. Skolnick Architecture & Design Partnership was maximizing the educational impact of an extremely small and fully mobile space. The designers produced a full immersion environment. Upon entering the Winnebago, children find themselves in the middle of the Gobi desert on an excavation site. Their journey continues into a working research lab where they can touch, explore, and discover on their own. The designers transformed the vehicle with a full-wrap exterior graphic treatment and outfitted it with dinosaur models to scale, five interactive video monitors, hands-on activities, two computer stations, a resource library, text panels, flip panels, meteor samples, mammal skeletons, microscopes, and a re-created excavation site. Fabrication materials

and finishes create several microenvironments that encourage active learning through creative role-play. Interior graphics and color are consistent with their thematic and contextual settings. The graphics in the dig area evoke the texture and vocabulary of a field site. Likewise, the lab is designed to reflect the kinds of clipboards and specimen labels used in a scientific setting. Overall, visual variety attracts and stimulates young visitors; the highest degree of legibility promotes clarity and understanding.

Lighting was an extremely crucial and challenging design element. To make the contrast between dig site and laboratory convincing, the designers created lighting effects that would make visitors feel they were outdoors in one part of the bus and indoors in another. Hidden lighting washing the wall murals created a consistent and natural effect in the dig area while fluorescent ceiling panels and actual desk lamps worked for the lab. Extreme care in the color balancing of lamps was key to achieving these believable environments.

The Movable Museum's billboard-sized graphics and vibrant exterior color-palette de-materialize the vehicle, create an arresting visual event, and promote AMNH to millions of New York-area drivers and pedestrians every time it hits the road.

DESIGN FIRM
Lee H. Skolnick Architecture + Design Partnership

PROJECT DESIGN
Lee H. Skolnick, principal
Joern Truemper, designer
Cynthia Smith, project manager
Maja Barker, museum educator
Diane Ward, graphic designer

FABRICATION
Showman Fabricators, Inc.

PHOTOGRAPHY
Chad Batka

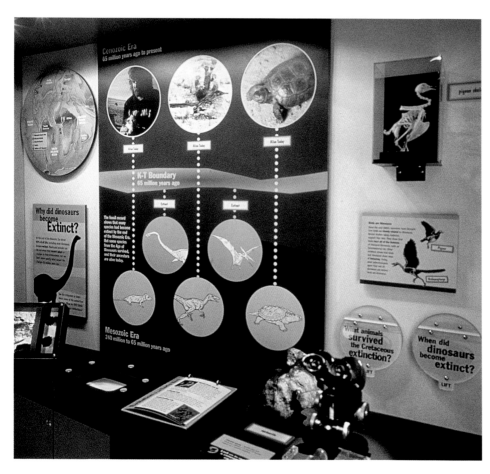

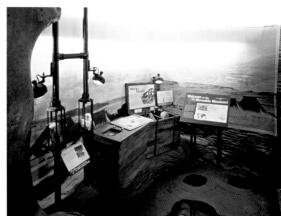

OPPOSITE PAGE: The Lee H. Skolnick firm designed movable museums on the topics of paleontology and of structures and culture.

On the mobile units' exterior facades, enormous sweeps of billboard-sized panels generate excitement and curiosity and promote AMNH.

On the exterior of the Movable Museum of Paleontology, seen on the right, full-scale illustrations allow children to measure themselves against their favorite dinosaur.

TOP LEFT: Text panels and flip panels explain several current theories concerning why dinosaurs became extinct.

TOP RIGHT: In the interactive re-creation of a Gobi Desert dig-site, video monitors detail the experience while an in-floor vitrine displays a partially unearthed dinosaur fossil.

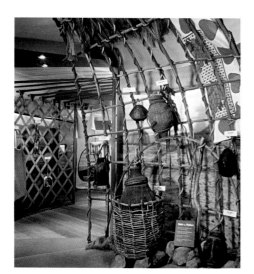

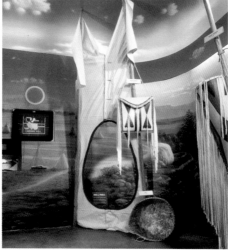

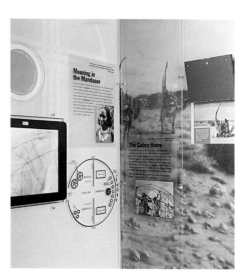

BOTTOM LEFT AND MIDDLE: In the Movable Museum on the topic of structures and culture, also designed by L.H. Skolnick for AMNH, housing types of native peoples are interpreted through full-scale re-creations of sections of the structures.

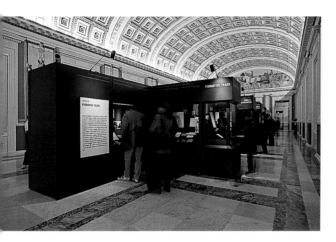

SIGMUND FREUD: CONFLICT AND CULTURE

Objects and surprising imagery can be effective graphic communicators. At the Conflict and Culture exhibit, the unusual forms of some of the displays bespeak the man and his practices, considered unorthodox in their time.

The design firm of Chermayeff & Geismar assembled an arresting display of visual images, textual information, and tangible objects to make Sigmund Freud come alive and to highlight the importance and impact of his ideas on modern culture. The exhibit includes Freud's famous couch, rare home movies, a radio address in halting English, and video clips of Freudian references in popular culture, delivered by Sean Connery, Woody Allen, Homer Simpson, and others. This juxtaposition of real objects of the life and time of Freud with examples of his impact on popular culture provides both a lesson in history and a study in cultural reaction.

The designers used exploded selections from Freud's original manuscripts in his precise, high-German hand to give visitors some insight into the nature of Freud's work. Mounted in display cases, these manuscripts are surrounded by their translations, references to other points of view, and illustrations that express Freud's thoughts and the controversy that they engendered.

Solid, sturdy display cases were retrofitted with case cozies, neutral panels that cover the tops of the elaborately crafted cases in order to focus visitors' attention on the contents rather than on the containers. This concept of smooth neutrality guided the overall exhibit design. The surrounding space was so decorative that an attempt to mimic or compete with it would have been prohibitively costly and would have had nothing to do with the subject matter of the exhibit. Further, the display cases not only hold the objects on display but also define how the user moves through the space of the vast hall to explore the exhibit. Their placement determines navigation without the need for signs or arrows. The graphics are seamlessly coordinated with the bold, heavy shapes of the large case structures; together their visual impact imparts a sense of seriousness and intensity.

DESIGN FIRM
Chermayeff & Geismar Inc.

PROJECT DESIGN
Tom Geismar
Jonathen Alger
Anita Ayerbe
Nina Katchadovrian
James Hicks
Molly Carlot
Chris Rover

FABRICATION
Richard Rew
Explus

PHOTOGRAPHY
Mark Gulezian

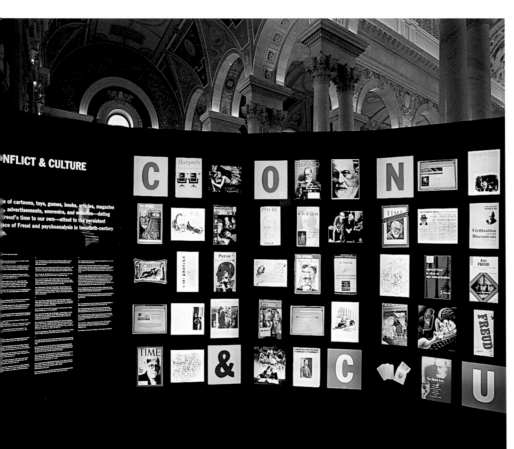

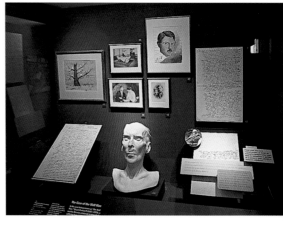

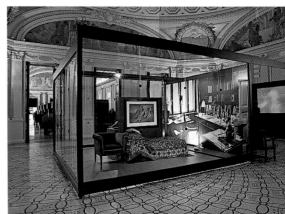

OPPOSITE PAGE: The smooth, simple display cases establish a solid presence for the exhibit in the ornate hall, carry a frieze of commentary on Freud's work, and serve as self-guiding wayfinding elements.

TOP LEFT: A curving wall made of images from magazines, book covers, and Web pages documents the legacy in visual form. The lighted wall balances historical images with playful examples of the profound impact Freud's thought has had upon modern psychology.

TOP RIGHT: Enlarged manuscripts allow visitors to delve into original work.

MIDDLE RIGHT: Like a tantalizing time capsule, Freud's actual couch casts an eerie spell. By setting the couch inside a glass exhibition case, the designers underline the almost mythic significance of this particular couch.

BOTTOM: The exhibition logo suggests the dramatic nature of Freud's theories and the controversy they stirred both in academia and in popular culture.

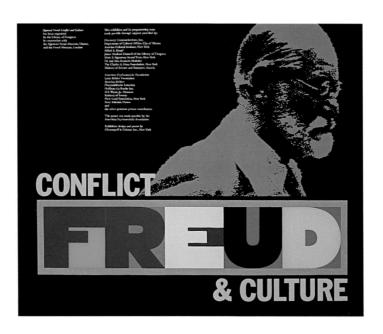

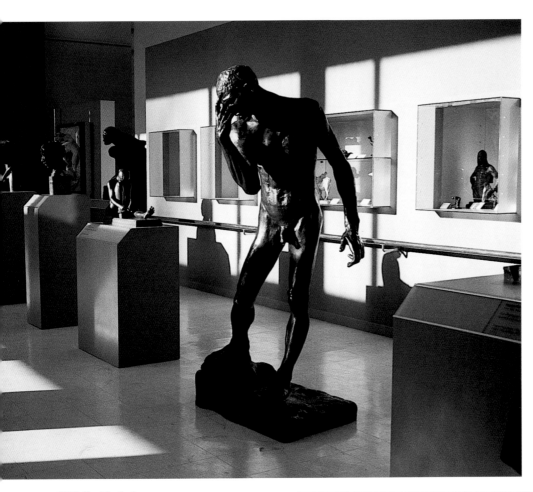

OPPOSITE PAGE: The tactile itinerary and facilities are raised on the main directory glass surface, along with Braille and text. An audio message activated by photosensor informs all visitors of the current lectures and events. The sighted visitor is presented with the overall gallery plan, printed on the subsurface of the glass.

ABOVE: Simplicity of gallery layout aids handicapped users without interrupting historical flow.

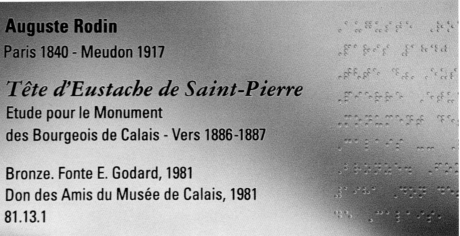

Auguste Rodin

Paris 1840 - Meudon 1917

Tête d'Eustache de Saint-Pierre
Etude pour le Monument
des Bourgeois de Calais - Vers 1886-1887

Bronze. Fonte E. Godard, 1981
Don des Amis du Musée de Calais, 1981
81.13.1

ABOVE: Information is offered in both printed text and Braille.

TACTILE REVELATIONS

MUSEE DES BEAUX ARTS/MUSEO NACIONAL DE COLOMBIA

Designers often employ media that communicate information to senses other than the visual. Using alternative means of imparting information is especially rewarding when the audience might otherwise be excluded. To create solutions that make the experience of art accessible to blind visitors, Coco Raynes Associates designed innovative installations in museums in France and Colombia that allow the blind to appreciate sculpture and other artworks.

DESIGN FIRM
Coco Raynes Associates, Inc.

PROJECT DESIGN
Coco Raynes
Seth Londargan (Colombia)

FABRICATION
Ostrom Metal Work

At the Musee des Beaux Arts in Calais, France, visually impaired and blind visitors can actually touch the bronze collection, which includes masterpieces of Antoine Bourdelle and Auguste Rodin. To facilitate access to the sculptures, the designers have produced a simplified floor plan that isolates more fragile works from the bronze sculptures while respecting chronological order. The information system addresses the needs of the general public and also permits the blind an autonomous visit.

The solution was to create only two rows of sculptures, with enough space between the pedestals to allow visitors in wheelchairs or with seeing-eye dogs free movement. The sculptures are displayed on pedestals with adapted heights that incorporate large-contrast text and Braille information etched on glass. The fragile sculptures are placed in elegant glass cases designed on a modular system to permit alternative configurations.

Two segments of RaynesRail, the Braille and audio handrail system designed by the firm, are positioned along both walls. The Braille messages, positioned on the inner face of the rails, guide visitors to and identify the adjacent sculptures. Audio comment, activated by photosensors along the rail, details the characteristics of the artworks.

At the Museo Nacional de Colombia, housed in a former 1847 penitentiary that is now an historical monument, the collections range from pre-Colombian era to contemporary art, displayed throughout two floors. Unlike the artworks in Calais, the Colombian art cannot be touched. The challenge for Coco Raynes Associates was to create a master plan for an educational program to address all visitors, including children, visitors in wheelchairs, and the visually impaired. The designers have developed an in-depth tactile and audio information program to present the collection's selected items within their ethnographic or historical context. The itinerary allows for an autonomous visit, highlighting typical examples of each period.

Replicas could easily substitute archeological pieces for tactile discovery. However, paintings, pieces of furniture, or equipment were more problematic. A common denominator had to be found to present these antiquities to the general public as well as to blind visitors. The creation of tactile drawings, hung near the originals, was one of the practical solutions.

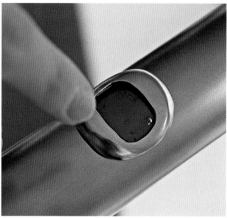

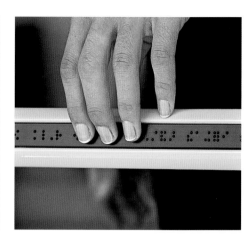

ABOVE: Activated by photosensors, audio units with multilingual capability describe the sculptures' characteristics.

ABOVE: Segments of RaynesRail, a Braille and audio handrail system, introduce each sculpture and give its exact location in paces.

ABOVE: The specially designed rails provide continuous wayfinding resources for visually impaired visitors.

BOTTOM: Ease of movement and efficiency are hallmarks of the exhibit at the Musee Des Beaux Arts. Spaces are wide enough to accomodate visitors in wheelchairs and to provide sufficient distance for viewing for sighted visitors.

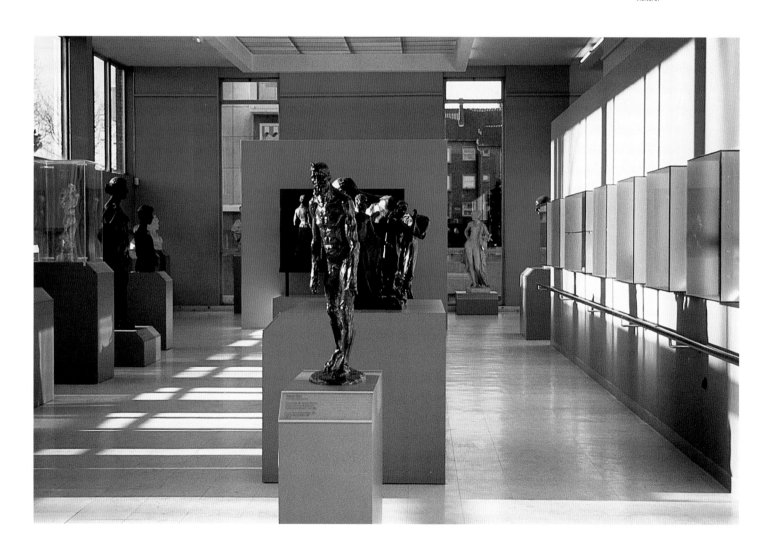

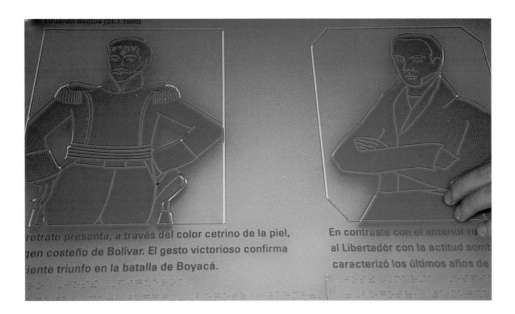

retrato presenta, a través del color cetrino de la piel,
gen costeño de Bolívar. El gesto victorioso confirma
iente triunfo en la batalla de Boyacá.

En contraste con el anterior r
al Libertador con la actitud som
caracterizó los últimos años de

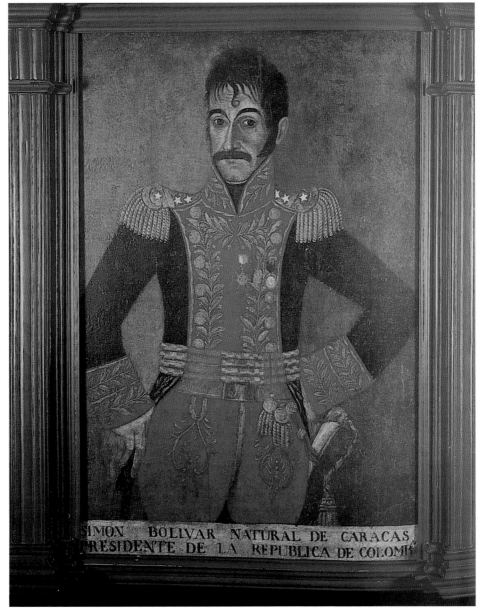

SIMON BOLIVAR NATURAL DE CARACAS
RESIDENTE DE LA REPUBLICA DE COLOM

TOP: At the Museo Nacional De Colombia, blind visitors can feel the tactile drawings of the Bolivar portraits.

BOTTOM: The actual portrait hanging on the wall is of the young Victorious Bolivar.

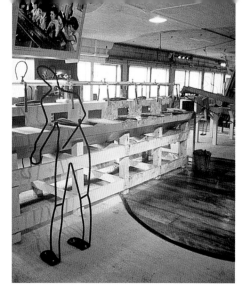

THIS PAGE: Simple wire figures made of rebar indicate each interactive workstation along the canning line. The designers chose to use low-tech rebar as a low-cost way to suggest human presence without interfering with sight lines.

GULF OF GEORGIA CANNERY

At the Gulf of Georgia Cannery, a national historic site on Canada's west coast, multi-sensory exhibits and non-traditional graphics not only educate but also add the look, smells, and sounds that simulate the flavor of the once bustling factory.

Parks Canada wanted to construct a salmon-canning-line exhibit at the Gulf of Georgia Cannery to engage visitors and to inform them of the complex process used at the century-old fish cannery. Mostly volunteer retired cannery workers collaborated with Parks Canada to design and construct the exhibit. Research for the project relied heavily on the memories of the former plant employees since little documentation existed and the plant's interior and equipment had been modified many times over the years. Artists sketched while workers described the scene as it had been. Anecdotal stories of daily life in the plant gave inspiration to the design interpretation.

The main salmon-processing-line exhibit is reconstructed to appear as it did in the 1940s. The canning-line exhibit includes salvaged mechanical parts, steam powered equipment, and a variety of interactive stations to engage visitors. A vintage delivery truck loaded with salmon signals the beginning of the adventure as visitors enter the exhibit. The truck, period black-and-white pictures of workers, and reproduction can and packing-crate labels serve as graphic elements that lend a sense of time and space. Modern graphic design style was kept to a minimum so that period views and the canning line itself would tell the story. Audiovisual stations housed in giant

salmon cans show the machines in action, including an animation of a fish-butchering machine. Because the cannery in operation was a very noisy place, the exhibit includes a soundscape that allows visitors to experience the din, as the whole building chatters, hums, and hisses with activity.

The exhibit's puddle of time section re-creates the period condition of the building's interior envelope for the fish butchering area. Walls were skinned and whitewashed, a section of wood floor was built over the existing concrete and aged, and a fresh section of tongue and groove ceiling was constructed. Yellow stained wood used throughout the exhibit separates informational segments from the mechanized process.

Model fish in all stages of preparation, fish blood and hand grime, partly finished cups of coffee, and dripping water from real hoses enhance the effect. The graphics on the interactive islands are hinged to allow them to function as demonstration platforms. Visitors can don aprons and rubber boots and participate in activities such as sorting fish, filling cans, and calculating their worth in salmon. Kids' activities are contained in doors and drawers. A red salmon-shaped drawer pull indicates more information is within. The pièce de résistance for kids is a bucket of fish guts into which they can stick their hands.

PROJECT DESIGN
Rob Ward
Gordon Fylewych

FABRICATION
Kadoke Display
Derrick Exhibits
Jim McKee
Numerous Volunteers

PHOTOGRAPHY
Gordon Fylewych

RIGHT: This fish butchering island is complete with simulated fish guts and cannery workers' tools.

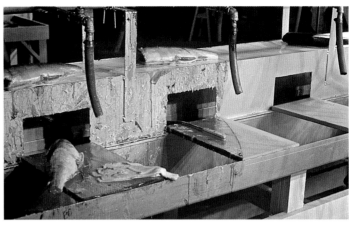

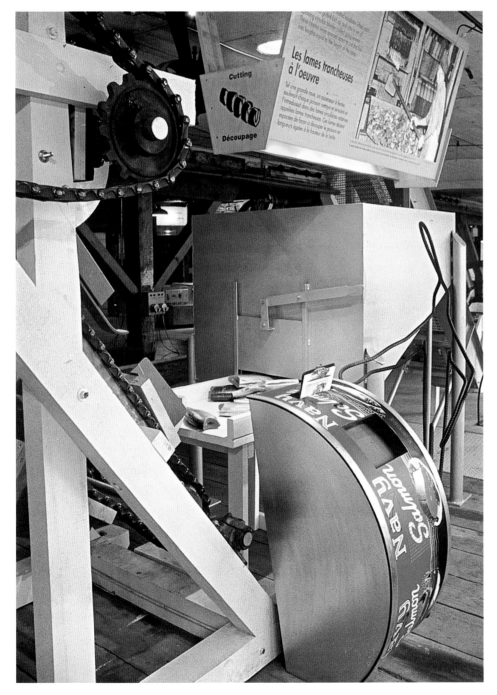

Les lames trancheuses à l'oeuvre

Cutting

Découpage

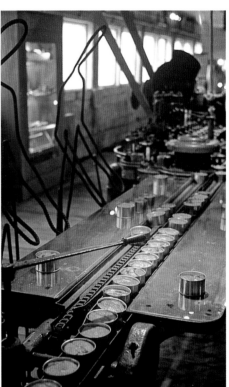

ABOVE: This hands-on, interpretive island allows visitors to try to finish filling a can of salmon to top-up the weight.

LEFT: In this section of the canning line, an audiovisual unit shows a salmon-filling machine in action and sound. An "inspector's clipboard" at each station provides technical drawings and more information. The overhead graphics keep sight lines clear.

THE JILL KUPIN ROSE GALLERY

Conceptualizing signage for an exciting site poses the challenge of maintaining a sense of unity between the displays and the environment around it. At the Jill Kupin Rose Gallery, not only did the design fit into the setting, the display cases enhanced the beauty of the architecture. Thoughtful integration of space and information provides users with a sense of continuity that strengthens their experience.

Chermayeff & Geismar were asked to design an exhibition to celebrate the past and present of the New York Public Library, one of the city's most important cultural institutions. The permanent 2,000-square-foot exhibit is situated along the grand stone corridor that runs the entire length of the second floor.

The exhibition casework is designed to allow elegant architectural finishes to read through large transparent black-and-white photographs. The exhibit panels and cases are dramatically backlit and act as light fixtures to illuminate the hall.

The display explores the history of the library and introduces the many services and programs offered through its vast system. The exhibit also spotlights rare library treasures and describes the diverse backgrounds of the system's users. Rare photographs, drawings, maps, film clips, sound recordings, and reproductions of rare books and manuscripts introduce visitors to the rich collections and services of this world-renowned library.

DESIGN FIRM
Chermayeff & Geismar Inc.

PROJECT DESIGN
Ivan Chermayeff
John Grady
Herman Eberhardt
Robert Henry
Thomas Ferraro
Fabio Gherardi
Julie Walsh
Charlotte Noruzi

FABRICATION
Explus, Inc.
Exhibitology

PHOTOGRAPHY
Richard Fahey

OPPOSITE PAGE: Display cases are unobtrusive along the grand stone corridor.

BELOW: The lighted exhibit panels that run the length of the library corridor include interactive programs and video displays.

TOP RIGHT: Backlit displays provide illumination in the gallery.

MIDDLE RIGHT: The transparent material used for the overhead photographic display allows the richness of the marble wall to enhance the exhibit. This is a prime example of integration of space and information.

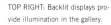

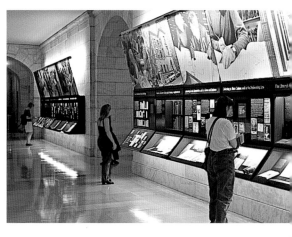

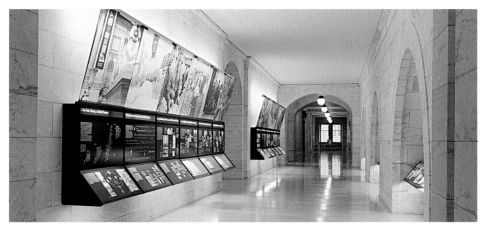

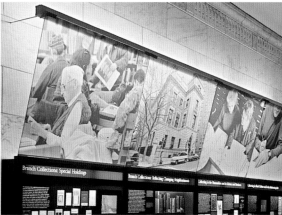

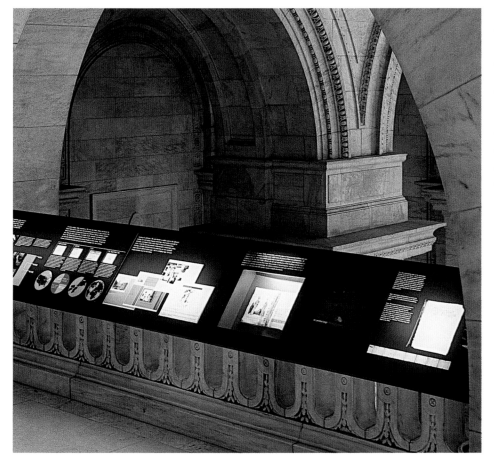

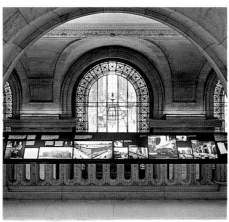

BOTTOM LEFT AND RIGHT: The exhibit was designed to fit into the existing architectural elements of the library's landmark 1911 Beaux-Arts building.

THIS PAGE: The icon on the
top of the tower provides an
identity for Starbucks while
paying homage to Art Deco
landmark building.

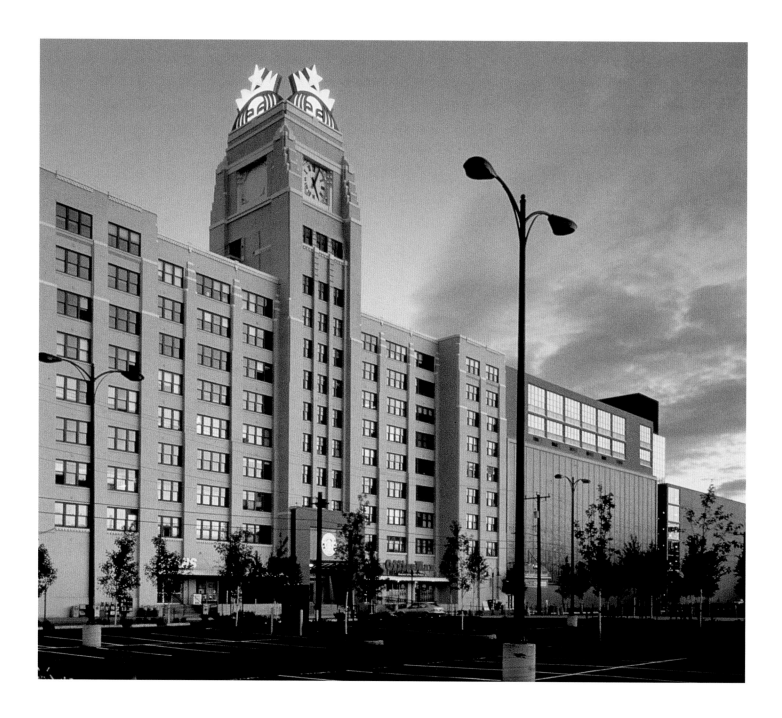

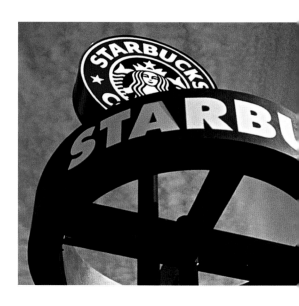

SEATTLE, WASHINGTON

STARBUCKS CORPORATE HEADQUARTERS

Like schools or museums, corporate sites employ signs and graphic displays to educate and inform. W P a, Inc.

incorporated space, sculpture, iconography, and text into a layered language to introduce and educate visitors to

Starbucks' unique corporate culture and its story of the making and consuming of coffee.

DESIGN FIRM
W P a, Inc.

PROJECT DESIGN
Anthony Pellecchia
Kathy Wesselman

FABRICATION
Doty & Associates

PHOTOGRAPHY
Rick Semple

W P a, Inc. was given the vaguely defined task of designing "park graphics" for the new Starbucks' headquarters. The design firm took advantage of the program's freedom by designing elements that reflect Starbucks' corporate culture while illustrating the presence of a new life on the site— a landmark Sears building with a Deco-style tower.

The work consists of five distinct components: location through entry and perimeter markers; movement via a long pergola, or arboreal passageway, leading to Starbucks' corporate entrance; marking by enlivening the top of the original Sears tower with Starbucks' familiar siren; direction through parking garage signage; and understanding by inventing four interpretive sculptures embodying each of the four elements of "the Alchemy of Coffee."

The disparate realms of parking lot and green space are mediated by a 148-foot-long pergola, which guides one toward the new entrance. Likewise, the pergola's simple columns relate to the birch trees that grow through the structure to knit together the natural and the man made. The pergola examines the values of movement and stillness through an inspiring quote from Luigi Barzini's The Italians about taking the time to

understand the "art of inhabiting the earth." This text, in frieze form, runs the entire curved length of the pergola, requiring the viewer to walk the length to read the full quote.

Near the entry, Starbucks' unique corporate identity takes a sculptural presence. The Alchemy of Coffee, a series of four elements reinterpreting the spirits of Earth, Air, Fire, and Water in material and sculptural form, reflects Starbucks' vision as it translates the essence of Barzini's wisdom into circular text on the sculpture's bronze base plates and as it celebrates the philosophy and science of growing and roasting coffee.

Starbucks also asked the designers to produce an icon for the top of the clock tower, which would serve as a marker in the city. WPa used the ubiquitous siren from the Starbucks' logo in a way that joins the figures of the logo and the clock tower in a three-dimensional landmark. Both temptress and guiding beacon, the siren inherits the beloved, aged landmark yet contributes something fresh to the landscape. The top of the siren's head peeks out from the clock tower in all four directions, playfully subverting its solemnity while giving the clock tower a face, a crown.

TOP: The curving design of the pergola acts as a giant arrow pointing to the Starbucks employee entrance. In addition, the pergola serves as a transition between the parking lot and the small park that provides a respite from the workplace. Simple column footings in the pergola relate to the birch trees that grow through the structure, further knitting it to the natural environment.

BOTTOM: A close-up of Barzini's inspirational quote.

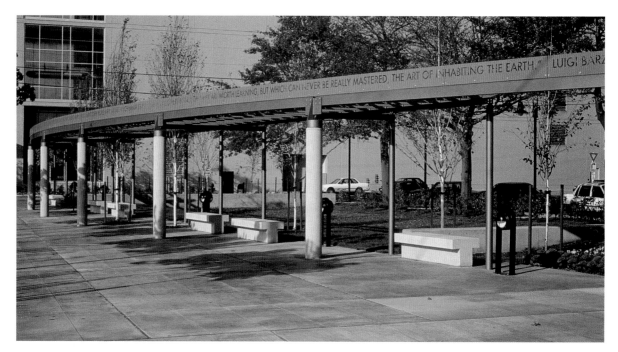

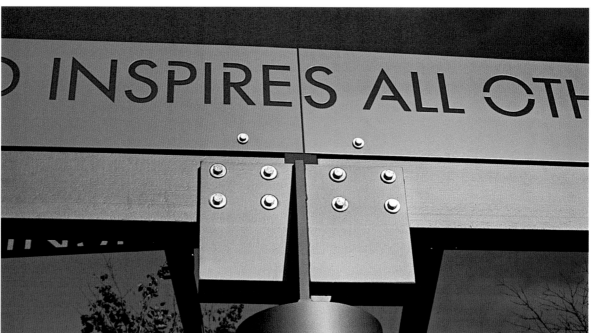

THIS PAGE: Three in a series of four elegant sculptures, titled The Alchemy of Coffee. The four sculptures—air, water, fire and earth—mark the public entrance to Starbucks.

The simple elegance of the sculpture, seen illuminated against the night sky (TOP), imparts the whimsy and mystique at the core of contemporary coffee culture.

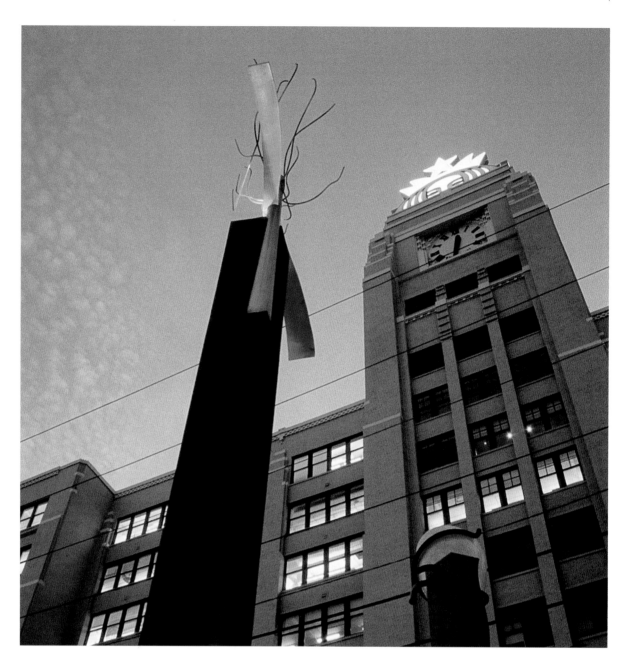

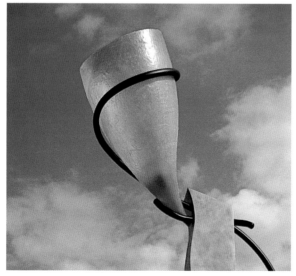

ESTABLISHING AN
IDENTITY

by Henry Beer

With all of the talk related to branding afoot in the business world, it's no wonder that modest new businesses and multi-national conglomerates alike have begun to focus intently on the identity of places that are intended to communicate their corporate or institutional message to the public. Identity is so often affiliated with products rather than environments, but that affiliation is changing rapidly as actual reality competes with virtual reality for everyone's attention.

It is important to recognize that there are three kinds of environments to which an environmental identity program might commonly be applied. The first can be referred to as *Purpose Built Environments* such as a showroom for Mercedes Benz, a store dedicated to specific cluster of interests and products such as REI, or the Nike Corporate Campus. Typically in these kinds of facilities, the identity can be systemically embedded in the design of all exterior and interior elements. This embedding can result in a strong, coherent, and unambiguous visual message.

Flexible Use Environments represent the second category of place for identity creation. Typically these environments are designed to accommodate a heterogeneous mix of uses. The Jacob Javits Convention Center in New York represents a civic facility that must provide great flexibility because of the range of venues that it serves.

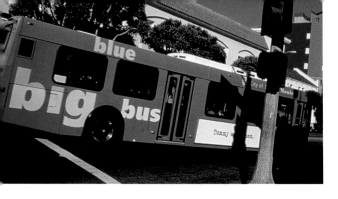

> It is important…to deeply embed the client's message in elements that are not simply appliqué. <

A commercial version of the *Flexible Use Environment* might be an enclosed shopping center such as Mall of America or the downtown commercial precincts of a city such as Boulder Colorado's Pearl Street or Santa Monica's 3rd Street Promenade. In the case of the Flexible Use Environment, often the character of the background facility is neutral, allowing an overlay of the current venue's identity to take precedence. A vivid example of this is Apple Computer's massive trade show staging at the Moscone Center in San Francisco. An attendee couldn't begin to describe what the base building looks like.

There is a third, hybrid, environment referred to as the *Contextual Environment*. Contextual evvironments are typically come complete with an underlying integral (and often beloved) identity. Sienna in Italy, a resort such as Vail in Colorado, New York's Metropolitan Museum of Art, and Churchill Downs are very different places but all are highly contextual environments. These are challenging, constraint-rich environments. In these settings there is often a strong background message and character that demands respect and impacts the design of any

overlay identity. Often these are environments that must be flexible in their use, but by virtue of their history, location, or inherent character they impose constraints on what may or may not be added without causing the host environment to be overwhelmed or embarrassed by inappropriate or misleading messages.

Each of these three environments provides the designer and the client with unique opportunities to take advantage of in the creation of an identity.

Purpose Built Environments afford the designer extraordinary freedom and depth of expression because the identity and the context are one and the same. It is important in this type of project to deeply embed the client's message in elements that are not simply appliqué. Nike Town uses furniture, casework, flooring, artifacts, lighting, and the products themselves to communicate the parent company's dedication to excellence through cutting edge design.

Establishing an identity in such settings requires that the designer communicate more than information. Information alone is simply wayfinding. The designer must search for the emotional content of the client's message

> The greatest storyteller is capable of weaving a narrative that results in the viewers seeing themselves in the story. <

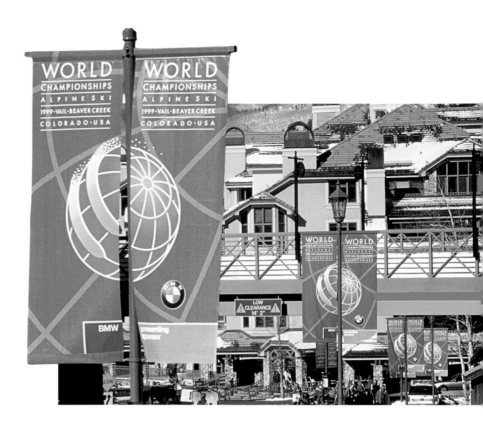

around which a design approach can then be crafted. The designer is a storyteller in such a context. The greatest storyteller is capable of weaving a narrative that results in the viewers seeing themselves in the story. That is, of course, inclusive rather than exclusive branding and identity.

Flexible Use Environments afford great freedom as well with the added advantage of the temporary nature of these environments. There is a reason why trade shows in cutting edge industries are so often a wealth of new design and media approaches to creating identity. First, they are highly visually competitive. Everyone's grasping for eyeballs, so solutions must be clever, compelling, and immediate. The solutions must connect quickly, much like a television commercial. There isn't time for a long, intellectual engagement with the viewer.

Make this mistake and no identity is established or, worse, the client is cast as "boring" or "self absorbed."

In a the Contextual Environment, the designer begins by exercising great caution and sensitivity, creating identity solutions that complement and enhance the host environment while clearly projecting the message of the event, program, or idea. However, the use of contrast, intelligence, and great design to convey a message can produce a legitimate and inspired answer in some cases. Brilliantly colored 68-foot banners were affixed to the Beaux Arts façade of the Metropolitan Museum in the late 60's announcing the arrival of the first "blockbuster" show. After the initial shock, nearly everyone acknowledged that the contrast the banners provided enhanced both the building and the identity of the show they heralded. These banners are now synonymous with the Museum's "brand."

CommArts was challenged with a Contextual Environment when the multi-disciplinary design firm was asked to design the identity and environmental graphics for the Alpine Ski World Championships in Vail, Colorado. The Championships are held annually in different ski areas around the world with 56 nations and over 1000 athletes participating. In 1999 the event drew over 125,000 spectators to Vail and Beaver Creek, creating the largest television audience in the history of ski racing.

The constraints were daunting in that the program designed for this world-class event had to be reviewed and approved by six separate groups, each with its own agenda. The Town of Vail and Beaver Creek Village both have restrictive signing guidelines, and the program had to demonstrate substantial compliance with those regulations. The development of the logo itself had to demonstrate almost superhuman levels of adaptability. The symbol had to work in a single color on a fax all the way up to multi-color renditions that could be proven to be effective on internationally televised media. Further, the economic success of the Championships depended on the sale of compelling attractive merchandise, so the logo had to look terrific on hundreds of souvenirs consisting of posters, apparel, jewelry and equipment.

Vail and Beaver Creek have an architectural vernacular liberally drawn from European Alpine resorts and into that setting CommArts had to place thousands of banners, informational kiosks and venue identification. An International attitude had to project from the graphic materials and issues, such as visibility during heavy snowstorms, dictated the levels of contrast and color used in creating the identity. Technically, the materials had to be robust but inexpensive to withstand high winds and enthusiastic souvenir collectors. CommArts was gratified to learn that their client, The Vail Valley Foundation was officially congratulated by the WASC Committee on successfully capturing the spirit of the event in the graphic materials, the project symbol and the banner and pageantry programs throughout the area.

All environments are not the same. Distinguishing and understanding the differences among spaces and places, and designing with those differences in mind, can empower the designer to create brilliant and appropriate environmental identity solutions.

Henry Beer, co-founder of Communication Arts Incorporated with Richard Foy in 1973, has completed over two hundred projects for national and international clients. He has been published in numerous professional and public interest magazines and journals and has appeared on national television. He is a frequent speaker at universities, professional schools, and national conferences. Mr. Beer has won numerous national design awards. He is married, with two sons. He fishes when he can.

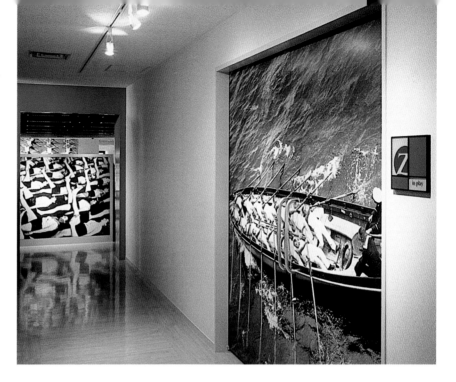

THIS PAGE: Strategic mural placement in the corridors also aids wayfinding through interior spaces.

ZURICH DIRECT

Corporate culture is more than a mission statement. The design of an office environment has a major impact on its culture. Design can set tone and provide a visual point of interaction and integration of a company's work ethic. Gensler's use of image, color, and material in the Zurick Direct workspace graphically conceptualizes Zurich's corporate culture.

After completion of the first phase of a new care center for the Zurich Direct Insurance office in Tokyo, the success of the new practice required Zurich to double in size. Gensler's first-phase interior design was well received by Zurich, so Gensler was asked to improve the design image for the expansion area as well. Zurich requested the designers "to raise the level of quality," but left it up to the design team to define the elements of that quality.

Gensler's design approach to the new expansion areas included the introduction of wood paneling, the use of bold yellow vinyl wall covering, and the integration of large-scale photo murals as important design elements. These elements became the backdrop for creating a stronger message reinforcing the Zurich corporate culture to the staff. Specifically, the large murals, depicting various sports teams being coached to victory, reinforce Zurich's concept of managers as coaches rather than supervisors. Mirrored wall surfaces with the company logo allow the staff to see themselves as the stars of the firm. The artwork, which Gensler also developed, conveys not only the Swiss culture of Zurich, but also symbols of excellence. Additionally, the entire office area is designed with wood-tone vinyl flooring, suggesting the indoor track of a fast-moving company. This is a team on its way to a win.

DESIGN FIRM
Gensler, Tokyo

PROJECT DESIGN
Steve Louie, designer/programmer/project manager
Patti Glover, mural designer
Chris Follett, mural designer

FABRICATION
Pacific Color Connection

PHOTOGRAPHY
Atsushi Nakamichi
Nacasa & Partners, Inc.

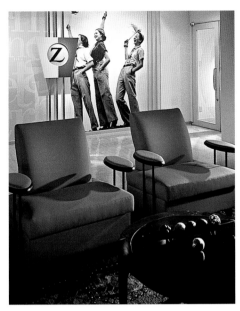

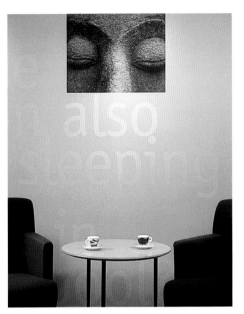

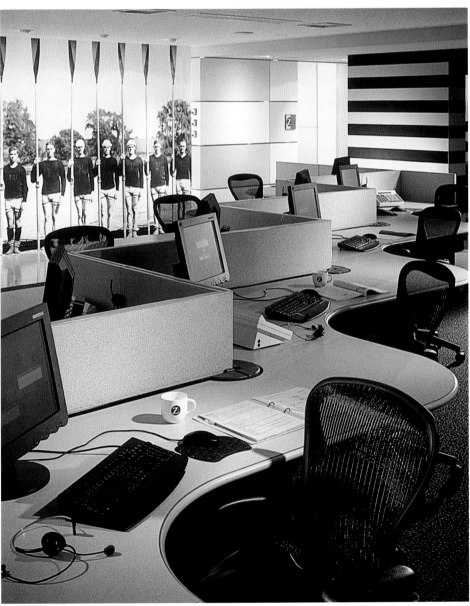

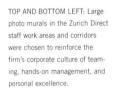

TOP AND BOTTOM LEFT: Large photo murals in the Zurich Direct staff work areas and corridors were chosen to reinforce the firm's corporate culture of teaming, hands-on management, and personal excellence.

TOP MIDDLE: Inspirational text and images of nature combine to make the staff lounge and waiting areas soothing without being dull.

TOP RIGHT: The juxtaposition of thoughtful quotes and photographs in the worker's lounge is designed to evoke quiet introspection.

STEELCASE WORKLIFE BUILDING

Thoughtfully chosen materials and the appropriate use of formal design elements, such as color, line, and shape, create a visually unified whole when incorporated into traditional wayfinding elements such as directional signs and room markers. These elements, even when used subtly in the environment, can reinforce a company's identity.

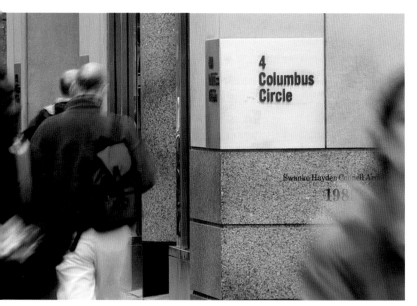

Steelcase, Inc. is one of the world's largest designers and manufacturers of office furniture. For its new corporate headquarters, Steelcase desired identity and wayfinding signage that would communicate its innovative designs for workspaces of the new millennium; its commitment to serving both the work and life needs of its clientele; and its significant place in the redevelopment of Columbus Circle, the company's new location. The graphic designers collaborated with the architect at every step of the project to develop and place modern, cutting edge signage that has the strength and longevity to

support Steelcase's firmly established identity. Each sign contributes to a potential buyer's concept of the firm.

Columbus Circle is the epicenter of New York City. Distances to the rest of the world are measured in concentric circles from this point. The building's arced interior space, designed by Kohn, Pederson, and Fox, incorporates circular and curved elements. Two Twelve Associates expanded on these cues in their concept for signage design. A ground level exterior sign, with circles on a stylized map of Manhattan, places Steelcase at the center of Columbus Circle's reinvigorated business environment.

Interior signs interpret the arced concept in their bowed surfaces. The pairing of fiberglass and stainless steel for wayfinding signage proves an unusual but effective one. Convex fiberglass panels are tension fit with bold frames and accents of stainless steel. Exhibit signs utilize bowed fiberglass panels pierced by stainless steel rod frames. The signs hold brushed steel plaques with magnets that enable printed messages to be quickly and easily changed. The signage symbolizes the company's work-life theme: the durability and strength of work and the fluidity of life.

Finally, the new space is both office and showroom. Visiting clients can view Steelcase office workers, who are actually using the furniture offered for sale.

DESIGN FIRM
Two Twelve Associates, Inc.

PROJECT DESIGN
Ann Harakawa, principal-in-charge
Jill Ayers, designer
Andrew Simmons, project manager
Patrick Connolly, production

FABRICATION
Kaltech Industries
Precision Engraving

CONSULTATION
IDEO, Design and Product Development

PHOTOGRAPHY
Erik Kvalsvik

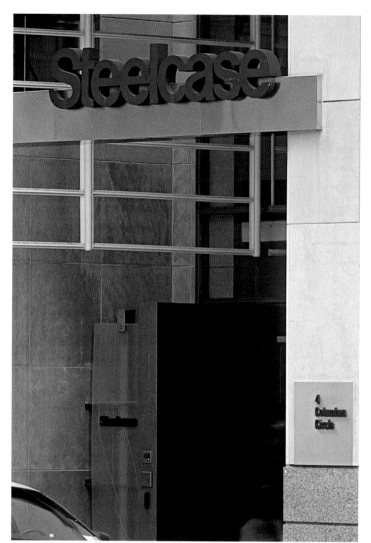

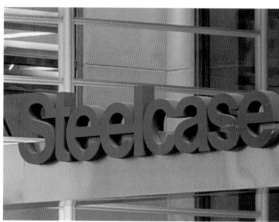

OPPOSITE PAGE: Street-level address signage makes it easy to find the building, which Steelcase shares with other tenants.

TOP LEFT: In the main exterior identification sign, the bold play between the three-dimensional letters and the horizontal steel bar communicates Steelcase's strength and flexibility.

BOTTOM: This room-identification sign maintains the vibrance of the overall design while complying with ADA standards.

TOP RIGHT: The designers considered every detail an integral part of Steelcase's worklife.

MIDDLE RIGHT: Detail of the logo as translated into a three-dimensional sign.

BOTTOM RIGHT: The exhibit sign system features easily changed messages printed on paper.

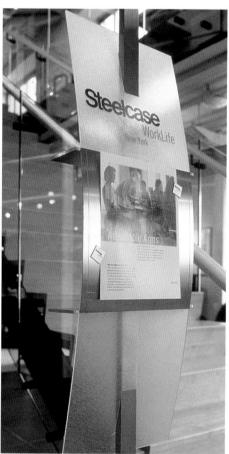

NOVELL SAN JOSE CAMPUS BANNERS

The medium is, indeed, the message. Often, the form a sign takes delivers the message. On the Novell San Jose corporate campus, banner shapes reinforce Novell's global identity in a way that traditionally static sign materials would not provide.

Novell, one of the largest software corporations in the world, needed a banner system that would reflect its leading role in the software industry. At Novell's new San Jose corporate campus, Hornall-Anderson Design Works designed banners and placed them at the most visible site, the main entrance to the corporate office, to serve as a focal point for the campus.

The orange-peel shaped banners, as if sliced from a flattened globe of the world, reflect various parts of the global market and reinforce Novell's international presence in the industry. Grid lines printed over the images reinforce this global aspect. In keeping with its international identity and companies worldwide, words and phrases in the various languages, layered tone on tone, reveal Novell's connecting theme: Making the Web Work for You. The typeface for these languages is based on hand-drawn words, adding a personal touch. Banner images contain patterns and colors that underline Novell's corporate identity and unity despite its massive network of companies worldwide.

DESIGN FIRM
Hornall-Anderson

PROJECT DESIGN
Cliff Chung
Jack Anderson
Alan Florsheim
David Bates
Mike Calkins

FABRICATION
Bannerworks

PHOTOGRAPHY
Fred Housel

THIS PAGE: Novell's bright and billowing banners herald the software giant's flexibility, imagination, and soaring growth.

The colorful banners celebrate the international communication revolution that fuels Novell's progress in the computer industry.

ALPINE SKI WORLD CHAMPIONSHIPS

For a site where events change frequently and each season brings a new look, temporary signage is an effective means to promote a visual identity, provide information, and create excitement.

Vail Associates hired CommArts as their strategic design consultant for a complete corporate re-imaging program, including corporate identity, cross-selling strategies and products, and base and mountain-area signage.

Since 1993, CommArts has worked closely with Vail Associates to design a cohesive image, signage and marketing materials for North America's number-one-rated resort. Diverse projects have included the design of new on-mountain signage and kiosks, directories for services and activities, new signage for on-mountain restaurants, numerous activity-related brochures, and a complete corporate identity system for the three resorts owned by Vail Associates.

Most recently, CommArts designed the logo and signing for the 1999 Alpine Ski World Championships held at Vail and Beaver Creek. This event attracted an estimated 125,000 spectators throughout the two weeks of competition. Bold banners were created by CommArts not only to direct crowds to the various events but also to accommodate the extensive media coverage. Thirty-one countries broadcast the Championships to approximately 500 million international viewers.

DESIGN FIRM
CommArts

PROJECT DESIGN
Dave Dute
Phil Reed

FABRICATION
EPS, Denver, Co.

PHOTOGRAPHY
CommArts

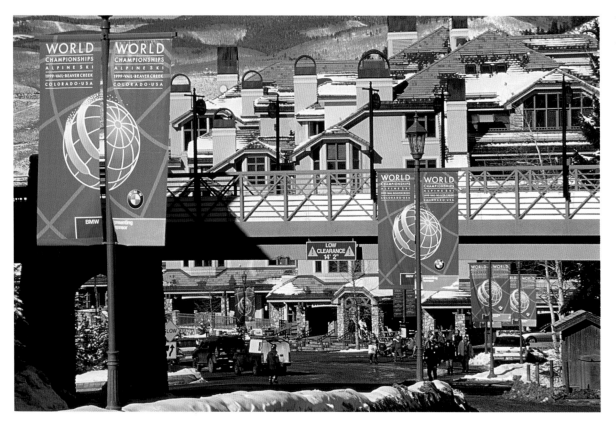

THIS PAGE: A double festival banner combines graphic appeal with wayfinding resources.

RIGHT: The vibrant red of the electronic text is easily seen because it contrasts sharply with the its natural setting.

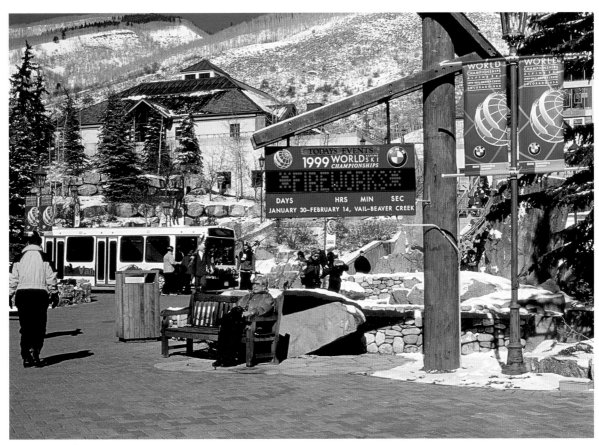

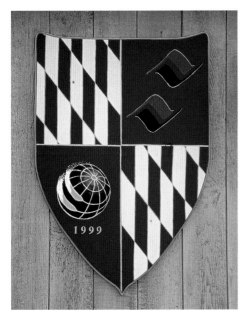

ABOVE: The Vail logo and the World Alpine Ski Championships logo come together in a heraldic banner.

ABOVE: The logo was applied to highway signs, as well as to uniforms and event signage.

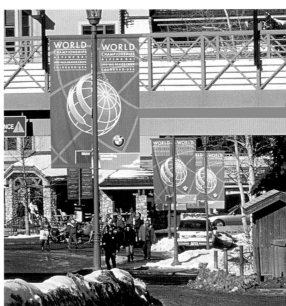

ABOVE: Double festival banners carry the excitement of the championships to the streets of Vail.

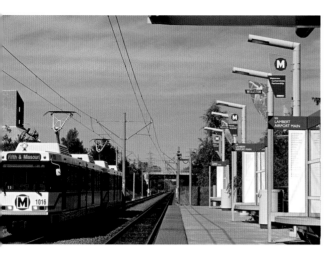

METROLINK

The prominence of graphics in the stations at MetroLink in St. Louis demonstrates the effectiveness of visual elements to promote an image as well as to provide useful information.

When MetroLink, St. Louis' light-rail system, began a rapid and extensive expansion program throughout metropolitan St. Louis and into Illinois, the new system needed a fresh, comprehensive identity, graphics, and signage program. Kiku Obata & Company's objective was to strengthen MetroLink's identity and eliminate passenger confusion through improved signage. At the same time, they had to maintain the integrity of the existing award-winning station architecture. The designers began with an understanding of the functionality of the transit system, an awareness of the personality it wished to convey, and its desire to be connected with the community.

Public transportation wayfinding systems work easily with simple, repetitive visual cues and consistent nomenclature, which the user begins to connect with as he moves through the system. The MetroLink project is designed as a series of wayfinding, directional, informational, and identity elements that fit together and can be added to as the rail system expands. Unifying color and typography and a mapping system that can be updated logically and simply are the hallmarks of the program.

Each MetroLink station features a tall, internally illuminated pylon that identifies the station by location. Parking pylons clearly tie associated parking lots to their stations and are beacons for the passengers. Wall-mounted station identification and directional signs and maps showing all stops illustrate the breadth of the system and how to use it. The clean, consistent graphics function with a variety of architectural styles and convey a strong brand image for MetroLink. The primary color palette of deep blue and red with white typography works well with the system logo developed some years ago. Blue is used primarily for identification signs, red for directional signs. The brighter more playful colors of yellow and magenta are used on banners to enhance the user experience by adding a sense of fun to a logical system.

At each station, the MetroLink system includes decorative, perforated-metal banners, which feature silk-screened graphic images from the surrounding neighborhood. The banners are an investment in the area's appearance and establish an individual identity for each station. They create a sense of pride for local passengers and add interest and color for visitors.

DESIGN FIRM
Kiku Obata & Company

PROJECT DESIGN
Russell Buchanan Jr.
Jonathan Bryant
Liz Sullivan
Heather Testa
Matt McInerney
Chris Mueller
Kiku Obata

FABRICATION
Star Signs, Lawrence, Kans.

PHOTOGRAPHY
Justin Manonochie
Hedrich Blessing Photographers

OPPOSITE PAGE: The new graphics reinforce MetroLink's identity, identify the station, and enhance the site elements.

TOP: The distinct color palette and unique materials are cost-effective and easy to maintain. The painted perforated aluminum banners have a changeable sintra panel for custom messages.

BOTTOM LEFT: The banners are silk-screened with community oriented graphics to create an overall identity for the station.

BOTTOM RIGHT: The system map offers flexibility as new stations are added to the line.

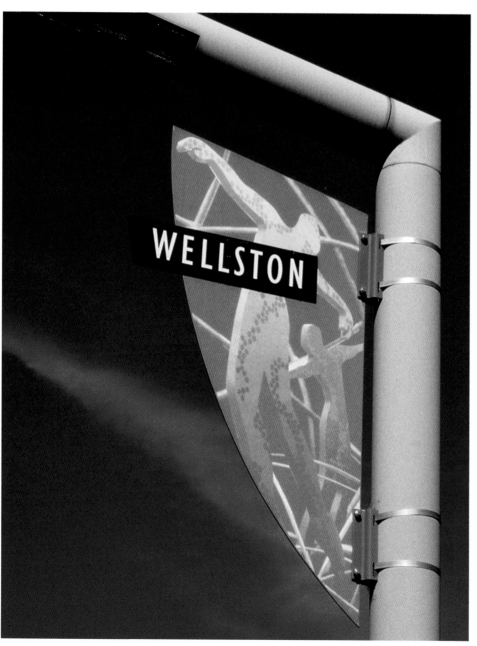

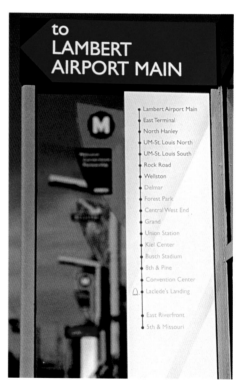

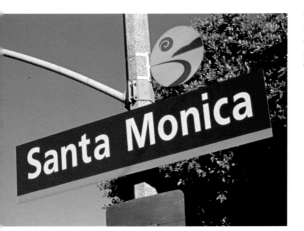

SANTA MONICA, CALIFORNIA

BIG BLUE BUS

Logos are a mainstay in contemporary culture. At times, they must be used exactly as designed. Other applications require that a logo be translated, or adapted, to fit a variety of other media. Sussman/Prejza & Company found a creative design solution in wraparound graphics used for the Big Blue Bus line in Santa Monica.

The small municipality of Santa Monica has always insisted on maintaining its own special identity. The city brought in a design firm to create a new symbol as part of a comprehensive identity program that would demarcate it from neighboring communities. Local leaders requested that the designers leave the city seal untouched because they expected the seal to "remain the linchpin of the city's image." The designers not only agreed to keep this historical artifact, but also based the design of their new symbol on the seal.

The design was developed using only the three elements from the seal that will never change— the curve of the bay, the silhouette of the mountains, and the setting sun. The sketchy, light-hearted style and clear colors are appropriate to a city that started life as a resort and continues today to attract a large number of tourists and beachgoers. The mark has been applied to print, city vehicles, and signage. The community and even the most conservative of council members have enthusiastically received the program. City departments have opted to use the new symbol over the old seal. Community groups also use the symbol for festivals and celebrations.

When the city added a new line of buses they asked Sussman/Prejza to design a new graphic identity to update and refresh the municipal bus lines' newly purchased fleet of Flyer buses and retrofitted "classic" buses. Within the Southern California Rapid Transit District, Santa Monica was known for its own line, the Big Blue Bus. However, the existing bus graphics showed more white and silver than blue.

The design solution was simple: minimize the number of design elements and reinforce the name—Big Blue Bus. Only three elements were used:

- one color, an unusual periwinkle blue (based on the blue in the Santa Monica color palette) over the entire bus.
- three words, as big and bold as possible, in Frutiger (one of Santa Monica's typefaces), which identifies the bus and ties it to the city logo.
- the Santa Monica city logo and logotype, identifying the bus's home base.

DESIGN FIRM
Sussman/Prejza & Co., Inc.

PROJECT DESIGN
Deborah Sussman
Debra Valencia
Paula Loh
Maureen Nishikawa
Hsin Hsien Tsai
Yuki Nishigawa
Luci Goodman

FABRICATION
Zumar Industries, Los Angeles, Ca.
Trenmark, La Mirada, Ca.

PHOTOGRAPHY
Jim Simmons/Annette Del Zoppo Productions

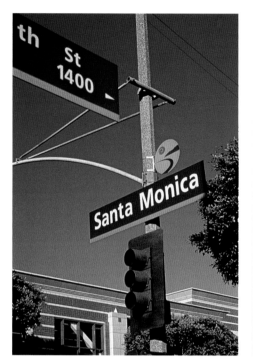

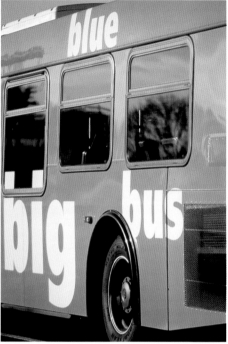

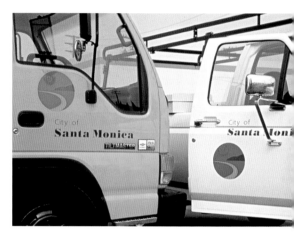

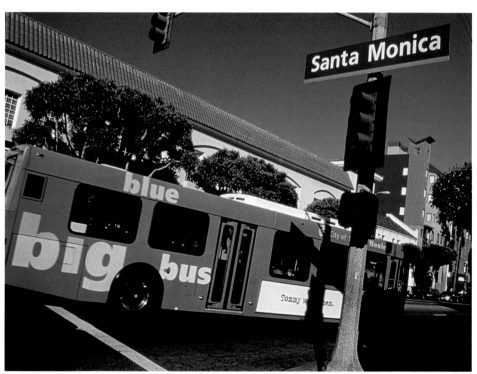

TOP LEFT: The coral color underlining the Santa Monica Boulevard sign offers a visual counterpoint to the city's terracotta roof lines and the blue sky.

TOP MIDDLE: Three little words make a big impact on the Big Blue Bus.

TOP RIGHT: The new city symbol enlivens city vehicles.

BOTTOM LEFT: The telltale-blue street signage provides an instant connection with the eye-catching graphics on the Big Blue Bus.

ROCKLAND, MAINE

FARNSWORTH ART MUSEUM

Signage graphics can integrate a building into its environment, but problems arise when contemporary design needs to be reconciled with a more traditional setting. For a museum in a quaint New England town, Arrowstreet Graphic Design developed contemporary but elegant signage that made the museum's presence felt without clashing with the surrounding architecture and culture.

The challenge at Farnsworth Art Museum in Rockland, Maine was to design a new identity and a comprehensive environmental graphics system that balanced the aesthetic of the original art museum with the new architectural additions and renovations.

Although the museum was located on Main Street in downtown Rockland, its presence as a landmark was not truly felt. This then was the task put before Arrowstreet Graphic Design. Today, banners greet visitors as they round the corner onto Main Street. A window display announces arrival at the museum by bringing color, illumination, and vibrancy into the street. A granite-and-slate monument sign marks the entrance while simple post-and-panel directionals assist visitors around the campus.

Arrowstreet Graphic Design began with a clean, sophisticated new identity, which was applied in various forms throughout the museum campus and was implemented as a full letterhead system for all museum correspondence and publicity. Designers achieved a careful balance among materials, typeface, composition, and proportions to give the system a unique, contemporary look without seeming out of place. The signs and environmental graphics were constructed of natural materials. Granite, slate, and clear glass were cut, sand-blasted, silk-screened, and fitted together with custom fastenings and hardware. The resulting signage is a mix of materials and design that works inside and out to define the campus and museum buildings and to guide visitors without overpowering the museum's unique atmosphere. The pace is slow and relaxed. Designers minimized the number of instructional signs so as not to take away from the experience, but did provide necessary information at key decision points.

DESIGN FIRM
Arrowstreet Graphic Design

PROJECT DESIGN
David Cajolet
Edward Wonsek
Kirsten White

FABRICATION AND
INSTALLATION

Wood and Wood, Waitsfield, Vt.
Kimo Griggs, Somerville, Mass.
Flagraphics, Somerville, Mass.
Harborside Construction,
Rockland, Maine
Sachs Lawlor, Denver, Colo.

PHOTOGRAPHY
Anton Grassl, Cambridge, Mass.

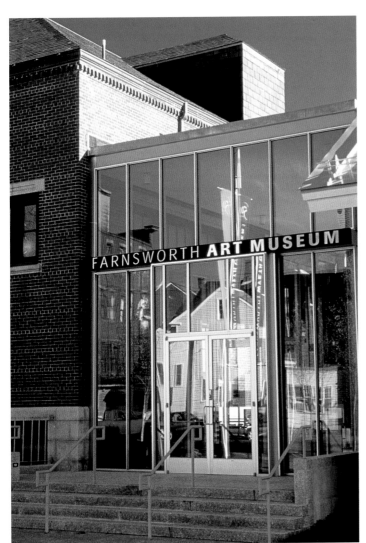

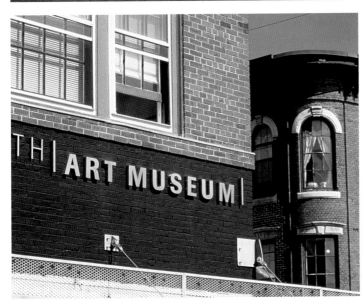

TOP LEFT: Polished stainless steel letters span the vestibule entry that links the original museum building with a portion of the new addition.

BOTTOM LEFT: The Museum's modern style was successfully reconciled with the quaint New England town setting of Rockland, Maine.

BOTTOM RIGHT: The museum houses many well-known pieces of art in a contemporary gallery setting. Three-dimensional exhibit titles are seamlessly mounted directly to the wall.

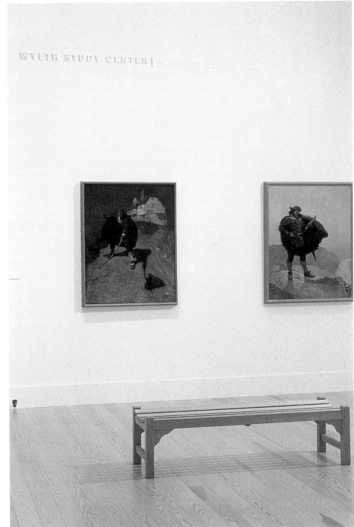

BELOW LEFT: Sleek custom poles and banners herald visitors to the museum and cue them to the location of the new main entrance.

BELOW RIGHT: The exterior directional and building-identification system reflects the traditional nature of the overall museum campus architecture.

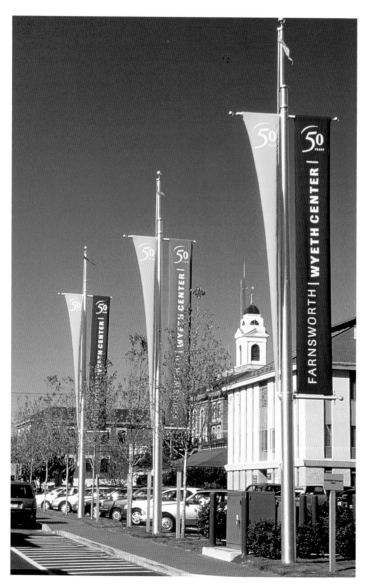

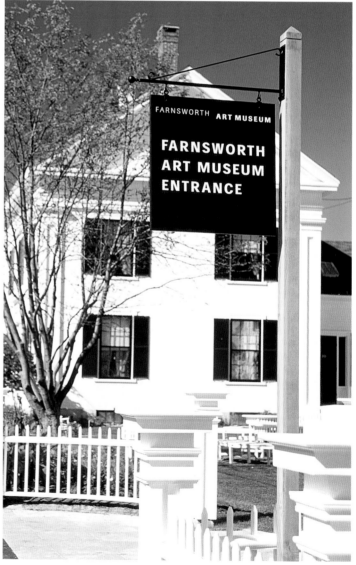

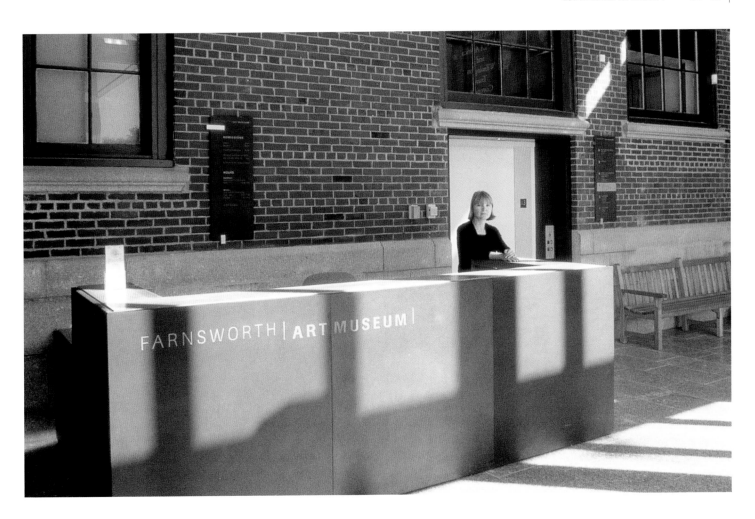

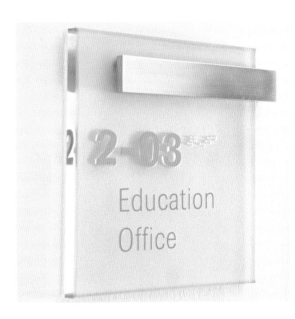

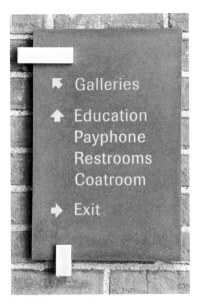

ABOVE: Interior bricked wall areas of the museum, like the new entrance lobby, support wayfinding signs of natural slate, with sandblasted and filled sign messages. The signs provide directional information to guide visitors to and through adjoining museum buildings.

BOTTOM LEFT: Wayfinding and identification signs in gallery areas are of glass with custom designed stainless steel supports. They provide directional and room information without being too prominent.

BOTTOM RIGHT: A detail of the slate signage used in the front entrance lobby.

SEGA GAMEWORKS

A collaborative effort brought a brave new world look to this mega-entertainment center. The resulting industrial high-tech image evokes a toy company warehouse of old reinventing itself.

Working in collaboration with the Jerde Partnership, SEGA, Dreamworks, and Universal Studios, Selbert Perkins Design developed the branding, identity system, environmental communications, and wayfinding elements for SEGA Gameworks, a 30,000-square-foot multi-environment entertainment center. Selbert Perkins created a *brave new world* positioning strategy to support the store's concept of blending old-world nostalgia with the future of multimedia. The facility is divided into three gaming "zones." The first traces the history of electronic games; the second creates high-energy, interactive excitement; and the third is a café and vending area. The typography is unified throughout and uses modern tech forms for wayfinding and Art Deco forms for retail venues.

DESIGN FIRM
Selbert Perkins Design with SEGA Gameworks

PROJECT DESIGN
Clifford Selbert (SPD)
Brian Lane (SPD)
John Snoddy (SEGA)
Stuart (SEGA)

FABRICATION
Signtech

PHOTOGRAPHY
Anton Grassl

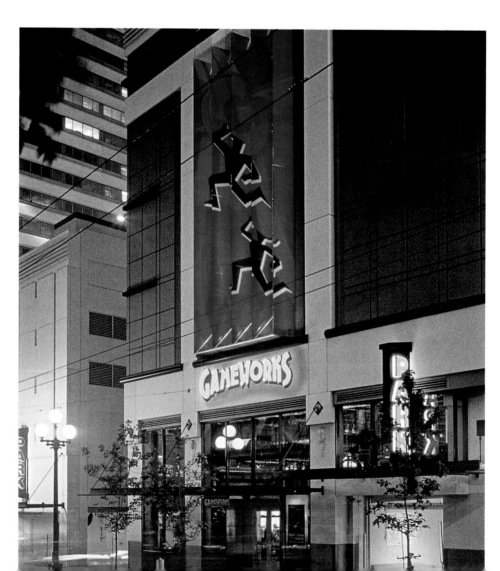

OPPOSITE PAGE: A series of large-scale vertical banners with bold colors, images, and forms creates a subtle animation across the facade as the viewer's perspective shifts.

BOTTOM LEFT: Detailed murals combine the characters, stories, and historical fantasy of games throughout the ages.

TOP RIGHT: Simple raw materials and connections reflect the industrial high-tech aesthetic of Gameworks.

MIDDLE RIGHT: Consistent typography, bold lighting and expressive use of materials create a dynamic system of standards for retail concessions.

BOTTOM RIGHT: A concession close-up illustrates the high impact of the dynamic graphic design.

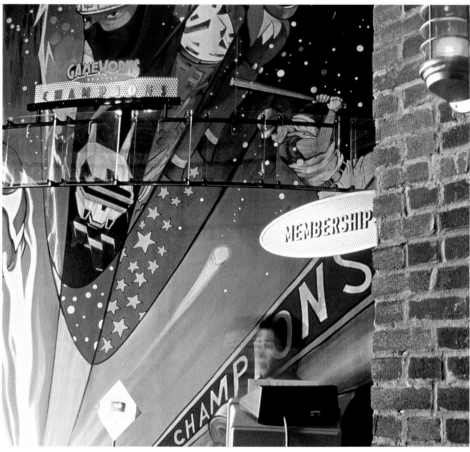

ABOVE: The exterior sign
with Charlie, the rooster,
portrays personality, history,
and innovation.

RIGHT: Exterior signage creates a
strong identity from a distance
then directs patrons to the
entrance.

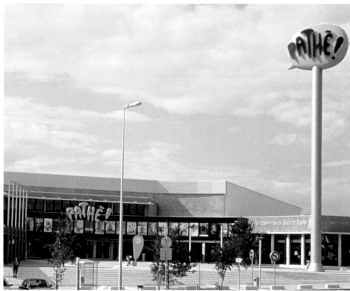

TOP RIGHT: The tall, freestanding sign establishes the Pathé image from a distance through rounded edges, three-dimensional feel, and vivid color.

BOTTOM RIGHT: The exterior signs are designed to be modified to meet the needs of different physical properties.

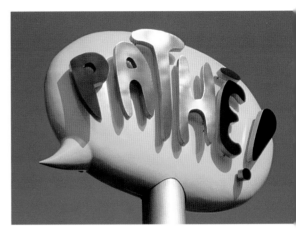

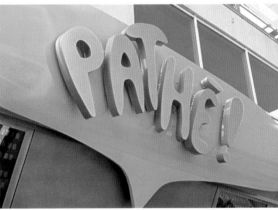

FRANCE

PATHÉ IDENTITY PROGRAM

The goal of Landor Associates and its client, Pathé, was to reassert the company's position as "more than just a movie." Like many companies, Pathé was determined to represent itself as a brand, not just a product.

DESIGN FIRM
Landor Associates

PROJECT DESIGN
Andrew Welch, account director
Margaret Youngblood,
creative director
Aaron Levin, creative director
Eric Scott, senior design director

designers:
Douglas Sellers
Kirsten Tarnowski
Michele Berry
David Rockwell
Carlyn Ross
Remy Amisse
Patrick de Moratti

PHOTOGRAPHY
Michael Friel
Catherine Gailloud

Founded in 1896 by Charles and Emile Pathé, this French company boasts an enviable heritage in the entertainment category, from the manufacturing of cameras, phonographs, and film to the production and distribution of movies and the management of movie theaters. Following many management changes over the years, new owner Jerome Seydoux hired Landor Associates to help reestablish the venerable company as an innovative entertainment leader. Landor identified a number of concepts to help Pathé reassert its position as "more than just a movie." Landor believed that, as a company, Pathé would need to develop a more collaborative culture with its employees and partners, and, as a brand, it would need to develop a point of view—its voice.

Landor selected three concepts to drive the brand: independence, innovation, and integrity. The Pathé visual icon, a rooster, had been in use since the late 1800s, and while it had been modified more than thirty times, the image had become static and inflexible, especially in exterior signage. Landor reinvigorated the image by renaming it. As Charlie, the rooster became the voice and spirit of the company, evoking not only the imagination and energy of company founder Charles Pathé, but also reflecting a responsive interaction with the modern world.

Charlie can be irreverent, provocative, bold, or playful, depending on the context. The consistent use of black-and-white imagery with the color yellow provides continuity from one brand touch point to the next. The Pathé identity program affects every point of contact—from theaters to film trailers, from corporate business papers to brand architecture, and from local promotions to corporate collateral.

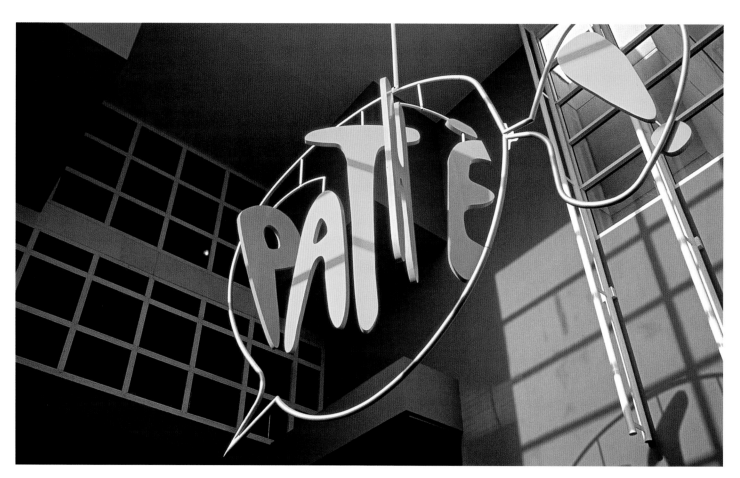

ABOVE: The mobile adds the
dynamics of change, energy,
and playfulness to both exterior
(shown) and interior signage
(opposite page, top left).

RIGHT: The interior clock
informs and entertains.

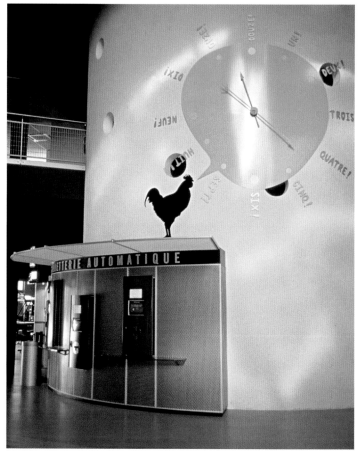

TOP LEFT: The interior mobile.

TOP MIDDLE: Marquee, billboard, and showcard signage work together for maximum effect.

TOP RIGHT: Elevated interior shot.

ABOVE: The colorful lounge utilizes the familiar Pathé exclamation point as a free-standing sculpture to house video monitors. It breathes life and interaction into the environment.

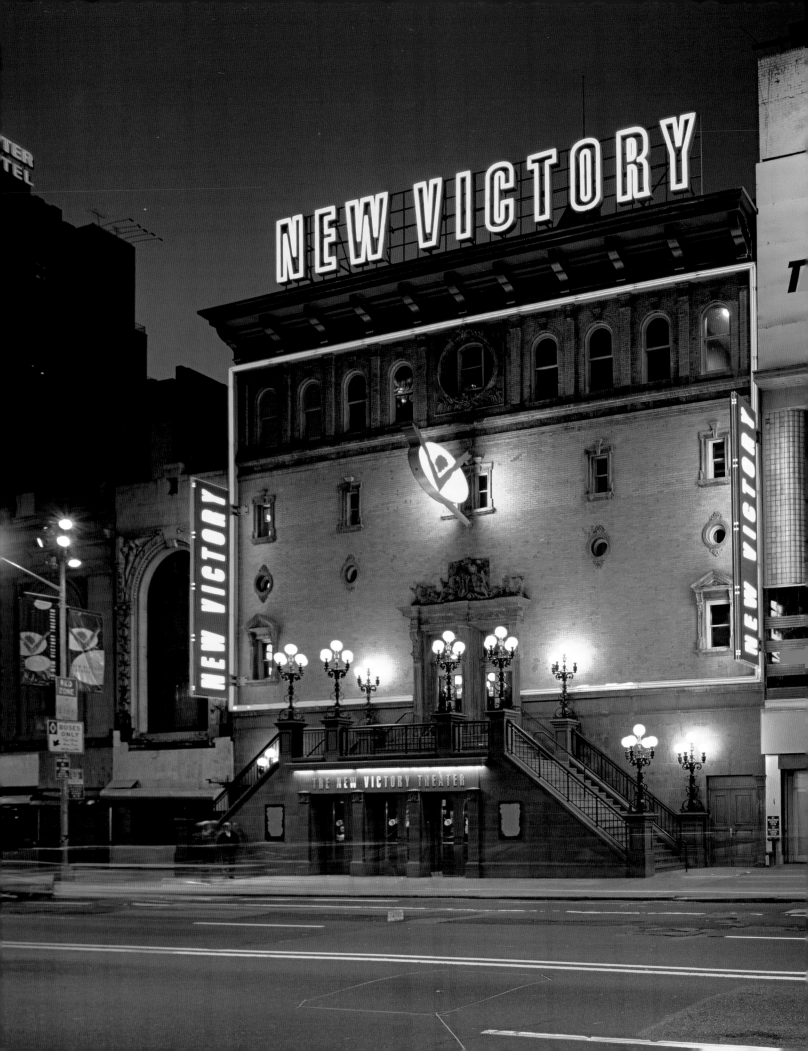

NEW YORK CITY, NEW YORK

NEW VICTORY THEATER

Alternative methods to the design process are evidence of how creative approaches to design can generate enthusiasm for a project. At the New Victory Theater, Chermayeff & Geismar included an unlikely group of "experts" in the process, promoting a sense of excitement and unity for the whole community.

To give the New Victory Theater a sense of optimism and renewed vigor in its renovation, Chermayeff & Geismar consulted New York City school children, who collaborated with the design firm on the creation of the theater's upbeat symbol. C&G developed concepts and the kids provided client input. The graphics were applied to ads, posters, and promotional items. So successful was the theater-renovation program that it earned the American Institute of Architects Honor Award.

The AIA noted: "This restoration has given a new life force not only to a building, but an entire community."

Exterior signs use neon, cut-outs, spotlights, and ovals to convey a contemporary spirit to the historic facade. Animated LEDs are used to create electronic posters of current and upcoming events. Inside, the vitality of Times Square is maintained with signs reminiscent of the street and with the juxtaposition of bright colors.

DESIGN FIRM
Chermayeff & Geismar Inc

PROJECT DESIGN
Steff Geissbuhler, principal-in-charge
Keith Helmetag, sign designer
Chuck Rudy, sign designer

FABRICATION
Art Kraft Strauss, exterior signs
King Products, interior signs

PHOTOGRAPHY
Rich Fahey
Karen Yamauchi

OPPOSITE PAGE: The rectangular blue neon frame contrasts dramatically with the bold New Victory lettering to draw attention to the renovated theater's lively new logo.

RIGHT: Close-up of the logo on a banner.

THIS PAGE: During construction, a curtain was raised on the barricade to reveal performers who spelled out the theater's name.

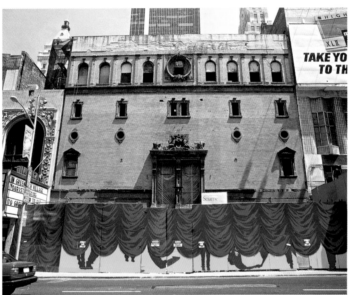

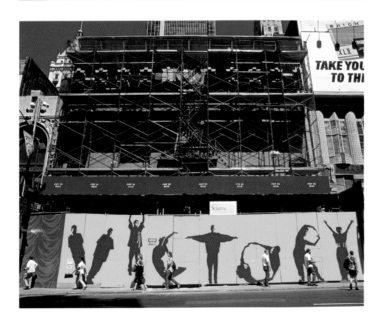

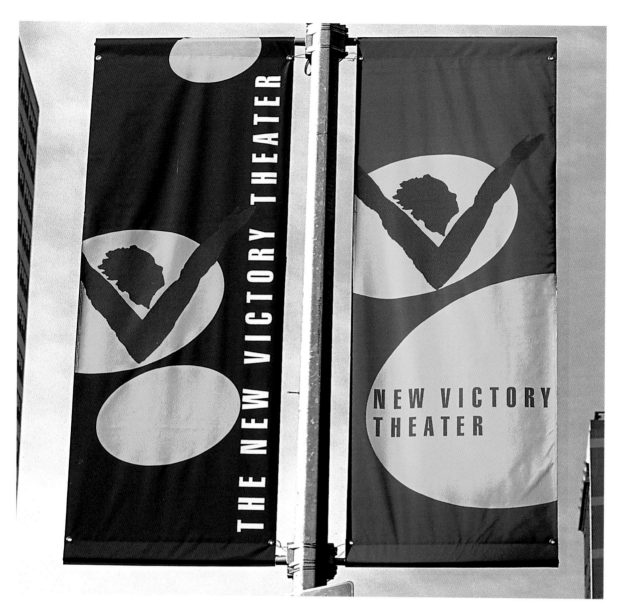

TOP: Banners with the new theater logo announce the location on 42nd Street.

BOTTOM LEFT: The dark purple and vivid yellow continue inside the theater to clearly mark the wayfinding signage.

BOTTOM RIGHT: Electric purple and yellow plaques guide visitors.

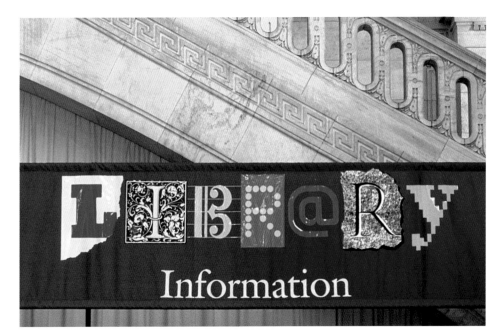

NEW YORK CITY, NEW YORK

NEW YORK CITY PUBLIC LIBRARY

Visual cues can relay information succinctly while adding an aesthetic dimension. The new image created for the New York City Public Library by Chermayeff & Geismar advertises its resources and services and puts this institution squarely into the twenty-first century while maintaining its past.

To celebrate the library's one hundredth birthday, a completely new visual-identity program and related centennial graphics have been created. The new image projects the library's preeminence into the twenty-first century—its physical expansion, its great archive of knowledge and information, and its ultimate accessibility for all via new technology.

The letterforms for the new logo are derived from and suggest the vast range of holdings in the library's collections, from ancient manuscripts to on-line services. The celebration rollout included stationery, press kit, invitations, posters, signage, and promotions. A comprehensive banner program marks the main library and its four research and eighty-two branch libraries. The decorative aspects of the logotype prompted the creation of numerous promotional items including T-shirts, tote bags, umbrellas, mugs, pins, stamps, pencils, bookplates, and bookmarks.

DESIGN FIRM
Chermayeff & Geismar Inc.

PROJECT DESIGN
Steff Geissbuhler,
principal-in-charge
Emanuela Frigerio,
graphic designer

PHOTOGRAPHY
Rich Fahey
Karen Yamauchi

BOTTOM LEFT: The new logo was used on all brochures and fliers, lending a sense of visual continuity and identity to all of the library's printed materials.

TOP RIGHT: Hung vertically, the banners flutter in fluid counterpoint to the city's solid skyscrapers, clearly identifying library facilities at diverse locations all over the city.

BOTTOM RIGHT: The bold, bright banners breath life into the solemn stone library edifice with its familiar lion statues. The banners give visitors the first indication that the library has cause to celebrate.

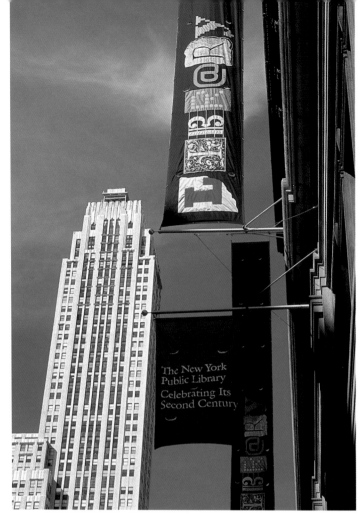

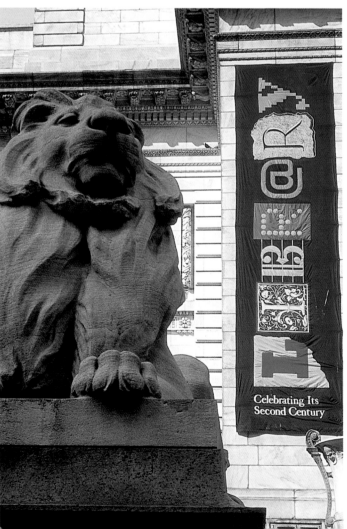

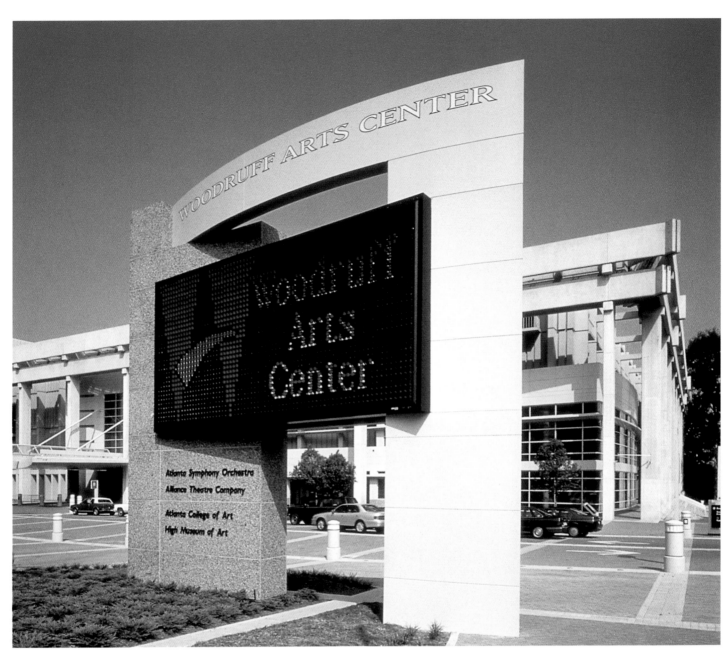

ABOVE: The marquis is located at the primary vehicular entrance and identifies the four component institutions of the Woodruff Arts Center.

RIGHT: A division-identification sign in front of the High Museum illustrates the curved lines and fresh style used to give new life to the Woodruff Arts Center.

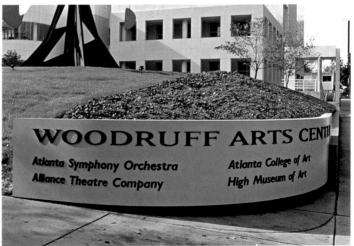

ATLANTA, GEORGIA

WOODRUFF ARTS CENTER

For the Woodruff Arts Center, the designers faced the task of reflecting in the center's identity the myriad arts celebrated at the complex's four component institutions: symphony, theater, museum, and college.

DESIGN FIRM
Lorenc + Yoo Design

PROJECT DESIGN
Jan Lorenc
Chung Youl Yoo
Steve McCall
David Park
John Mulhauser,
wayfinding consultant:
Mulhauser Design & Associates

FABRICATION
Architectural Image Manufacturers

PHOTOGRAPHY
Rion Rizzo,
Creative Sources Photography

At the former Woodruff Memorial Arts Center, Lorenc & Yoo Design was asked to remake Atlanta's premier cultural institution into a more inviting space. Working with a trimmed-down budget of $16 million, the designers collaborated on a plan that transformed the once mausoleum-like marble box into a place of light, free-flowing space, and entertaining activity.

Designers had to create exterior marquis signage that served two critical functions: to inform the public of ongoing events at each of the center's four institutions and to signal the architectural intent of breaking the box. Renovation construction added new light and openness to the building, and this distinctive marquis needed to reflect the new clarity in graphic communication for the arts center.

The building's original interior graphics had been a confusing jumble of competing messages. Each institution designed, sized, and placed signage as desired. Corporate sponsors hung their own banner panes, with no regard to style, size, or color palette. Donors were recognized on flimsy silk-screened plastic sheets that changed yearly. The resulting scene was cluttered and, even worse, unsophisticated.

The designers worked closely with the architects and the institutions to define identities for the member institutions. The program established a format for signage that related to the architecture of the building and tied the signage to the structure in an attractive merge of form and color.

Now, each resident institution is provided its own promotional opportunity with curbside poster kiosks faced with plaques that bear its logo. The disparate images of the institutions are unified with matching canopies and metal identification plaques fully integrated into the walls. Corporate sponsors provide their own graphics, but they are controlled and organized in two-story portal entries that house cabinets to present the information. Donor and patron walls with ancillary signage support the concept of light and openness with bronze squares and brushed aluminum signs. Donor plaques of brushed stainless steel and brushed bronze use vinyl lettering that appears to be engraved but is easily removed when change is necessary.

No longer a mausoleum of vanished patrons and staid marble, Woodruff Arts Center, with its layers of materials, arches, curves, and colors, is now a vibrant place for people and the arts.

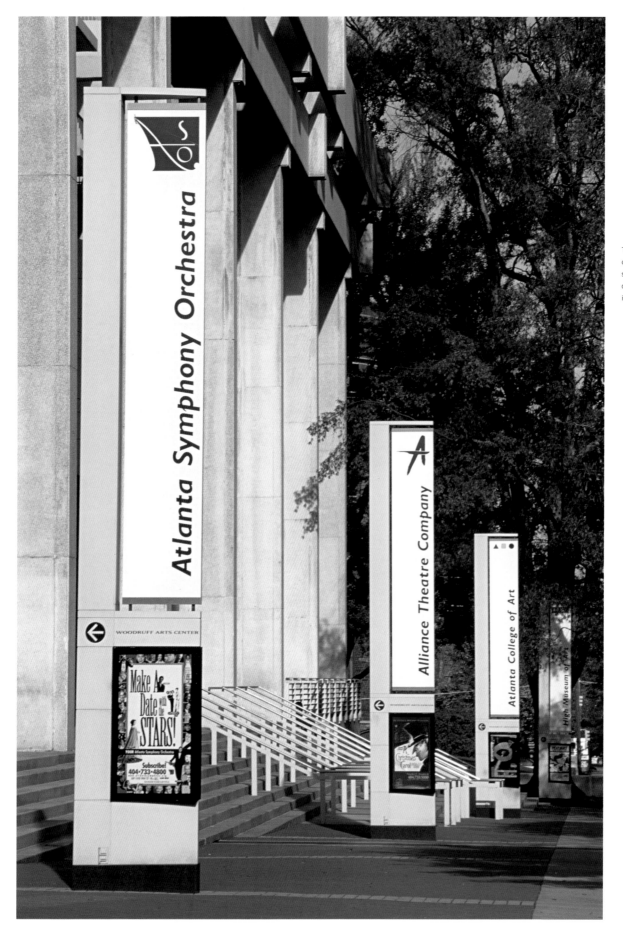

THIS PAGE: Each division of the center was given a single free-standing pylon for identity application and a lit poster box with identity logo on both sides.

TOP LEFT: A freestanding sign directs visitors arriving at a concourse along the rapid rail station to the Alliance Studio Theatre.

TOP RIGHT: Detail of a sign that directs patrons to the Alliance Studio Theatre.

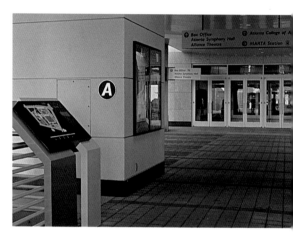

BOTTOM RIGHT: A custom directory, located in a heavy traffic area, provides patrons with a quick understanding of their location and the layout of the arts center.

BOTTOM LEFT: This box office identification sign demonstrates the designers' careful merging of signage with architecture.

TOP RIGHT: The names of donors and patrons are highlighted in credenza cases to the right and left of the Symphony Hall entrance.

BOTTOM LEFT: The gallery entrance identification sign incorporates an insert panel for exhibit information.

BOTTOM RIGHT: A detail of the Woodruff Donor Board.

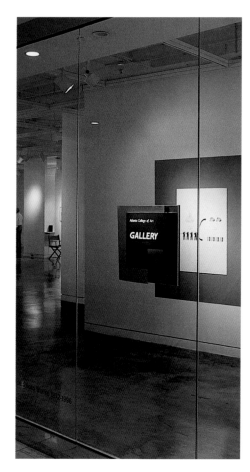

TOP: Identification signage at the entrance to the Alliance Theatre incorporates a system of rails used to display information that includes photographs and biographies of performers.

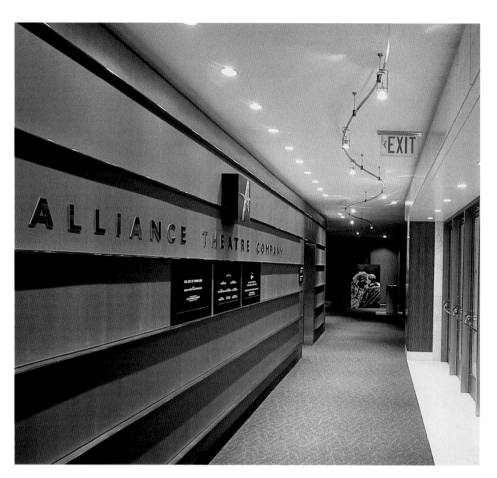

BOTTOM: A memorial surrounding a Rodin sculpture outside the High Museum of Art pays tribute to one hundred and thirty arts community leaders who were killed in a plane crash near Paris, France in 1962.

THIS PAGE: A detail from the primary identity graphics illustrates the dignified tone set for the whole.

OPPOSITE PAGE, TOP: The symphony hall facade occupies an entire city block. The primary identity recognizes the scale and responds to the architecture.

OPPOSITE PAGE, BOTTOM: The secondary entrance to the symphony hall is also the entrance to the mass transit system, so the signage gives both entities an identity.

SEATTLE, WASHINGTON

BENAROYA HALL

The designers at W P a created signage designs for Benaroya Hall that reflect the vital role of serious music in contemporary society and that give to a transitional downtown area a lively yet elegant graphic presence. Throughout, references are made to the rich cultural context of music, from music theory to composers and instruments.

The new Benaroya Hall needed a graphic design concept that would communicate the presence, purpose, and significance of the concert hall and symphony in downtown Seattle. W P a provided marquee design, concert-hall and recital-hall identification, the donor wall and other donor plaques, directional and parking garage signage, and the graphics for the construction enclosure.

To herald the arrival of the new hall and to raise awareness and generate excitement about the new building, temporary signage was attached on all sides of the multi-story scaffolding at the four corners of the construction site, which covered one full city block. Printed images of the symphony in action, announcement notices, site plans, and quotations were visible from all points, including from office buildings rising above the site. The lively color palette added brightness to the often gray skies.

The building itself occupies a vital place in the daily life of the city. It is surrounded by office buildings and a museum. Below the symphony hall, an underground city parking lot and the city's mass transit system occupy the entire site. The wayfinding system had to guide people arriving by a number of travel modes, as well as make the public aware of the concert facility and its events and those in Seattle's central business district. The signage also had to provide an identity to both the city's mass transit system and Benaroya.

In keeping with its vital role, the building is outfitted with video-capable marquees flanking each end of the façade, affording the opportunity of projecting live performances to passersby. The identification above the main entrance reads as a contemporary frieze floating on a sandstone façade. Trajan letters, a typeface chosen for its elegant proportions, are internally illuminated at night. The face of each letter is of perforated metal, giving the viewer the impression of the letters being open or closed depending on the angle of the viewer to the sign.

Since the life of the building revolves around the performance and appreciation of music, musical notation inspired W P a's approach to the design of interior signs. Abstract notational shapes mark the signs. Likewise, sign construction materials are those of various musical instruments selected and recombined.

DESIGN FIRM
W P a, Inc.

PROJECT DESIGN
Kathy Wesselman
Anthony Pellecchia

FABRICATION
Tube Art, exterior
Doty & Associates, interior

PHOTOGRAPHY
Rick Semple

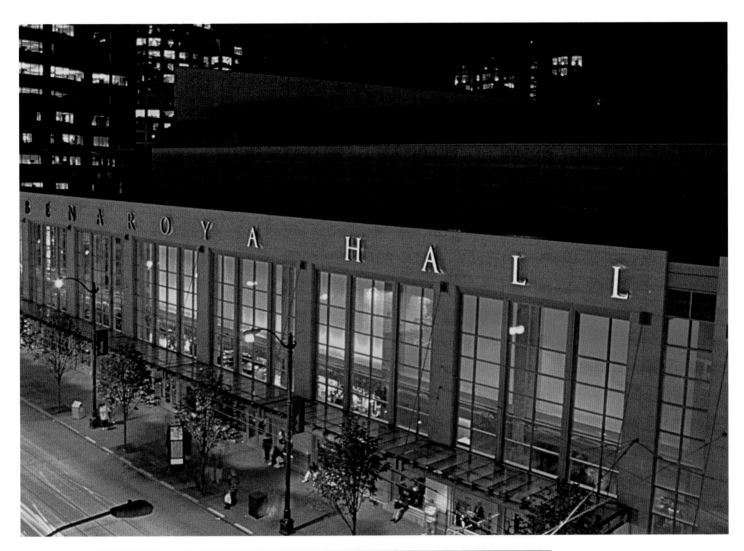

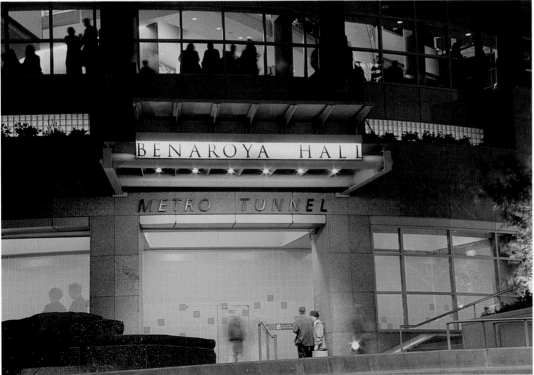

OPPOSITE PAGE, TOP: The interior signs express the purpose of the building as well as providing clear wayfinding. The designers used abstractions based on musical notation to produce fitting means for attaching signs to the walls and ceilings. Directional signage in the Benaroya Hall makes use of musical imagery to underscore the building's purpose.

OPPOSITE PAGE, BOTTOM: The symphony hall has an extensive donor program. Donor plaques located around the hall honor music supporters.

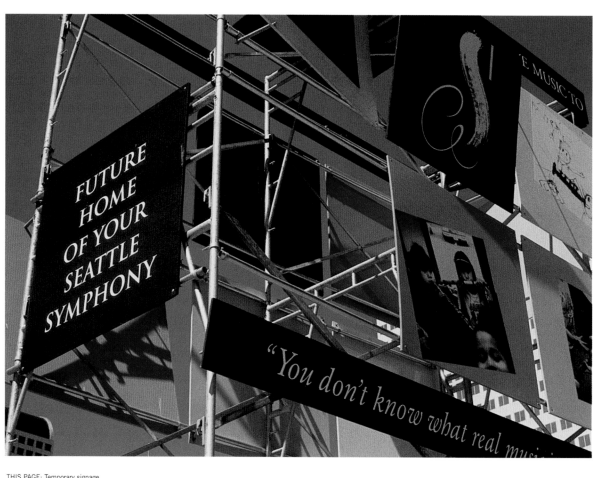

THIS PAGE: Temporary signage, attention grabbing in its colorful display of imagery and information advertising the new hall, shouts out from the construction site.

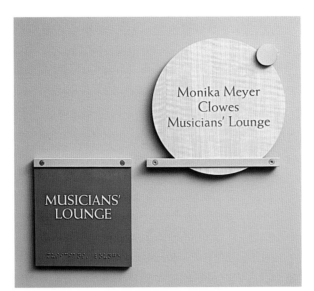

Monika Meyer
Clowes
Musicians' Lounge

MUSICIANS'
LOUNGE

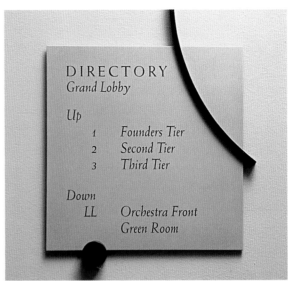

DIRECTORY
Grand Lobby

Up
1 Founders Tier
2 Second Tier
3 Third Tier

Down
LL Orchestra Front
Green Room

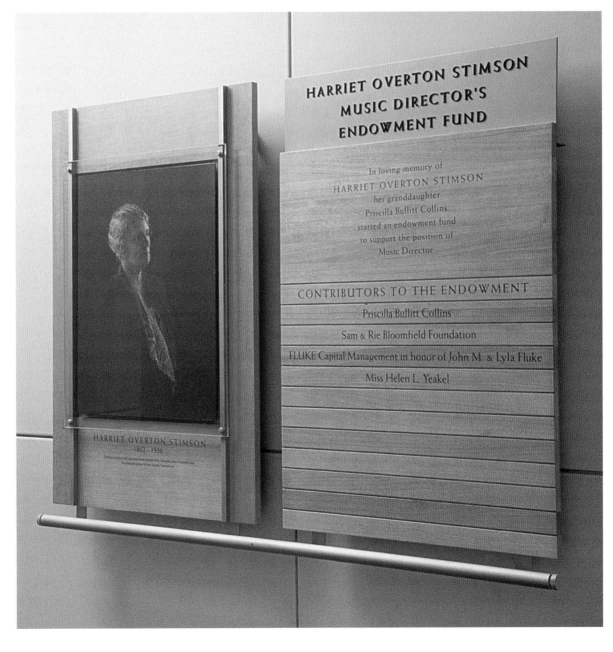

HARRIET OVERTON STIMSON
MUSIC DIRECTOR'S
ENDOWMENT FUND

In loving memory of
HARRIET OVERTON STIMSON
her granddaughter
Priscilla Bullitt Collins
started an endowment fund
to support the position of
Music Director

CONTRIBUTORS TO THE ENDOWMENT

Priscilla Bullitt Collins

Sam & Rie Bloomfield Foundation

FLUKE Capital Management in honor of John M. & Lyla Fluke

Miss Helen L. Yeakel

HARRIET OVERTON STIMSON
1862-1936

SHOWCENTER HAEDO

Pentagram developed an innovative and profitable graphic-design program encompassing a wide variety of visual communicators for Showcenter Haedo, a new ten-block-long entertainment complex in Buenos Aires, Argentina.

With destinations ranging from movie theaters, concerts, and live shows to restaurants, boutiques, bowling alleys, game arcades, and bars, Showcenter Haedo presented a challenge for designers at Pentagram to construct a seamless personality for the complex that would be recognizable yet flexible. To achieve this, Pentagram devised a system of basic elements: a circle motif; a selected pastel color palette of blues, pinks, greens, and yellows to underscore the sense of excitement in the complex; and distinctive, oversized photographic imagery to suggest Showcenter's scope and custom typography. The system is established on the exterior facade, an enormous sweep of billboard-sized panels that not only complement the architecture but also generate revenue as outdoor advertising space.

Inside, the panels continue along interior walls, creating the sense of an ordered equivalent of Times Square, with circular signs and billboards suggesting an arcade-like space. Tenants and sponsors may lease the signage panels to display their own logos or messages in keeping with the color scheme and clean, uncluttered imagery

established by Pentagram. The black-and-white photographs of many of the Showcenter's icon images were tinted in pastel shades to produce a subtle, nocturnal quality suited to the nightlife.

Together the architecture and graphics reinforce a powerful visual identity. The use of strong, simple images in its wayfinding signage demonstrates the ideal of the genre, in which a clear, strong image (rather than text) provides the visual cue. To design a coherent, easily recognizable system, Pentagram used the repeated circle image to indicate direction, e.g., a cup and saucer denotes the food court, a film reel identifies the cinema, a soccer ball locates a sports retail sponsor. The use of simple images in wayfinding allows the visitor to quickly access the information without being bogged down by maps or distracting graphic overload. Signage designed to encourage lingering is more appropriately located in destinations such as restaurants, shops, and museums. Pentagram's designs for Showcenter Haedo include institutional print materials and packaging, internal and external direction, identification signs and structures, and decorative murals and flooring.

DESIGN FIRM
Pentagram

PARTNERS
Paula Schere (identity)
Michael Bericke (signage)

PROJECT DESIGN
Ed Chiquitucto
Lisa Mazur
Anke Stohlmann
Maria Wenzel

FABRICATION
Fontana Design,
Buenos Aires, Argentina

RETAIL ARCHITECT
RMO Associates,
Marblehead, Mass.

THIS PAGE TOP AND BOTTOM: Like party balloons, the repeated circular sign shapes lend a festive atmosphere to the arcadelike interior of the Showcenter.

MIDDLE: On the Showcenter's exterior facade, an enormous sweep of billboard-sized panels generates revenue as outdoor advertising space.

OPPOSITE PAGE: The graphic imagery of the circular signs throughout the Showcenter interior guide visitors with graphic imagery and contribute to the overall symmetry of shapes.

BOTTOM RIGHT: The communication design is direct and lively, as much about entertainment as the Showcenter itself. The considered approach is in keeping with South American culture, in which visiting such a mall would be tantamount to a social promenade on a city boulevard. The Showcenter was conceived as a place that would reflect the gregarious social life of the Haedo community. The abundance of decorative visual images help bring a sense of excitement to the space.

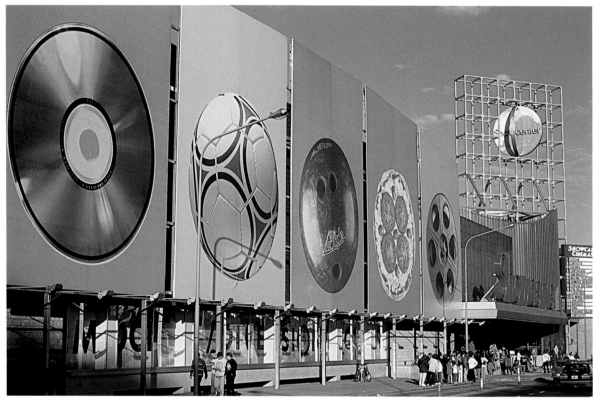

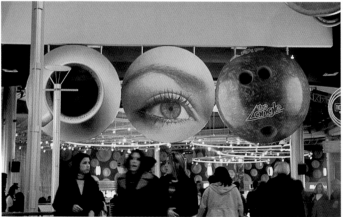

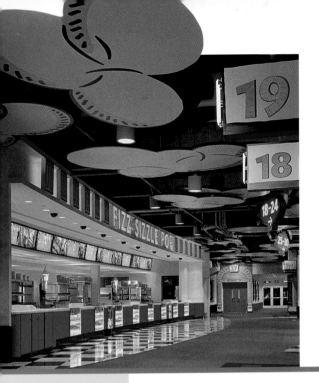

DESIGNING AN
INVITING SPACE

by Carol Jerome

Creating the poetry of life begins with the challenge of filling an emptiness with an appropriate somethingness. Writers confront their blank pages. Painters face stark canvases. Designers gaze into empty spaces and imagine function-enhancing messages and moods conveyed through carefully selected finishes, fixtures, signage, graphics, lighting, architectural elements, plantings, landscaping, and color palette. A well-designed space not only gains attention, but can also touch people's hearts and even change their lives.

When developers or site owners contemplate configuring the space for such projects as a theater complex, a sports facility, an airport terminal, an entertainment center, or a medical facility, they recognize the overwhelming importance of selecting the right designer for the job. Successful spaces reflect design expertise that facilitates the seamless integration and precise coordination of all disciplines: architecture, environmental graphics, lighting, wayfinding, and signage. The innovative designer is the consummate collaborator, acknowledging the numerous resources it takes to create a great destination. Original, creative design solutions that withstand marketplace realities do not occur solely within a design studio, but are generally derived through a combination of exhaustive research tecniques, which includes asking the right questions. Proper research and attention to

 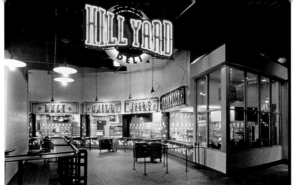

> Although people visit public spaces to experience human interaction, they seek out environments that speak directly to them, to their needs and to their lifestyles, in compelling and enticing ways. <

detail will guide experts in their selection of the appropriate elements to connect a space to an audience, ensuring a unique, meaningful, and relevant design.

Spaces are as much living entities as the people who occupy them. In a dynamic world, an optimally designed space responds and grows, meeting the challenge of change. By listening carefully to clients discuss their unique needs and the nuances of their business or industry, designers can develop effective and innovative solutions that will offer maximum growth and the ability to adapt to shifts and trends. A thoughtfully designed space with a welcoming interior voice appeals not only to visitors, but also to employees and staff members, translating into positive attitudes, greater motivation, and increased productivity.

One of the very first steps in defining what will constitute an inviting space parallels the first maxim in any artistic medium is "know your audience." Designers must first thoroughly research their target audience and integrate their findings with the intent of the space and its

proposed goals. Research can take many forms, including face-to-face interviews, focus groups, or observation of people in similar facilities. It isn't always true that "if you build it, they will come." Although people visit public spaces to experience human interaction, they seek out environments that speak directly to them, to their needs and to their lifestyles, in compelling and enticing ways. The needs and expectations of a hockey fan, for example, differ widely from the needs of a visitor to a medical facility.

Signage and graphics create identity, bring architecture to life, reinforce image, organize environments, prompt behavior, and direct people's movements at appropriate decision-making points within a space. Visitors seek out the visual cues provided by graphics, signage, lighting, color, and other architectural elements as they navigate a facility. Effective signage takes into account the aesthetics of a space and provides a hierarchy of information to eliminate confusion and ease orientation in an unfamiliar environment. It balances a fluidity of design and motion, allowing people to move efficiently toward, through, and

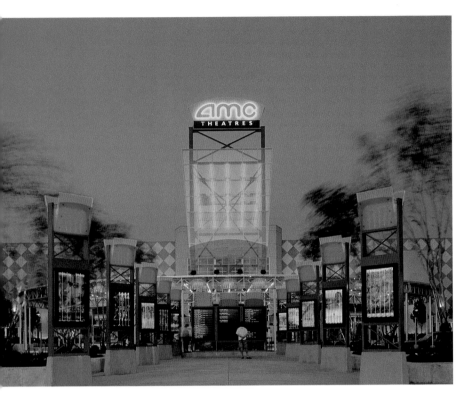

within an area. Intuitive wayfinding generates positive perceptions of a space, helps visitors feel familiar and at home, and cultivates the ease associated with welcoming environments.

Truly inviting spaces are environments that are accessible to everyone. They respond to cultural, age, and ability differences. Contrasting color-coded sign systems placed at appropriate heights not only offer visual interest and a vocabulary for wayfinding, but

from an ADA perspective they also make directionals easy to see and understand. By using recognizable glyphs and images to convey broad, generally understood themes, designers bypass language barriers to signify destination points within a space. Additionally, welcoming interiors offer barrier-free floor plans, with accessible doorways, elevators, concession stands, drinking fountains, restrooms, and public phones.

Designers understand environments and recognize that graphics and sign systems must captivate and compliment and communicate intuitively to be effective. In this increasingly isolating information age filled with the intangible, the mass produced, the transitory, the

illusory, and the counterfeit, people find themselves drawn to places that give them a sense of belonging, that offer value, and that provide a sense of stability. People gravitate towards things that are real, that generate real feelings. They want to spend time in environments that make them feel delighted, entertained, welcomed, intrigued, and good inside. They remember such places and visit again and again. At the AMC Studio 30 in Houston, Texas, for example, an ordinary movie theater becomes a participatory event in the hands of Kiku Obata & Company. The designers put visitors "backstage" of movie making company; three themed movie sets transport visitors into worlds of imagination. For the renovation at the famous New Amsterdam Theatre in New York, Two Twelve Associates

succeeded in creating an environment that transports visitors to another century. Designers, electing to honor the theatre's rich history and stunning Art Nouveau interior, used materials, colors, and images which evoke a bygone era.

The more memorable, authentic, accessible, simple, clear, and well-planned a space is the more social benefit it offers. Signage and graphics that appeal to the senses in concert with an eclectic mix of fixtures, colors, and textures, can surprise, intrigue, enchant, or comfort. Indeed, in a truly inviting space, the journey becomes as important as the destination.

Carol Jerome is a writer with Kiku Obata & Company and often articulates the ideas, messages and philosophies of the firm for book and publications.

She is also responsible for name and byline development for corporate identities and branding strategy, and writing for brochures, annual reports, and promotional pieces.

NEW YORK CITY, NEW YORK

NEW AMSTERDAM THEATRE

For the elegant surroundings and décor of the New Amsterdam Theatre, the design firm, Two Twelve Associates, created a seamless fit with signage reminiscent of the theater's Art Nouveau architecture, evoking the rich history of the site.

When the famous New Amsterdam Theatre on 42nd Street, one of America's earliest and finest examples of Art Nouveau style, underwent a three-year renovation effort, Two Twelve Associates was asked to develop interior signage for both the public spaces and the theatre's management and actor areas.

The designers elected to emphasize the classic elements of Art Nouveau while improving wayfinding for visitors negotiating the old theater's dark hallways, stairs, and long corridors. The backstage signage system capitalizes on the theater's rich history as the original home of the Ziegfeld Follies. Names and images of theater luminaries such as Billie Burke, Will Rogers, and Eddie Cantor highlight the signage for meeting spaces and other locations. Stained glass panels with bent, flat-metal surrounds coated in a verdigris patina hold location and directional signs cantilevered over the public space.

DESIGN FIRM
Two Twelve Associates

PROJECT DESIGN
David Gibson, principal-in-charge
Jean Lambertus, designer
Andrew Simons, project manager
Patrick Connolly, production

FABRICATION
Ampersand

PHOTOGRAPHY
Whitney Cox

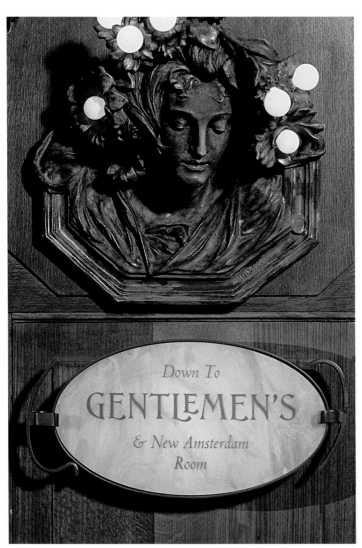

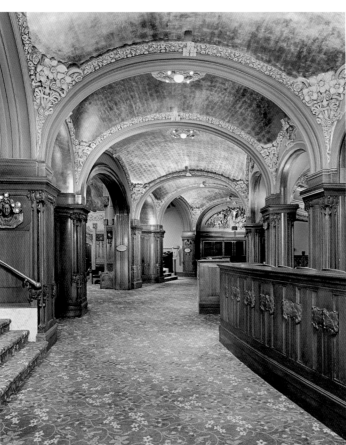

TOP LEFT: The renovated signs convey the sense of a bygone era and mesh seamlessly with the classic elements of the building's architecture.

TOP RIGHT: Panels maintain the Art Nouveau style while providing useful information. Like the front-of-house signage, this sign is stained glass with organically shaped metal coated in a verdigris patina.

MIDDLE RIGHT: Level identification (in-house sign). The typeface used in all the signs evokes an earlier era.

BOTTOM LEFT: The new signage at the landmark Broadway theater blends perfectly with the rich Art Nouveau style of the architecture. The architectural firm Hardy Holzman Pfeiffer lead the restoration effort.

BOTTOM RIGHT: Backstage location signage pays homage to famous actors in the theater's past while complying with modern ADA requirements.

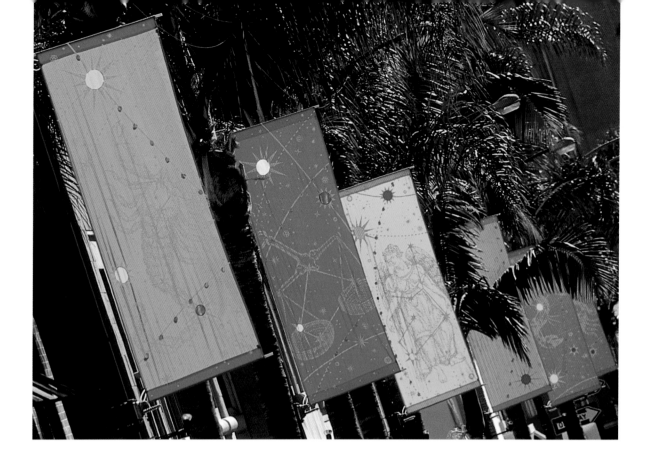

1999 BEVERLY HILLS HOLIDAY DECORATIONS

The millennial New Year's decorations for Beverly Hills transformed the area, evoking a celebratory mood.

The City of Beverly Hills asked the design firm of Sussman/Prejza to develop a "shimmering and celebrating" quality for its 1999 decorations to celebrate the millennial New Year. The designers chose the signs of the zodiac—important to civilizations even before this millennium—as subject matter. The twelve constellations of the zodiac were designed to wash the streets in an undulating flow of color, through warm and cool shades, sequenced to the music of Beethoven's "Ode to Joy."

Each banner showcased a silk-screened drawing based on Renaissance depictions of the twelve zodiac signs. Challenging the traditions in banner fabrication, the program combined materials in unusual ways. Translucent nylon, silk-screened on both sides, was appliquéd with oversized holographic sequins and attached on both sides of the hand-sewn finished banners. Reflecting sunlight by day and streetlight by night, they filled the street with shimmer and shine, an appropriate metaphor for the glamour of Beverly Hills.

DESIGN FIRM
Sussman/Prejza & Company, Inc.

PROJECT DESIGN
Deborah Sussman
Holly Hampton
Paula Loh
Miles Mazzie

FABRICATION
AAA Flag & Banner,
Los Angeles, Ca.

PHOTOGRAPHY
Jim Simmons/Annette
Del Zoppo Productions

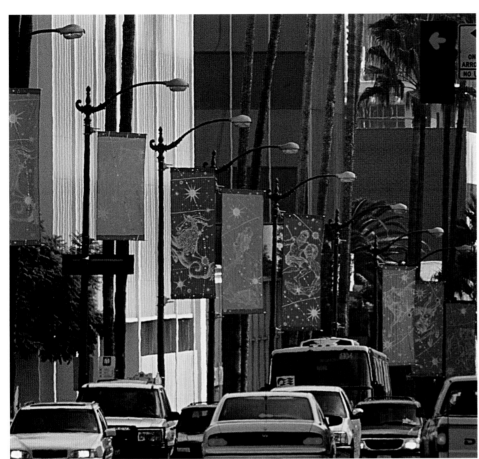

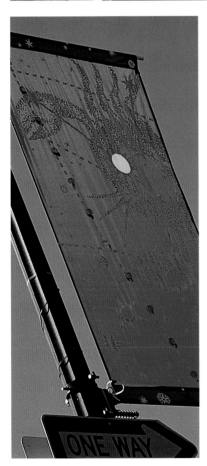

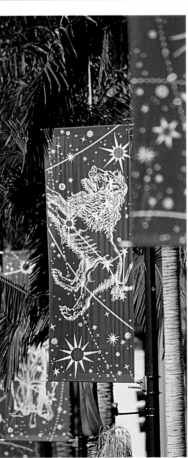

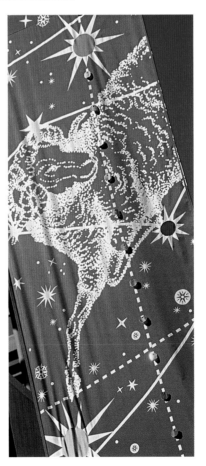

OPPOSITE PAGE: A family of banners within the warm color sequence glows with backlit sunlight.

TOP LEFT: The banners enliven an ordinary streetscape.

BOTTOM LEFT: The crab, symbol for the zodiac sign of Cancer, claws the air.

BOTTOM MIDDLE: Sunlight illuminates the white silk-screening on nylon to produce a radiant banner sequence.

BOTTOM RIGHT: The constellation banner with its Aries symbol echoes the past in a refreshingly modern manner.

THIS PAGE: Detail of main entrance sign illuminated at night.

AMC STUDIO 30

For a business facing competition from similar contenders, creating a memorable experience can be the deciding factor in where consumers spend their time. At the AMC Studio 30, brilliant signage and environmental graphics invite visitors into the space, create a sense of place, and allude to dramatic themes and imaginary locales.

In the 1920s and 1930s, architecturally unique, elaborately detailed theaters created a sense of place; set exotic, historic, and romantic moods; and alluded to dramatic themes and imaginary locales. Theaters served as information centers, shaping public opinion, arousing patriotism, and promoting social values with each dramatic newsreel and spectacular feature film. However, in the 1950s, Americans became enamored of their television sets, and declining theater attendance forced film exhibitors to focus on their bottom line. The theatricality of movie house architecture disappeared, giving way to bland storefront designs and stark interiors. Today, spurred by increasing competition with other entertainment options, AMC Studio 30 is in the forefront of a movement to once again immerse movie patrons in a total environment that will delight the senses, create a mood, and blur the distinction between fantasy and reality.

Through the total integration of architecture, environmental graphics, lighting, and signage, Kiku Obata & Company created a total entertainment environment that distinguishes AMC Studio 30 from the ordinary movie theaters of today. This new theater prototype aims to rekindle the magic and momentousness of going to the movies in bygone times.

The 110,000-square-foot facility on 23 acres simulates a studio back-lot and soundstage where guests become part of the action. Theaters are located off the soundstage lobby, within three themed movie sets that transport guests into fantastic worlds of animation, action/adventure, and cyberspace. Concession stands within these areas are correspondingly themed: Fizz Sizzle Pop, Wildebeest Feast, and Quantum Bits. Each of the three areas suggests distinct design solutions. Specialty lighting, signage, and coordinated interior finishes conspire to create provocative and intriguing atmospheres. Here, the guest experience is as important as the movie viewing.

AMC Studio 30 treats its guests to a total entertainment event. The distinctive nature of this movie experience creates brand identity and heightens customer anticipation of coming attractions in industry development. The prototype's appeal to all age groups; its ability to integrate retail, food, and guest services; and its flexibility as a community forum for corporate use, live broadcasting, and/or expanded viewing could redefine the motion-picture exhibition industry.

DESIGN FIRM
Kiku Obata & Company

PROJECT DESIGN
Kiku Obata
Kevin Flynn, AIA
Heather Testa
John Scheffel
Gen Obata
Theresa Henrekin
James Keane, AIA
Joe Floresca
Liz Sullivan
Lisa Bollman
Cliff Doucet
Carole Jerome
Alissa Andres
Jonathan Bryant

FABRICATION
Adcon, Ft. Collins, Colo.
Design Communications, Boston, Mass.
Federal Sign, West Hartford, Conn.
Slarks & Associates, Boulder, Colo.

PHOTOGRAPHY
Gary Quesada
Hedrich Blessing Photographers, Chicago, Ill.

TOP: Special banners and themed lighting welcome visitors to the theater complex. The exterior plaza expands the moviegoing experience by offering additional entertainment such as music, food, and a place to congregate to enjoy the atmosphere.

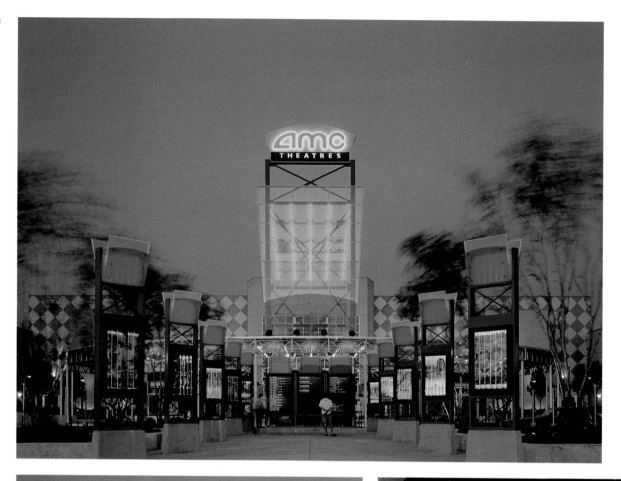

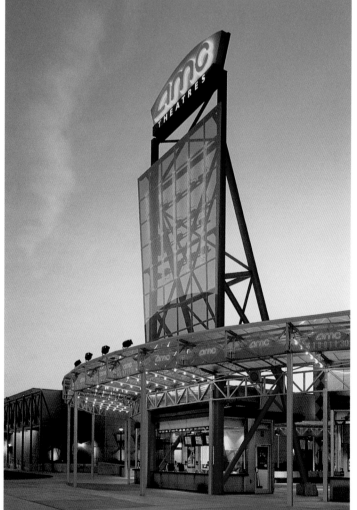

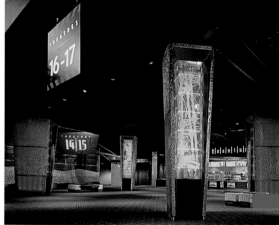

BOTTOM LEFT: Both landmark and icon, the big tower, flanked by two side structures with lit graphics, dominates its surroundings and recalls vertical towers of early movie palaces and the icons of drive-in movies.

BOTTOM RIGHT: The clapper board wayfinding signs, seen at the top left corner of the photo, direct guests to a specific theater rather than to a certain movie. This approach is modeled after airport systems, where visitors are directed to departure gates rather than destination cities. In Cyberspace, guests find themselves in an abstract, futuristic world with brushed aluminum walls and a ceiling and floor of the same color. The columns that rise partially to the ceiling give the illusion of a void without boundaries.

THIS PAGE: In the Fizz Sizzle Pop concession, the identity and blimp directional signs floating in a blue sky with flat clouds enliven the colorful space.

TOP RIGHT: In the animation section of the complex, the architecture reflects the lively style of the medium. In a space designed to resemble an animation cel, flat two-dimensional cartoonlike graphics are outlined in black, filled with color and applied on an exaggerated scale.

BOTTOM LEFT: The action/adventure area resembles a rainforest with wet leaves, bamboo, and rock directional signs. Fiberoptic eyes that change color peer out from behind the rock outcroppings down the corridors. The wall covering is custom designed to look like the cave markings of prehistoric people carrying everyday objects associated with movies and movie-sgoing such as popcorn, movie cameras, and megaphones.

BOTTOM MIDDLE: Close-up of the cartoon-like graphics used in the animation section of the complex.

BOTTOM RIGHT: The Wildebeest Feast concession features layers of aluminum leaves, amber acrylic channel letters, and fiber optic eyes peering out of the darkness to create a jungle/rain forest atmosphere.

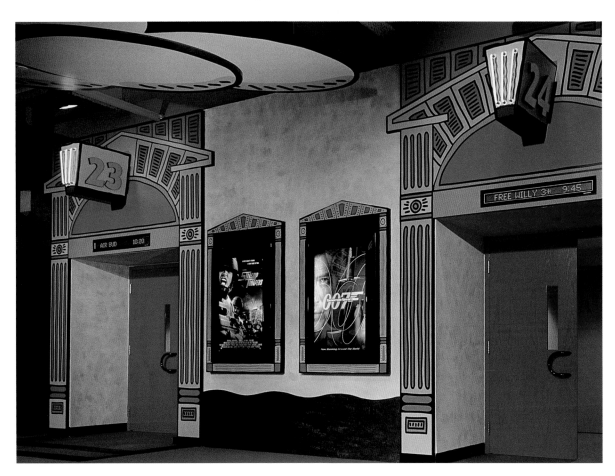

TOP: The fountain serves as the courtyard's focal point and adds to Studio 30's total entertainment experience. Images of Hollywood's earliest stars add glamour to the balcony.

BOTTOM: Attention to detail was essential in every respect of the design in order to create an atmosphere where movie going isn't just an activity, it's an event. Bold neon and acrylic encircles the courtyard to heighten customer's anticipation and excitement.

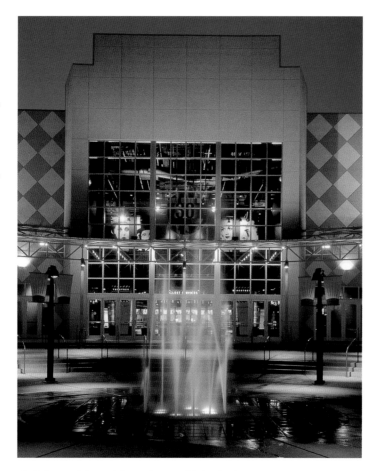

TOP: AMC Studio 30's appeal to all age groups, its ability to integrate retail, food, and guest services, and its flexibility as a community forum for corporate use, and/or expanded viewing could redefine the motion-picture industry.

BOTTOM: Three box offices welcome patrons under a circular canopy/walkway that forms the courtyard.

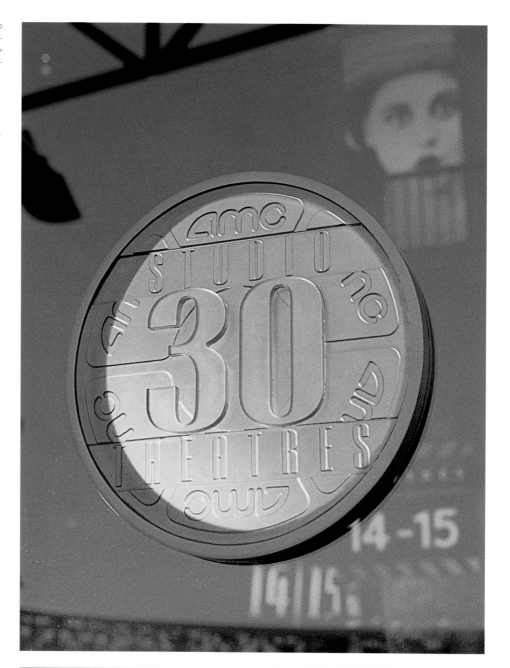

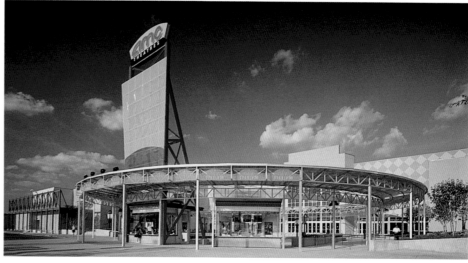

THIS PAGE: Barricade panels help generate excitement about the multitude of new shops and restaurants soon to appear.

OPPOSITE PAGE, TOP: Giant banners featuring the photograph of the sculpture of Mercury, which adorns Grand Central, announce the upcoming grand reopening of the terminal in a big way.

NEW YORK CITY, NEW YORK

GRAND CENTRAL TERMINAL

When this bustling landmark building was given a new identity, colorful and exciting graphics eased the transition for users and the completed renovation was welcomed with a citywide grand flourish.

Grand Central Terminal, the beloved Beaux-Arts rail and transportation hub in the heart of New York City, underwent a $175 million renovation that began in 1997 and was completed in 2000. Traversed by hundreds of thousands of people daily, the retail area of the vast station had become a hodgepodge of low-end merchants. Hot dog vendors, newsstand vendors, and flower sellers predominated. The restoration would transform this dull scene into a prime retail venue and a destination unto itself, featuring a food market, cafés, full service flower shops, and high-end fashion boutiques—a mix of over one hundred merchants.

The building was completely shrouded during the heaviest construction. When the terminal reopened to limited pedestrian traffic, Grand Central Terminal Ventures commissioned Two Twelve Associates to design construction barricades. In addition to the functional mandate of guiding commuters while protecting them from construction debris, the barricades were to involve the public in the renovation and to create interest, anticipation, and excitement for the new shops and restaurants.

Noted illustrator Maira Kalman was enlisted to shower the barricades with myriad whimsical, witty figures that would give a sense of the attractions to come and show people enjoying the space in everyday use. The color palette was carefully chosen in moderately bright primary colors to create a fun, yet sophisticated style. The panels were enthusiastically received by the public and press and won several awards.

As the terminal neared completion, Two Twelve was asked to develop a celebratory campaign theme and an array of materials to promote the grand opening. Using the theme, Uniquely Grand, Totally Central, the designers visualized the grandeur of the terminal with a photograph of the famous Mercury sculpture that adorns the building's facade. The photograph was used to spread the message in a series of five different posters and giant banners displayed in the station's central atrium and local stations, as well as in buses, subways, and commuter rail cars. The designers used bold, modern colors and simple typography to highlight the elaborate architectural details of the station and to help the graphics stand out in the busy environment of the city.

DESIGN FIRM
Two Twelve Associates, Inc.

PROJECT DESIGN
Ann Harakawa, principal-in-charge
Colleen Hall, senior designer
Patricia Kelleher, designer
Lisa Mooney, designer
Victor Russo, designer

CONSULTATION
Maira Kalman, illustrator

FABRICATION
Mega Art

PHOTOGRAPHY
Erik Kvalsvik
Mark Reinertson

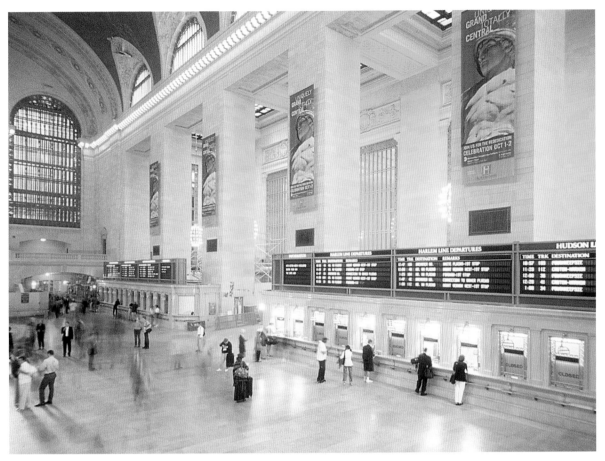

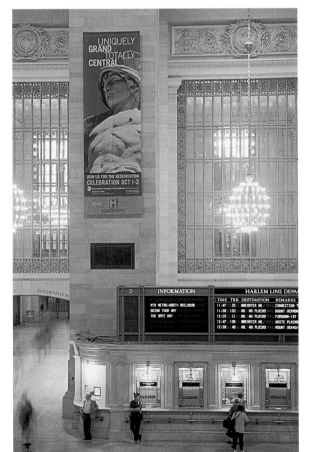

BOTTOM: The Mercury messenger poster translated effectively on a wide range of scales and applications.

THIS PAGE: The construction barricades included panels with wayfinding signage. The panels also helped generate excitement about the multitude of new shops and restaurants soon to appear.

Posters with the same Mercury motif carried the message throughout the city.

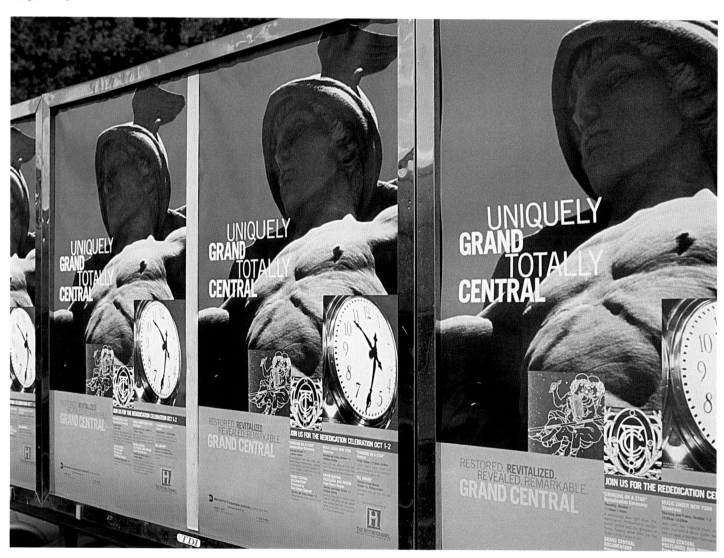

THIS PAGE: Brightly colored
panels, complementing Maira
Kalman's illustrations, acted as
wayfinding cues during the
construction process at Grand
Central Terminal.

Additionally, Kalman's clever
work conveyed the incredible
diversity of people who make
New York a city like no other.

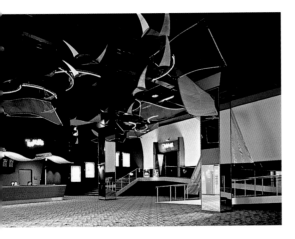

CINEPLEX 8 THEATERS

As an alternative to signage appendant to the environment, directionals integrated into graphic elements of the space pleasantly welcome visitors and intuitively guide them to their destination.

Koryn Rolstad Studios/Bannerworks was asked to create a theme and interior design for the first in a series of Cineplex 8 movie theaters in Japan. The theater is located in a shopping complex near water, so a seascape theme was developed. The Ocean Shore concept was chosen from several computer-generated model proposals.

In the theater lobby, designers establish a visual image of a place by the sea using folded and airbrushed steel mesh, neon aluminum tubing, iridescent fabrics, and PVC color coated cable to create clouds, birds, and a sculptural sailboat. These elements are suspended at various heights and oriented to lead moviegoers through the space.

Because the cinema's corridor is very long and dark, with four cinema entrances on each side, the Flock of Birds is employed as a visual device to direct theatergoers down the sunset hallway to their varied destinations. The curves and arches of the formed aluminum tubing act like wind currents, carrying the birds on wing.

The design elements logically define the ocean shore theme. They also define and connect the various forms of the building's architecture. The ceilings are open with exposed HVAC, electrical and plumbing, so the decorative, floating ceiling application hides these mechanical systems.

The shape, color, and imagery of the design guide people almost intuitively to their destination. This type of wayfinding is particularly useful in international situations since people are able to navigate without depending on signs in a language they may not understand. This is wayfinding at the cutting edge.

DESIGN FIRM
**Koryn Rolstad
Studios/Bannerworks**

PROJECT DESIGN
**Koryn Rolstad
Ryan Rosenberg**

FABRICATION
**Bannerworks, Inc.
Ross Technologies
Reliance**

PHOTOGRAPHY
Toshinori Hattori

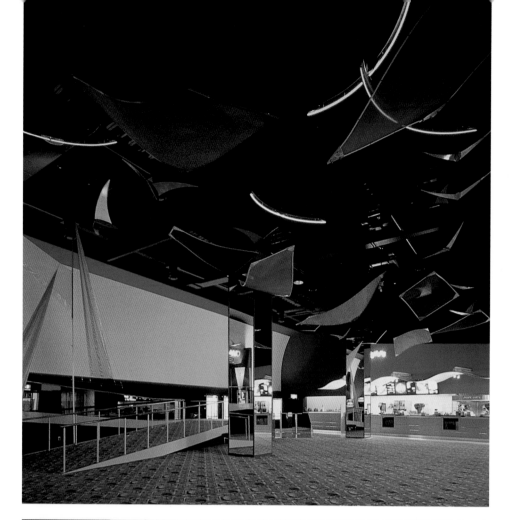

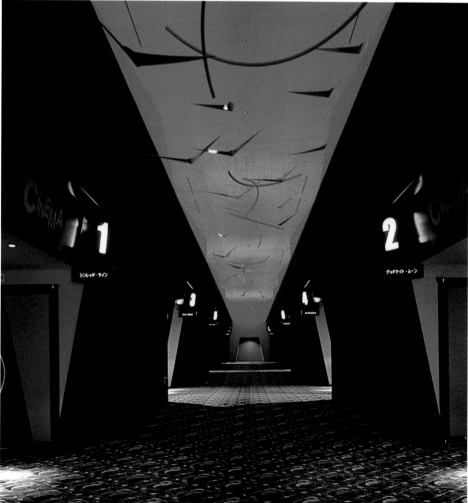

OPPOSITE PAGE AND TOP: From the abstract clouds to the stylized birds, all the elements are suspended from the ceiling and meet the rigid standards of Japan's building codes.

BOTTOM: The lighting was developed to continuously change through the day, from a "sunrise" in the morning to a "sunset" in the evening. This constant shift in light plays on the suspended elements, giving patrons a variety of abstract seascape impressions.

BUFFINGTON HARBOR CASINOS

Often we think of signs as two or three-dimensional graphics. Another effective medium for expressing a purpose or message in signs is light. Light from a variety of sources can make an area easier to navigate and elicit a mood to establish a certain experience.

Nothing conjures the gambling aura like the bright light of neon, so to put the Casinos at Buffington Harbor, Indiana, on the map, ComCorp, Inc. used plenty of colorful displays in the exterior signage and entry design. Ninety-foot-high towers were erected in the flat landscape to create a grand entrance to the Trump and Majestic Star Casinos in a gambling rich area in the northwestern part of the state. The steel construction of the towers is exposed, reflecting the work of the nearby steel mills. Rotating spheres of light and radiant neon channel letters guide visitors to their destination and serve as beacons in the night sky. Neon signage based on playing card and game themes adds to the atmosphere. The use of neon continues into the pavilion, unifying interior and exterior signage.

DESIGN FIRM
ComCorp, Inc.

PROJECT DESIGN
Dave Stuart
Frank Riordan
Rick Smits

FABRICATION
White Way Sign

PHOTOGRAPHY
Robert McKendrick

OPPOSITE PAGE: Glowing hearts, spades, clubs, and diamonds generate excitement at the casino's parking area.

TOP LEFT: The neon banner framing the casino entry gives visitors the unmistakable sense of having arrived.

TOP RIGHT: Spirals of neon accent the clearly marked overhead signage.

BOTTOM: Illuminated overhead directional signage reinforces the futuristic theme, and non-illuminated plaques constructed of perforated metal reflect interior design motifs and architecture.

COORS FIELD

Designs for recreational spaces are often around specific themes, but themes can also be general in nature and still be effective. At Coors Field, the design is not that of a specific era. Rather it draws on the rich visual history of baseball to evoke a nostalgic experience.

Traditional baseball during the 1940s and 1950s, when the game expanded west, is at the heart of the graphics, signage, advertising, and sponsorship programs that Kiku Obata & Company designed for Coors Field, home of the Colorado Rockies. The graphics take their cue from the industrial vernacular of the architecture, the rich historical railroad tradition of the district, and western themes evoked by the Rocky Mountains. These influences combine to produce the ultimate baseball experience at the ballpark.

Section identification signs were suspended from the structural elements with clevis bolts that allow the signs to sway in the wind, reinforcing the experience of being outdoors. Neon was used throughout the facility for commercial and specialty applications in bars, restaurants, and gift shops. The exposed neon reinforces the nostalgic flavor of the ballpark.

A clock was chosen to serve as an identity beacon from the street side and as a commercial beacon from the backside.

DESIGN FIRM
Kiku Obata & Company

PROJECT DESIGN
Kiku Obata
Todd Mayberry
Tim McGinty, AIA
Beth Mayberry

FABRICATION
AGI, Virginia Beach, Virg.
YESCO, Denver, Colo.
Gardener Signs, Denver, Colo.
Star Signs, Lawrence, Kansas

PHOTOGRAPHY
Gary Quesada
Hedrich Blessing Photographers, Chicago, Ill.
Thorney Liberman, Denver, Colo.
Bob Greenspan, Kansas City, Missouri

OPPOSITE PAGE: The modified Modula Serif Black typeface used for the main identity has a heavy industrial, western feel.

TOP LEFT: The scoreboard incorporates the Rockies logo and a baseball clock with nighttime neon illumination. Advertisers were encouraged to follow an established design criteria in order to enhance the traditional baseball look of the stadium.

TOP RIGHT: Entrances are identified by name according to the relationship to the field, for example: Center Field, rather than a numbered set of gates. This wayfinding system underscores the ballpark's intimate atmosphere.

BOTTOM LEFT: A row of purple seats identifies the mile-high mark in the upper seating area. At Coors Field, the fans enjoy an open, fan-friendly ballpark that places them closer to the field.

BOTTOM RIGHT: Pinstripes add a baseball feel to the wayfinding signs.

TOP LEFT: From the main identity of the clock tower to the logo treatment of the steel gates surrounding the plaza, the graphic components relate to the character of the neighborhood and its history.

MIDDLE LEFT: The six-foot tall, perforated alluminum letters that look opaque by day, transform to glowing white forms by night, giving the ball park a distinctive night-time presence.

BOTTOM LEFT: Custom designed seat stanchions adorn the end of each row of seats. A single row of seats near the top of the upper deck is purple, signifying the mile-high mark.

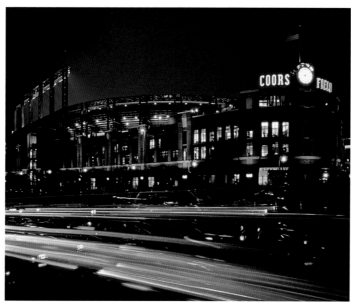

TOP LEFT: Typography set between steel rails was one of the basic design elements used to convey the feeling of the site's railroad history.

TOP RIGHT: Neon illuminated signs were designed for specialty and commercial functions.

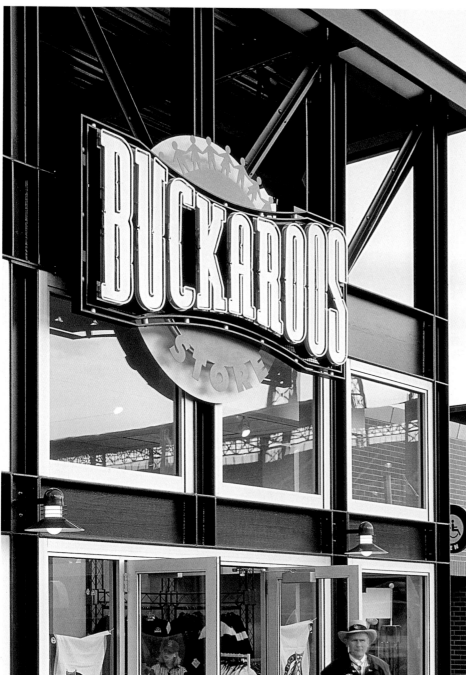

BOTTOM: Themed names were developed for retail and other commercial venues.

TOP RIGHT: Alluminum letters are mounted to a metal grill with gooseneck lamps that cast shadows on the wall below and add a nostalgic character to the signs. The concessions at Coors Field are laid out so that fans can walk around the stadium during game time and never lose sight of the field.

BOTTOM RIGHT: Criteria were developed to integrate the advertising into the advertising and wayfinding components.

THE BLOCK AT ORANGE

The designers at CommArts were faced with the task of developing an environmental graphics program that was unique, powerful, and visually compelling for a massive outdoor entertainment/retail complex. The Block at Orange, celebrating the high-energy, outdoor California lifestyle, has set a new standard for outdoor entertainment projects.

The Block at Orange is the first of a new brand of entertainment/retail centers to be splashed across the country by The Mills Corporation. With more than 70 percent of The Block's 811,000-square footage dedicated to entertainment, The Block aims to be reminiscent of the world's great city blocks, like Times Square, Pier 39, and Melrose Avenue, but with a California state of mind. CommArts worked with The Mills Corporation to create an atmosphere that celebrates the hip, healthy California lifestyle. The Boulevard, lined with trees and custom benches, creates a quiet shopping street. The Strip is a lively, animated promenade featuring a thirty-screen movie theater complex and a mega-skatepark.

Unifying this massive complex are twenty-two visually powerful stylons (style + pylons)—six 92-foot high placed at strategic points within the inner shopping streets and sixteen 36-foot high at major parking lot entrances—whose large format graphics and internal illumination are riveting against the night sky. By day, the crisp black-and-white imagery stands out among the rich Mediterranean color palette of the buildings. The designers consciously determined how best to animate the spaces from several different perspectives, from the automobile on the freeway and the site entrances to the tenant storefronts and restaurants. These modern megaliths, with their ever-changing graphics and images reflecting the community and its California culture, have become attractions in their own right.

Several other strategies were used to strengthen the unifying image of the complex. Tenants submitted their storefront designs for review, and, through an integrative process, suggestions and alternate ideas were made. Tenants were encouraged to break free of traditional sign box solutions and to add more impact and punch to their storefronts. For example, the man-made wave that forms Ron Jon Surf Shop's front wall is 40 feet tall. Design teams worked together to discover ways in which individual branded appearances could add to the visual excitement of the project within the standards criteria set to enhance the overall look and quality of typical storefront signage.

Conscious planning has assured a flexible space that can adapt to the ever-changing styles and fashions. From the stylons and the streetlight bases to the graphics and the lighting, the project design provides an area that can quickly and efficiently change its style and appeal to ensure a fresh, hip image.

DESIGN FIRM
CommArts, Inc.

PROJECT DESIGN
Henry Beer
Jim Babirchak
Jim Redington
Grady Huff
Aaren Howell
Dave Dute
Paul Mack
Chuck Desmoineux
Kurt Sinclair
Kristian Kluner

FABRICATION
Universal Sign Company
Penwal Industries
SmithCraft
ASI
Inner-Force
Quality Outdoor Advertising
Nationwide Retail Interiors
Super Color Digital
Decals, Inc.
Color Concepts, Inc.

PHOTOGRAPHY
Aaron Hoffman

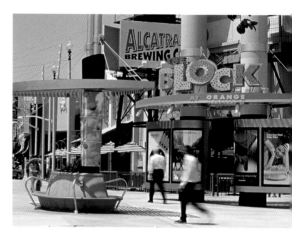

BELOW: The main entry sign sets the tone for The Block—innovative, high energy, and anything but the usual.

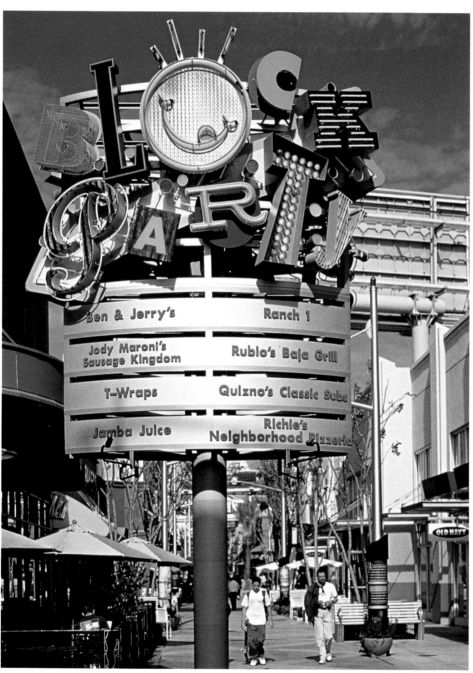

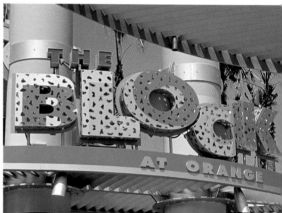

TOP RIGHT: The Block's splashy signs and eye-catching storefronts make every entry memorable.

BOTTOM RIGHT: Surfing iconography finds its way into a number of graphic displays at The Block.

TOP: The open-air retail center aims to be youth oriented, from the entry styles to the block- party atmosphere.

BOTTOM: Billboard elements give character to a pedestrian shopping street in The Block.

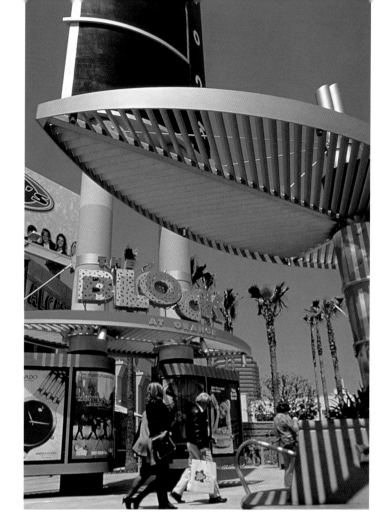

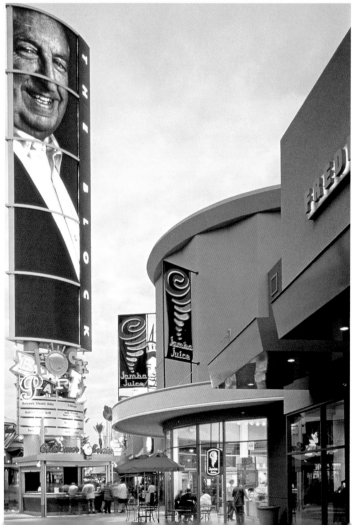

TOP: Even a sign for valet
service gets star treatment
at The Block.

BOTTOM: Two 91-foot stylons
flank the front entry to the open
air complex.

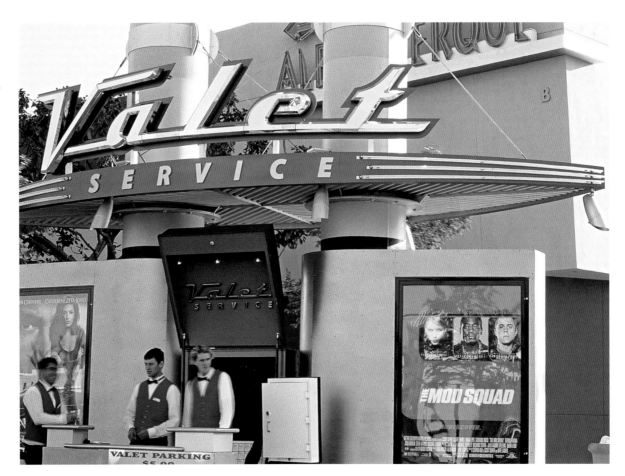

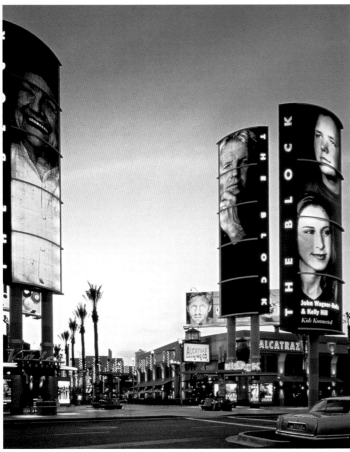

AIKMAN'S ENDZONE

CHILDREN'S MEDICAL CENTER/COOK CHILDREN'S MEDICAL CENTER

Children's health care facilities present unique challenges to creating friendly spaces. Unlike leisure and recreational environments, these centers must meet the needs of medically challenged and distressed children and their families. Healing environments can be made more comforting and pleasant through the use of friendly graphics and imagery with which children and adults can identify or interact.

HKS, Inc. designed The Troy Aikman Endzone to provide a safe and interactive haven for sick children and their families at Children's Medical Center of Dallas and Cook Children's Medical Center in Fort Worth, Texas. The goal was to design a kid-friendly, football-inspired place in a high-tech, aesthetically pleasing package. The designer accomplished this mission, from the entry colors to the signage typefaces. Brushed aluminum was used to create a slick, clean image. Textured aluminum mimicking pigskin added a football-like effect. The Dallas Cowboy team colors, as well as other complimentary hues, created a child-friendly environment.

A 1,110-gallon saltwater aquarium with thirty exotic fish greets visitors entering the 6,000-square-foot centers. The dominant element in each center is a 10-foot Dallas Cowboy helmet. Through an opening in the back of the helmet, children can enter, sit on a white cushion seat, and enjoy quiet activities. Each of thirty uniquely conceived signs is designed to turn approximately 15 degrees to resemble a football in flight.

The innovative center design includes two separate areas—the Huddlenet and Theater 8. The Huddlenet, an interactive computer network and multimedia entertainment and communications system, incorporates Steven Spielberg's Starbright Network. Additionally, the system allows children to interact with sports and other celebrities on-line. Six separate Star stations afford the children privacy. The Theater 8 area hosts an intimate screening room and stage with state-of-the-art audio and video equipment with a wide-screen television, laser disk, surround sound, touch-screen interface, and 1,200 colored fiber-optic twinkling lights.

Both facilities provide a special place for children to exercise their imaginations, using cutting-edge technology and a themed, playful design that transforms the hospital environment into a world created especially for kids. Dedication plaques of fabricated aluminum with raised decorative elements and silk-screened graphics complete the facility.

The project went from programming and schematics to completion in eight weeks. The schedule allowed four weeks for the fabrication of the thirty signs. The first Aikman's Endzone opened in 1996 and since then, similar facilities have been designed and built. HKS designed the facility with prototype standards in mind, making it easier to utilize components in different facilities.

DESIGN FIRM
HKS, Inc.

PROJECT DESIGN
Nancy Goldburg

FABRICATION
EEC Industries

PHOTOGRAPHY
Ron St. Angelo
Bill Bolin

TOP RIGHT: Starbright interactive computers offer high-quality visual imagery and virtual reality for the children's' hospital.

MIDDLE RIGHT: All of the signs in Aikman's Endzone suggest the elliptical shape of a football.

BOTTOM RIGHT: Layered materials and chemically etched graphics enhance the design of the dedication plaques.

RIGHT: Scotchprint images were face-mounted onto Lexan in the display case.

RIGHT: Astroturf creates a football-field effect at Cook Children's Medical Center in Fort Worth. An 8-foot replica of Aikman's Dallas Cowboy helmet dominates the end of the corridor.

LEFT: The clock provides a central landmark for the site and represents Winter Hill, the founding site of the City of Somerville.

RIGHT: One of seven mounted plaques, each detailing the history of one of the seven hills of Somerville.

In the 18th century, Clarendon Hill's land use was agricultural and remained so until the mid-19th century. Fishing for Alewives in the stream at the bottom of the hill (now known as Alewife Brook) was an occupation of some early residents. The fish were salted and shipped to the West Indies in exchange for molasses which was brought to nearby rum distilleries.

SOMERVILLE, MASSACHUSETTS

SEVEN HILLS PARK

Public spaces can incorporate design elements inspired by local history and culture to connect a site with its location and the citizens who use it. In this way, these social spaces can contribute to a sense of community.

Selbert Perkins Design provided landscape architecture, sculpture and environmental communication design services to create this landmark, award-winning urban park. Seven Hills serves as the gateway to an extensive linear park system that includes trails and bicycle paths. The park plan is reinforced by seven sculptures that represent the original Seven Hills of Somerville and that reflect the historic activities conducted on each hill.

The sculptures have become landmarks that establish a strong sense of place and identity for the site. The park is located behind a one-story subway building, so the sculptures were placed on towers for greater visibility. Each sculpture was hand carved and painted using traditional techniques and modern materials, including high density foam and automobile paint. The supporting towers utilize brick and granite for the bases, a reflection of traditional New England construction materials, and steel for the tower elements, which is reminiscent of the railroad tracks formerly occupying the site. The final result is dramatic, whimsical, and even educational.

DESIGN FIRM
Selbert Perkins Design

PROJECT DESIGN
Robin Perkins
Clifford Selbert

FABRICATION
Amidon Sign
Cornelius Architectural Products

PHOTOGRAPHY
Anton Grassi

THIS PAGE: At Seven Hills Park, each of the sculptures, atop their towers, is fully three-dimensional, hand-carved, and colorfully painted.

The cow sculpture, for example, is constructed as a single weathervane and gently turns with the wind.

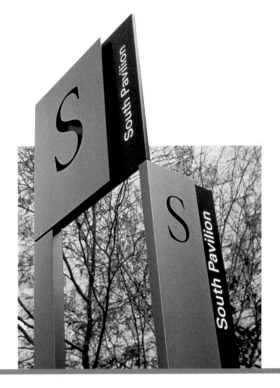

by Adrianne Gregory

DEVELOPING
WAYFINDING AND NAVIGATION

Wayfinding terminology such as user interface, ergonomics, cognition, and environmental psychology has become all too familiar, but true understanding and involvement in the principles of wayfinding quickly separate the neophytes from the professionals. Navigating from one place to another, or wayfinding, is a very basic activity, one in which people engage throughout their lives. Wayfinding is also a developing field of study in multi-disciplinary design as well as computer science. There are principles of human spacial cognition (3-D awareness) that have been—and continue to be—developed. Much of what wayfinding analysts do is to apply principles and methodologies to structured spaces.

Wayfinding is more than reading signs. It involves spacial problem solving of the type we do every day. When we get lost, we usually know where we began and where we want to go. The question is how to get there. An effective wayfinding strategy creates clear paths by using visual, verbal, and/or auditory clues such as signs, maps, landmarks, and other signals. People must find their way through many types of complex environments: museums, hospitals, multi-building companies or institutions, airports, shopping centers, campuses, hotels. These people represent different types of users: tourists, patients, workers, travelers, shoppers, students. They need different levels of information so that they can get

Arrow from user to destination.

Mouse chewing through a maze.

> An effective wayfinding strategy creates clear paths by using visual, verbal, and/or auditory clues such as signs, maps, landmarks, and other signals. <

to and from their destinations. Without some kind of wayfinding strategy (and often it can be a simple strategy), people get lost. In the worst cases, this can be fatal. In less crucial situations, it can bring confusion, stress, and/or the impression that a facility doesn't care about its users. Horrors!

A successful wayfinding system gives users a sense of order. Effective design orders the environment by identifying a series of zones, establishing different spaces, creating intuitive paths, and presenting memorable landmarks along the way. It also gives one a sense of calm through architectural order, aesthetics, materials, color, lighting, and messages that reassure and sometimes even amuse.

By understanding user patterns and destinations, wayfinding analysts understand how a facility operates and how occupants and visitors should be moved through spaces and directed to destinations. The goal is to reinforce architectural cues that support wayfinding. ComCorp's sign program for the new BlueCross BlueShield corporate headquarters is a prime example. Glass is the predominant material throughout the facility, giving an almost spiritual dimension of light and space. Glass and stainless steel are the materials of choice for the sign program, using subtle colors and typestyles. For installation of public area signs, ceiling mounts from cables, rather than wall or glass mounts, create clear, unobstructed landmarks for a navigable environment.

Effective programs achieve impact with the fewest number of signs and messages. Careful attention to the hierarchy of sign types not only establishes a system of visual cues that a user can cognitively understand, but saves money as well. Such a hierarchy includes primary and secondary directional signs for major destinations: wayfinding to guide to a destination, identification for arrival at destinations, regulatory to manage behavior, instructional to educate, and informational signs to inform and to build interest.

First time users of a facility usually determine what to look for in the first few moments. To speed this process, a sign program must communicate critical information quickly, clearly, and memorably. When using a coding

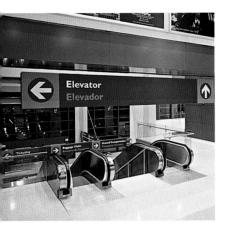

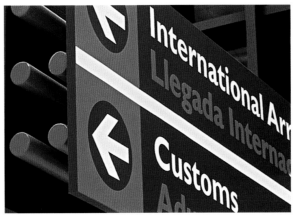

device such as color, four colors are generally agreed to be the understandable limit for most humans. Each color's function must be clearly defined. How much of a particular color is needed to convey a message properly must also be determined.

Nomenclature is a standardized set of words, syntax, grammar, spellings, and symbols used to communicate information. Standardizing information for public use ensures that it will be presented consistently and that the content of wayfinding messages will be clear. Essential components of good nomenclature must be addressed in all wayfinding projects. They include the following: consistency · common usage · reasonable grammar and spelling · punctuation · symbols vs. words · foreign language · color coding · national standards · industry-specific vocabulary · comprehensiveness.

In a multilingual society, a dual-language system is sometimes recommended. The Laredo Airport case study in this section is an excellent example of two languages

sharing space to convey critical messages. With total message area on signs at a premium, communication that reads quickly takes careful thought and programming. International symbols or icons are often more effective than words to communicate services: directions, emergency information, elevators, and public amenities such as food, telephone, restrooms, and shops. While the design profession has implemented a library of icons that are now part of most users' mental library, newly designed icons need to be tested so that their intended messages are ones which are universally understood. Many errors of recognition are realized only after implementation of a sign program because pre-design testing was not made part of the wayfinding design process.

Maps are one of the most effective additions that can be used, after the fact, in existing facilities, or where current sign programs need supplemental explanations. You-are-here maps help re-orient and relax a confused user and are especially useful for large facilities where

the use of signs and other visual messages can overwhelm. ComCorp's illuminated maps for Chicago's Navy Pier, a tourist destination, serve a supplemental function by exploding a huge facility into three distinct levels with call-outs for exact destinations, services, and amenities. Lighting and strong colors act as beacons in dark corners. Inexpensive acrylic panels ensure easier updating to accommodate continual architectural additions for this facility.

Because most buildings support many different users daily, wayfinding analysts solicit information from those who are familiar with building functions. These may include the following:

- Organizational leadership (CEO, financial, marketing, public relations)
- Architectural team (project managers, construction managers)
- End users (visitors, guests, patients, shoppers, vendors)
- Facility planning managers (security, maintenance)
- Operational managers (department heads)
- Regulatory agencies (ADA, municipalities, fire departments)
- Signage consultants (may or may not be the wayfinding consultants).

A core group of two or three key decision makers or a larger group of specialists, depending upon the facility's complexity, can develop a successful strategy. For example, when designing for theme parks, airports, and large hospitals, it's not uncommon to seek additional support from behavioral psychologists, security consultants, demographics researchers, and marketing consultants.

Training personnel throughout a facility is essential to the long-range success of a wayfinding program. This cannot be overemphasized. A lengthy and expensive program is compromised when information desk personnel (or an elevator panel) continue to use "Lower Level" to designate a scheme that designates it "Ground Level." Training should include familiarization with tools such as maps, building outlines, orientation videos, and support materials that are internet-generated, faxed, mailed, or verbalized as a script prior to visiting a facility. The support and upkeep of a sign program is made more crucial when ADA, state, and local building code changes are a continual reality.

More than ever, wayfinding analysts are utilizing the design principles of information technology. Practical applications, spatial cognitive principles, and systems programming presentations appear side by side where navigation for cyberspace or the real world is needed. In a consumer-driven society, ease in wayfinding translates "user friendly."

Adrianne Gregory has worked as a graphic designer and university educator in the Chicago area. She now directs new business development for ComCorp, Inc. and oversees their environmental graphic design group. ComCorp is a Chicago-based design company that creates communications solutions for environments, as well as for print and web applications. A comprehensive bibliography of publications on wayfinding is available by e-mailing Adrianne (gregorya@comcorpinc.com).

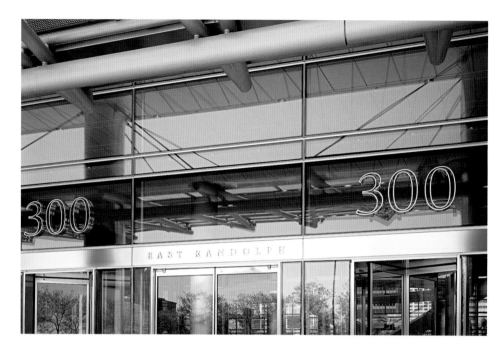

CHICAGO, ILLINOIS

BLUECROSS BLUESHIELD OF ILLINOIS

A basic rule of wayfinding is that signage must be clearly marked and legible from a distance. For this project, simple, clean materials and graphics predominate.

ComCorp used a variety of materials to produce a comprehensive signage system for the new thirty-story BlueCross BlueShield of Illinois headquarters on Chicago's lakefront. Floating signs of glass and steel accentuate this thoroughly modern structure, which was honored with three awards by the American Institute of Architects. The directional signs used throughout the building complement the expansive feel of the interior and guide visitors to their destinations easily and quickly.

DESIGN FIRM
ComCorp, Inc.

PROJECT DESIGN
Dave Stuart
Frank Riordan
Brenda Voglewede
Rick Smits
Kristen Apple

FABRICATION
ASI Sign Systems, Chicago, Ill.

PHOTOGRAPHY
Robert McKendrick

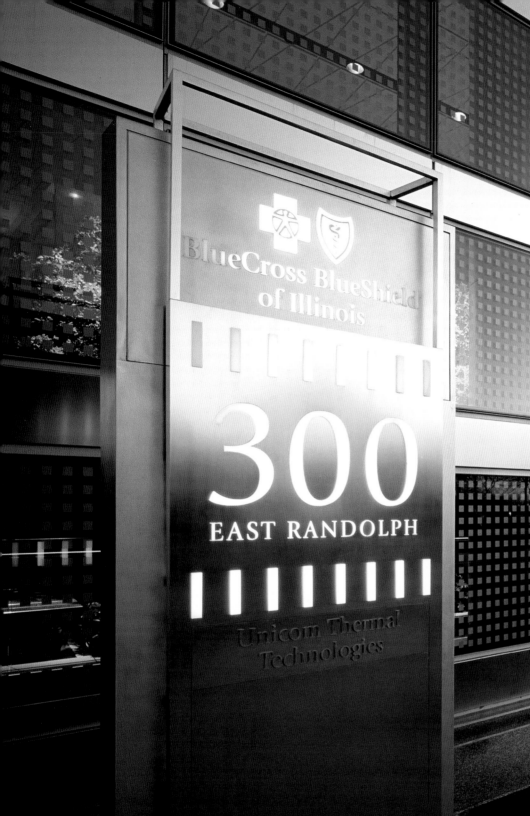

THIS PAGE: Room identifiers are a modular sign system that can be changed at any time by removing set screws that suspend the floating glass panels.

The signs' graphic details include grid patterning that repeats throughout the entire facility.

OPPOSITE PAGE: Interior acrylic and aluminum signs are suspended from the ceiling using aircraft cable to enhance the openness of the building's atrium design without sacrificing the visibility of important directional information.

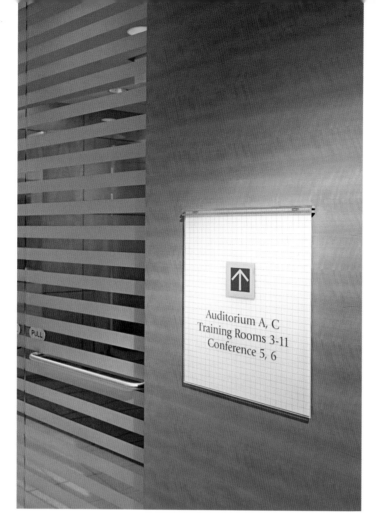

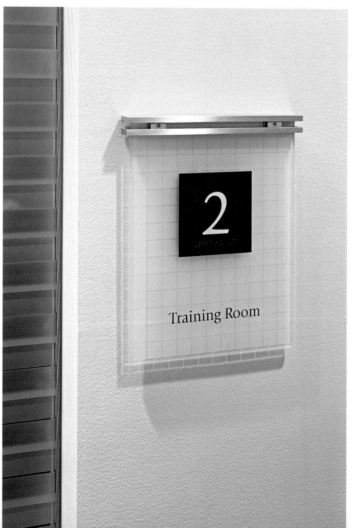

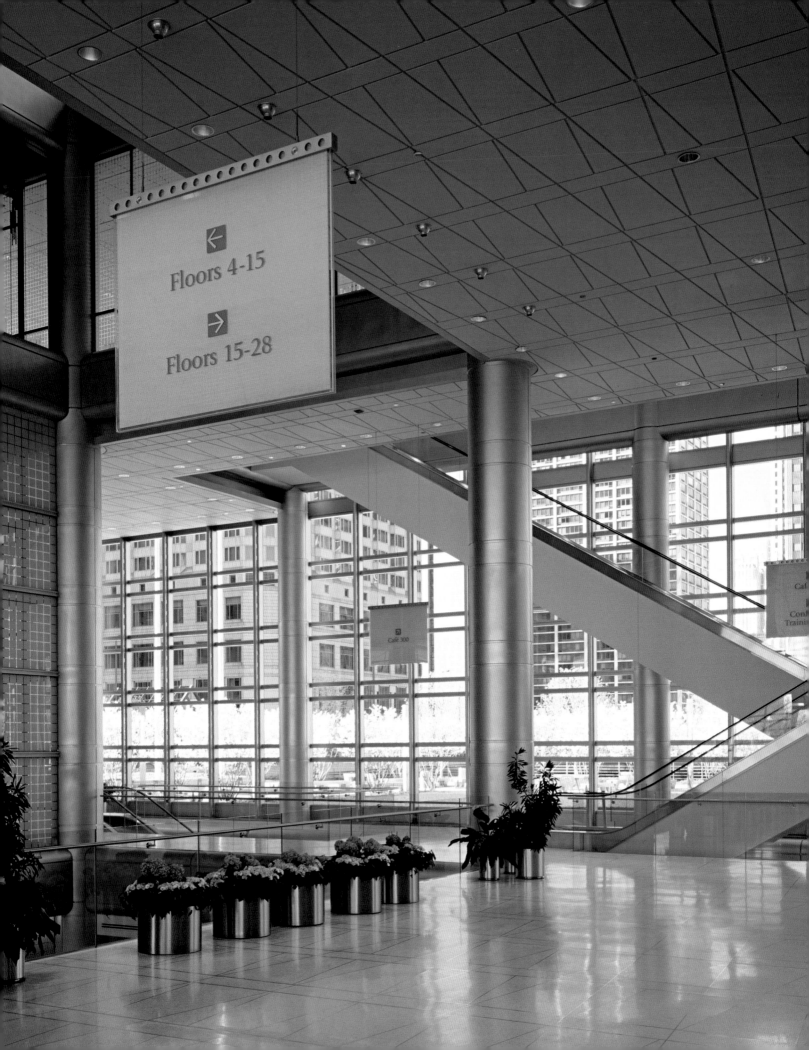

PHILADELPHIA MUSEUM OF ART, PHILADELPHIA, PENNSYLVANIA

RODIN AND MICHELANGELO EXHIBIT

Some of the most successful wayfinding tools are those that perform the primary task of guiding visitors and, at the same time, that act as interpretive backdrops. The designers of the Rodin and Michelangelo exhibits employ graphic devices to organize the space as well as to highlight important themes linking the two exhibits.

When two exhibitions at the Philadelphia Museum of Art shared the same temporary exhibit space, Susan Maxman & Partners were asked to organize a space that would relate the two separate exhibits: *Rodin and Michelangelo: A Study in Artistic Inspiration* and *The Hands of Rodin: A Tribute to B. Gerald Cantor*. The organizing features of the presentation are three large translucent scrims that create an architectural setting for the works while allowing the sculpture and drawings of the artists to be the primary elements of the exhibitions. A long corridor forms the entrance to the exhibits, displaying a quote from Rodin. Visitors subsequently enter a common introductory area that links the two shows and allows visitors to pass freely from one to the other. At the core of the Rodin and Michelangelo exhibition are three larger-than-life plaster casts of Michelangelo's sculpture in Florence's Medici Chapel, a space that had a profound influence on Rodin. A large scrim of the architectural features of the chapel forms a backdrop for the sculptures. Visible throughout the display, this image is a constant reminder of the theme of the exhibition. The display culminates with a second scrim, *The Gates of Hell*, a theme that relates to the later work of Rodin.

An image of *The Thinker* in front of the Rodin Museum in Philadelphia anchors *The Hands of Rodin* exhibition. This scrim frames a statue of Lorenzo di Medici, creating an additional link to the Rodin and Michelangelo exhibits.

DESIGN FIRM
Susan Maxman & Partners, Architects

PROJECT DESIGN
Missy Maxwell
Susan Maxman & Partners Architects
Mark Willie, Willie Fetchko Graphic Design

CONSULTATION
George Sexton, Lighting Design
Daiji Asani, Digital Imaging

FABRICATION
Philadelphia Museum of Art
Vision Graphics (scrims)

PHOTOGRAPHY
Graydon Wood, Philadelphia Museum of Art

"...making a study of Michelangelo will not astonish you,
...the great magician is giving up a few of his secrets to me."
—Auguste Rodin, 1876

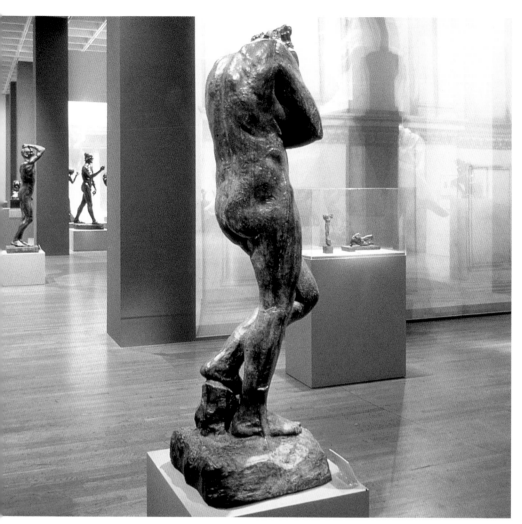

TOP AND BOTTOM LEFT: The two exhibits are seamlessly organized around the architectural setting created by the scrims.

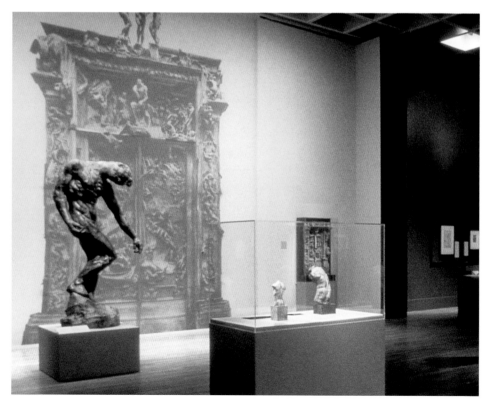

BOTTOM RIGHT: A view from the introductory area that links the two exhibitions shows the scrim with the image of *The Thinker* in front of the Rodin Museum in Philadelphia.

J. PAUL GETTY MUSEUM

To help visitors feel comfortable and welcomed at the sprawling new J. Paul Getty Museum in Los Angeles, the museum's Exhibition Design Department developed and installed an adaptable wayfinding and signage program that allows for change in the system based on visitor feedback.

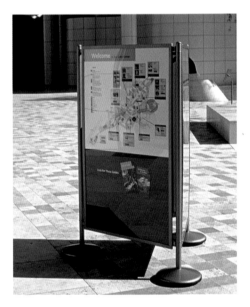

The wayfinding program at the J. Paul Getty Museum provides visitors with direction and orientation to the site, buildings, and art collection at the new museum, which opened in 1997. The program is an adaptable, high-quality solution that can be refined within the first years of operation, and indeed, modifications have already been made to improve the system in response to visitor feedback.

Signs fall into three main categories: orientation, direction, and identification. Clarity, accessibility, and usefulness for visitors were the primary goals. Signs range from three-dimensional orientation models to gallery identification signs. The signs have a sense of scale and an affinity with the bold architecture, yet still stand out from their surroundings. Design and typography maintain a stylistic unity across the spectrum of sign types and extend into interpretive materials and labeling in the galleries.

DESIGN FIRM
J. Paul Getty Museum
Exhibition Design Department

PROJECT DESIGN
Merritt Price, principal-in-charge
Tim McNeil, senior designer
Robert Brown
Michael Lira
Leon Rodriguez

MAP ILLUSTRATION
Doug Jamieson

FABRICATION
Carslon and Co.
Fabrication Arts

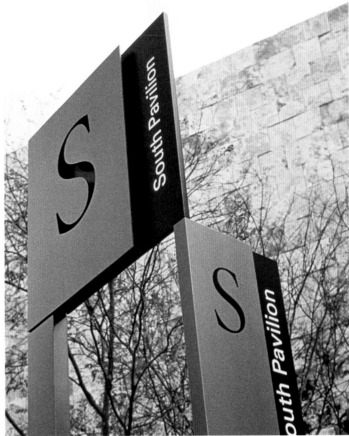

TOP LEFT: Valuable wayfinding information is compressed into map form in displays located both outside and within the Getty Center.

TOP RIGHT: Exterior signs identify the buildings, or pavilions, that house the museum's extensive collections. The sculptural quality of this building identification sign, with its perpendicular faces, allows ease of wayfinding.

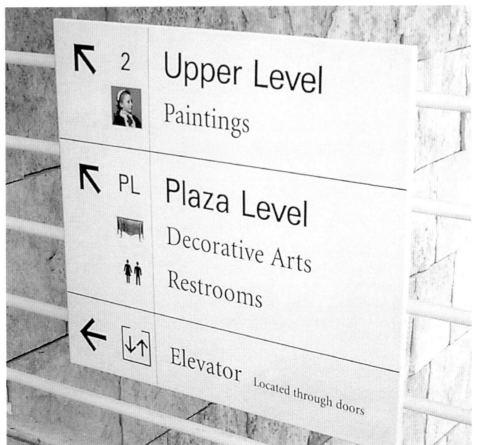

BOTTOM: Following visitor input, many of the museum's directional signs were redesigned in 1999 to further improve their usefulness. The signage fits with the architecture, yet stands out to assist wayfinding.

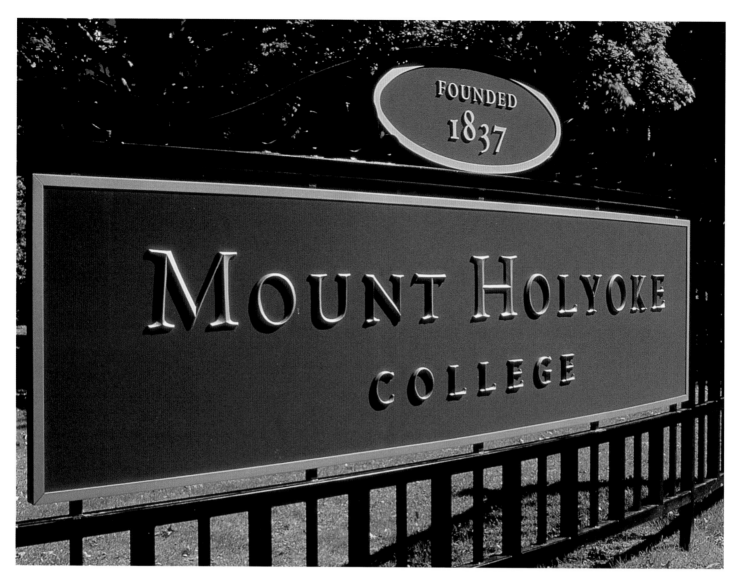

ABOVE AND OPPOSITE PAGE: Rich, cast iron details and classic typography are integrated to reflect a beautiful, contemporary, yet timeless, New England campus. The cast bronze numerals provide a sense of permanence and quality.

RIGHT: Traditional forms and typography were used in the new logotype developed for the college.

MOUNT HOLYOKE
COLLEGE

MOUNT HOLYOKE COLLEGE

Selbert Perkins Design brought a distinct new graphic identity to Mount Holyoke College.

This new look contributed to a significant increase in applications to this prestigious school.

DESIGN FIRM
Selbert Perkins Design

PROJECT DESIGN
Clifford Selbert
Robert Merk
Michelle Phelan

FABRICATION
Design Communications

PHOTOGRAPHY
Clifford Selbert
Anton Grassi

Mount Holyoke College required a clear and consistent identity for its classic campus, as well as a communications master plan. Selbert Perkins Design began the process with research on campus awareness that involved administration, faculty, alumnae, students, and visitors. Working closely with the college administration, Selbert Perkins created a system that included a new logotype, an extensive print communications program, and a complete identity and wayfinding system for the campus.

The logotype reflects the college's classic appeal and the new identity and communication plan portrays the private women's college as strong, solid, confident, energetic, and timeless. A unified wayfinding system for vehicles and pedestrians clearly identifies streets and buildings and creates a seamless integration of the 120-year-old campus. Materials used include highly detailed cast iron elements combined with patina finished steel. The overall design brings a distinct new look to the prestigious school.

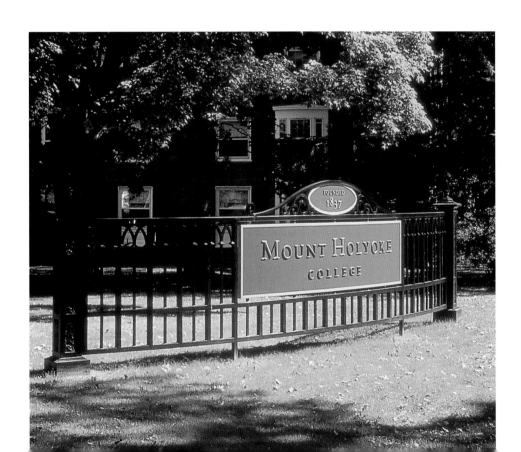

TOP LEFT : Intricate details combine with classic typography uniting all the sign types, such as this parking identity sign, in the Mount Holyoke system.

TOP RIGHT: Traditional forms and typography were used throughout the street-identity systems to reinforce the college identity and character.

BOTTOM LEFT: The building identity system complements the classic forms and details found in the traditional campus buildings.

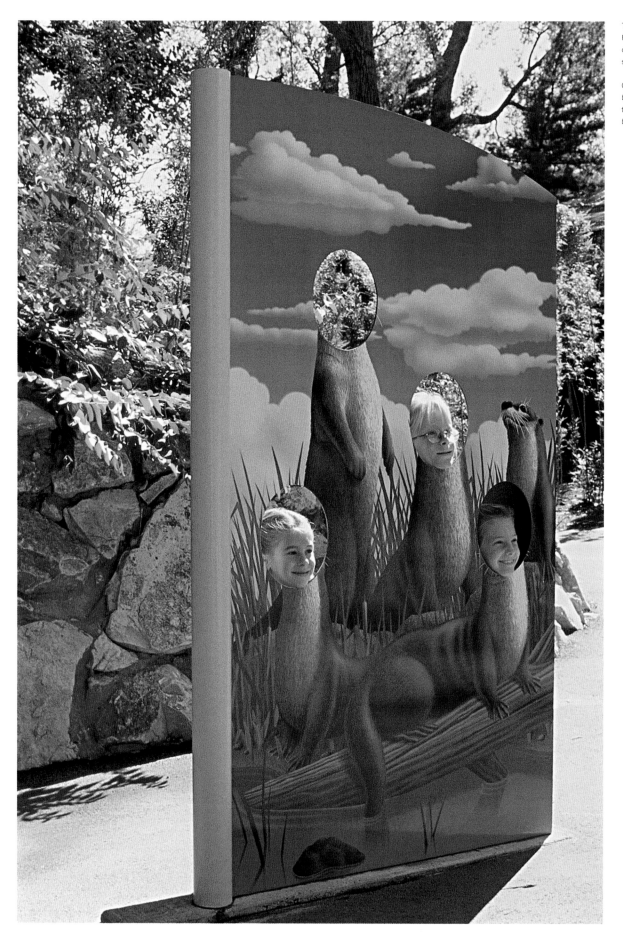

THIS PAGE: The Otter Family Photo Opportunity is fabricated of porcelain enamel with a silk-screened illustration.

OPPOSITE PAGE: The admission booth to the Children's Zoo captures visitors' attention with boldly colored blade signs.

ST. LOUIS, MISSOURI

ST. LOUIS CHILDREN'S ZOO

Kiku Obata & Company was invited to remake the St. Louis Children's Zoo into a fun and informative experience and to help dispel the traditional notion of a children's zoo.

DESIGN FIRM
Kiku Obata & Company

PROJECT DESIGN
Todd Mayberry
Rich Nelson
Arden Powell
Jonathan Bryant

FABRICATION
Engraphix Architectural
Signage, Inc.
Pannier

PHOTOGRAPHY
Justin Maconochie, Hedrich
Blessing Photographers,
Chicago, Ill.

The children's zoo in St. Louis recently underwent a major renovation to make it a year-round facility offering young people and adults many more close-up and hands-on encounters with animals. The zoo staff wanted to bring children "face-to-face" with the animals and their habitats as well as to teach them about the animals. Above all, the staff wanted to change the perception that a children's zoo was just a petting zoo. These concepts guided everything from the design of the habitats and exhibits to the content of the descriptive text. Kiku Obata & Company's challenge for the new children's zoo was to design an identity and a comprehensive sign and graphics program that would be educational, engaging, and, most of all, fun.

For the designers, fun interprets as brightly colored signs, creatively used materials, and uniquely interactive exhibits. The new, distinctive logo, illustrating a human face intertwined with an animal face, communicates the face-to-face interaction with the animals that visitors can experience at the new facility. "Face architecture" was used for the signage; signs were mounted at "kid height" and text was written at grade school level.

Several exhibits and interactive signs encourage children to think about what it is like to be an animal or to compare themselves to the animals. The "I'm As Big As" sign compares the children's height to a variety of animals. The playground features slides where once can "slide like an otter" and a sandbox where children can "dig like a gopher."

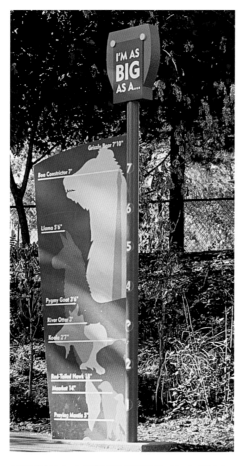

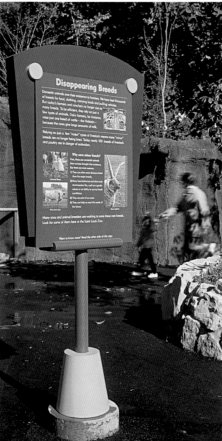

TOP: The signs and graphics help direct visitors to the attractions and inform them of animal life and habitat. Some of the signs function as interactive exhibits, such as the "I'm as Big As..." display, which allows visitors to see how they measure up to a grizzly bear and other animals.

BOTTOM: The sign system is based on an abstract facelike shape with yellow aluminum buttons that serve as the eyes and a red aluminum tube at the bottom that serves as the mouth.

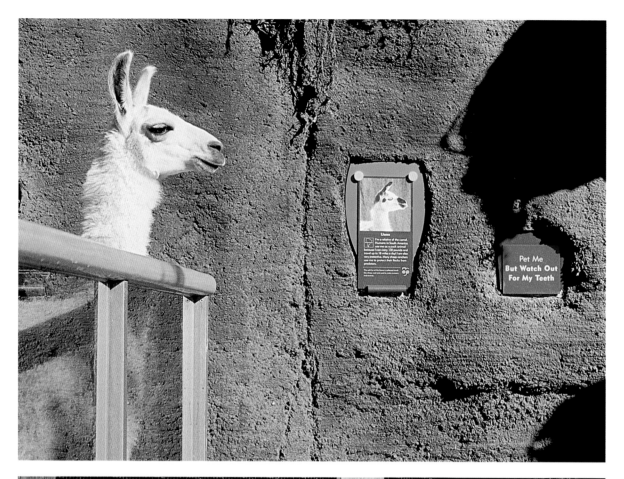

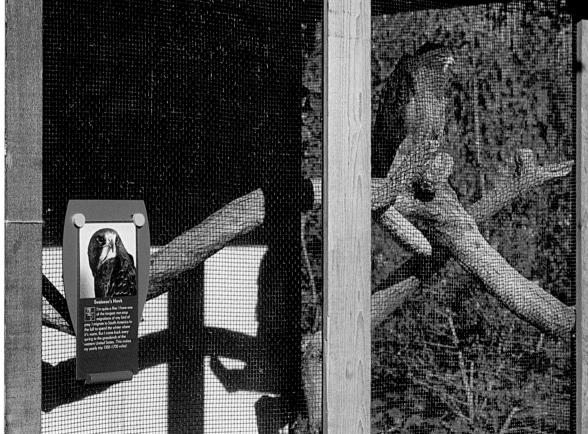

TOP: Designers carefully considered sign placement in order to keep them out of reach of animals.

BOTTOM: The new signage and graphics also easily accommodate exhibit changes. Species labels can be removed and replaced as animals change, by screwing the aluminum buttons and slipping the graphic panel out of the routed aluminum tube.

LAREDO INTERNATIONAL AIRPORT

Wayfinding systems for airports can be complicated and demanding. HOK Graphics' consistency in sign placement and their consistency of colors and forms for both exterior and interior signs make the wayfinding for Laredo International Airport a success.

The designers at HOK Graphics were key in helping Laredo International Airport achieve its goal as Airport of Choice. For air travelers, issues such as legibility and accessibility are crucial when navigating under short deadlines and through highly trafficked areas. Airport wayfinding includes guiding departing passengers from roadways to terminals to planes and arriving passengers from planes to baggage claims to exits and ground transportation or parking. Connecting passengers must be able to find their flights quickly, if necessary. In addition, all airport visitors need information, concessions, and other airport services, often within a limited time frame. This basic wayfinding paradigm rapidly grows more complex. Cognitive factors such as distance, speed, and varying lighting conditions affect a person's ability to perceive a sign. Hesitation in an unfamiliar environment and insecurity in large, crowded spaces are psychological factors that affect the ability of people to absorb information. These factors are best met by a wayfinding system in which a logical hierarchy is slowly revealed in controlled, limited doses. Sight lines, size, color, placement, and spacing must be resolved to create a signage system that creates a smooth flow of pedestrian and vehicular traffic.

These problems are further compounded in a bilingual environment. HOK's bilingual wayfinding program separates each language by color. This color-coding provides consistency and clarity in identifying each language. The project designers took great care to translate messages in ways that reflect both local and traditional Spanish. However, international symbols added unnecessary clutter to the already information-intensive directional signs, so such symbols were used only for secondary directional signs, such as those for restrooms and telephones.

The airport signage design for Laredo International Airport mirrors the modern geometric forms of the architecture and local colors of the Hispanic heritage in southwest Texas. Shell stone used on the exterior face of the building serves as a base material for the exterior monument and direction signs. The shell stone, wrapped with a painted aluminum angular box, provides interesting form and contrast. Interior overhead directional signs are cantilevered from stone columns with three steel tubes, incorporating the angular geometry found throughout the architectural detailing. Sign panels are removable for future message changes as there are expansion plans for the airport.

DESIGN FIRM
Hellmuth, Obata + Kassabaum, Inc.

PROJECT DESIGN
Kamela Janke
Michael Gilbreath

FABRICATION
Architectural Graphics, Inc.

PHOTOGRAPHY
Joe Aker

OPPOSITE PAGE: The exterior internally illuminated 20-foot monument sign clearly identifies the airport entrance and reflects materials and forms of the architecture.

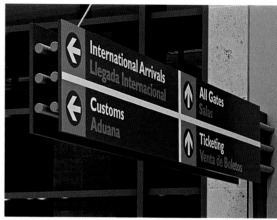

TOP LEFT: Horizontal tubes were integrated into the architecture early on to avoid any visible attachments to the structure, as shown in this overhead directional sign.

BOTTOM LEFT: A series of cantilevered overhead and flag-mounted directional signs guide visitors to ticketing and up the escalators to the gates.

TOP RIGHT: Cantilevered directional signage utilizes the angle form from the exterior signage as well as the architectural detailing, as a decorative element.

BOTTOM RIGHT: Exposed tubes and cable supports give an industrial quality to the design.

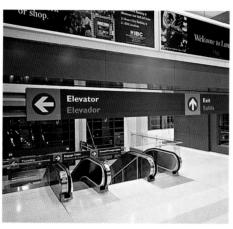

CHICAGO STREETSCAPE

Wayfinding systems in large cities are often inadequate. Two Twelve Associates's standardized city signage system marries esthetic appeal to functionality.

In Chicago, as in most cities, the approach to street signage has been to liberally apply the standards of the Manual of Uniform Traffic Control Devices. As city administrations change, so do new design ideas, often with no guidelines for the thoughtful placement and creation of signs. Typically, the result is visual clutter and confusion. The challenges facing the designers at Two Twelve Associates were fourfold: to improve the visibility and clarity of traffic and directional signs by standardizing the design and placement of signs; to streamline the sign-production process by creating modifiable templates and specifying uniform materials; to improve the aesthetics of city streets by reducing sign clutter; and to create a welcoming environment by creating directional signs accessible to residents and tourists alike. In addition, working with a major city involves working with a variety of departments and agencies. Every budget must be justified and each plan and design often requires multi-departmental approval.

The designers had to determine the navigational needs of various groups within the city: tourists, daily commuters, frequent visitors, and residents. They then had to address these varying needs while getting the information across efficiently and effectively and maintaining the residents' sense of neighborhood. Five pilot neighborhoods were identified to study implementation of the new standards.

Two Twelve's first, and perhaps most important, step was the selection of the internationally acclaimed typeface, Transit, developed for Berlin's new transportation system signage. Transit, with its international feel and easy legibility, was a perfect complement to Two Twelve's designs incorporating international wayfinding symbols. Symbols and words worked together. Standard traffic colors were used according to the National Traffic Guidelines outlined in the MUTCD; for example, yellow was used for taxi signs. However, blue, the identifying color of the Chicago Transit Authority, was incorporated and brown, the color of Chicago's bridges, was used on cultural signs.

Two Twelve developed a uniform post and panel system and new custom pieces to complement current materials, with each component—engineered for simple, efficient assembly—designed to fit into the new stock system. The genius of the system lay in its inherent ability to determine the number and placement of future signs. Standardization and a comprehensive manual, in which symbols replaced wordiness to help users understand city regulations, made the system easy to use and expand.

DESIGN FIRM
Two Twelve Associates

PROJECT DESIGN
David Gibson, principal-in-charge
Jean Lambertus, design and project manager
Jill Ayers, designer
Patrick Connolly, production

FABRICATION
ACME-Wiley
City of Chicago Sign Shop

CONSULTATION
TY Lin Basco International, Traffic Engineers

PHOTOGRAPHY
Erik Kvalsik

OPPOSITE PAGE: Clear and concise, the Chicago streetscape signage created a whole new atmosphere, making the experience of living in and visiting the city more memorable.

TOP LEFT: In light of the importance of Chicago's immigrant history, neighborhood names were added to the signage as a means of establishing identity.

BOTTOM LEFT: Taxi-stand signage makes it clear where to catch a taxi.

TOP RIGHT: Bold symbols enhance understanding of streetscape regulations. In keeping with Chicago's international community, the designs made use of international icons, such as this snowflake, to help locals and visitors from all over the world easily identify and navigate the city.

BOTTOM RIGHT: Two Twelve designed not only the graphics, but also the hardware assembly that would further standardize Chicago's streetscape.

CHICAGO, ILLINOIS

NAVY PIER DIRECTORY MAP

Diagrams can be useful tools for wayfinding. Signage at the Navy Pier in Chicago employ illustrated maps using color coding, symbols, and labeling to aid travelers.

The illuminated directories throughout Chicago's newest waterside entertainment district are designed to assist visitor wayfinding. The custom-fabricated, curved maps are illustrated with vertically enlarged aerial maps to help users identify locations, which are color coded to make navigation easy.

DESIGN FIRM
ComCorp, Inc.

PROJECT DESIGN
Dave Stuart
Rick Smits

FABRICATION
White Way Sign,
light box installation
P&R Group, Duratrans map

PHOTOGRAPHY
Robert McKendrick

OHTO-MACHI TOWN SIGNS

Design Network, working within the standards set for this Japanese town, effectively lends the contemporary to the traditional to create a sign system that is as appealing as it is functional.

Visitors to the town of Ohto-machi in the Fukuoka Prefecture of Japan hardly ever noticed where they were, but that situation has changed. Design Network was asked to devise a system of signs that would put Ohto-machi on the map and enable visitors to navigate throughout the town, find information, and learn about the town's history.

The central task, as envisioned by the designer, was to create consistency of design for all signage and to break away from the staid practicality of previous signs. Before this project got underway, signs were designed in a vacuum, without shared design concepts, and only with an eye to practicality. The result was ineffective and not very inviting.

The colors, symbols, and town theme as authorized in the town development master plan were reflected in the sign design. However, the project designer was determined to create long-lasting designs that would never feel out of date.

To this end, the symbols and the town epigraph, Home of flowers and fresh-water clams, were graphically abstracted in order to avoid the humdrum, uninspiring images resulting from the direct use of these features.

For the gate sign at the town entrance, the medium the designer chose is glass. Its transparency gives visitors a sense of the openness of the town and its residents. Newly introduced signs to indicate public facilities and to detail the town's history use a uniform color palette, making the signs easy to find and identify. In an attempt to communicate clear, accurate information about the history, the designer uses the written word instead of graphic images for explanation.

Ohto-machi now has a total sign system that is consistent in style, clear in its presentation, and aesthetically attractive to visitors and residents alike.

DESIGN FIRM
Design Network Co., Ltd.

PROJECT DESIGN
Hidetoshi Furuie

FABRICATION
Nichihatsu Industry Co., Ltd.

PHOTOGRAPHY
Hidetoshie Furuie

TOP: The coloration of each sign design is based on an authorized key word indicating some aspect of the town's development. This sign notes that Ohto-machi is the "Hometown noted for flowers and fresh water clams." The symbol character is a fresh water clam.

BOTTOM: The designer chose red as the color for flowers and a deep purple/blue as the color for fresh water clams. The information sign is composed of six ceramic plates measuring 60 cm by 60 cm.

OPPOSITE PAGE: The gate-sign is 5 meters high, which gives the appearance of the town's name floating in air, a delightful illusion for visitors. The gate-sign makes it clear that visitors have reached the town.

MADEIRA, CALIFORNIA

VALLEY CHILDREN'S HOSPITAL

HKS was faced with the challenge of creating for a children's hospital a logical wayfinding program that engages these primary users while providing all of the necessary information for adults as well.

Creating wayfinding systems for hospitals is always a challenge. Distinguishing among the many corridors, departments, and levels requires a wayfinding system that is at once complex yet quickly decipherable for the many categories of users: emergency and medical teams, patients, and visitors.

This challenge is compounded when children are the hospital's primary clientele. The system must function for adult users but be sufficiently visual, engaging, and non-threatening for these young patients, who are in a strange, frightening environment and often away from home for the first time. With all of this in mind, HKS developed an exterior and interior program that is fun, logical, and sophisticated that facilitates user navigation into and through this 625,000-square-foot children's hospital.

George, the wayfinding giraffe, is the common graphic element throughout the hospital. A total of nine variations of the six-foot tall animal are used along with shaped spots and colors designating entrances and building zones. These shapes and colors are integrated into the exterior and interior architecture as well as sign and graphic elements to emphasize the zone identity. The elements also coordinate in public areas with the interior designers' universe theme, resulting in a multi-station spaceship directory and a Sputnik ceiling directional. The system also accommodates expansion and upkeep.

In addition, HKS developed donor signage that is the first of its kind. The fabricated aluminum structures are designed to resemble classic children's storybooks. The larger-than-life books (7 feet by 11 feet and 8 feet by 13 feet), whose edges are flared to accentuate their large scale, recognize various levels of hospital contributions with the donors' names appearing in easily updated digital print.

DESIGN FIRM
HKS, Inc.

PROJECT DESIGN
Nancy Goldburg
Todd Light

FABRICATION
Cornelius Architectural Products
Ampersand Contract Signing Group
Skyline

PHOTOGRAPHY
Khaled Alkotob (exterior)
Kelly Peterson (interior)

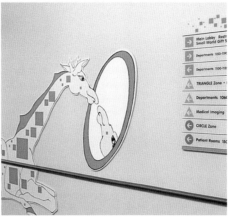

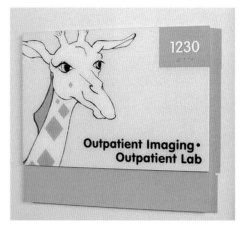

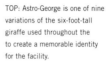

TOP: Astro-George is one of nine variations of the six-foot-tall giraffe used throughout the to create a memorable identity for the facility.

A typical department identification sign makes use of the designer's coordinating colors and theme.

MIDDLE LEFT: The universe theme is carried throughout, even to personalized patient room identification signage.

MIDDLE RIGHT AND BOTTOM: Fabricated aluminated structures designed to resemble classic children's books display hospital donor names in a colorful and memorable manner.

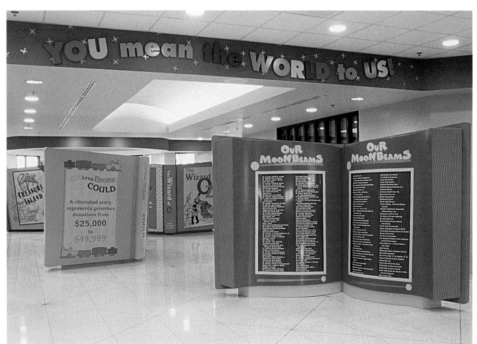

SAN JOSE, CALIFORNIA

GUADALUPE RIVERWALK

At the Riverwalk, signage highlights a specific area of the space as a focal point. With reference to this point, graphics throughout the park link entry points and define the area within the site.

In 1995, the Redevelopment Agency of the City of San Jose contracted Landor Associates to provide a wayfinding system and identification program for Guadalupe River Park. Unlike a typical urban park, the 3-mile riverwalk is linear in form, yet lacks clearly defined boundaries. The riverwalk has numerous entrances at each of the major downtown bridge crossings that lead pedestrians to the river. Landor decided to stage the park's identity at the bridges.

Large cast-bronze letters mounted along the bridge railings announce the park to vehicular traffic; mosaic panels direct visitors into the park.

Inset into the ground, two large-scale compasses with major park destinations articulated on their faces provide visitors with a base location. Smaller directional medallions give visual reinforcement and help guide visitors. Freestanding decorative trellises identify park destinations and continue the riverwalk motif of the mosaic panels.

To enrich the experience for park visitors, Landor included "discovery points" that offer clues to the area's former history, inhabitants, and roadways. The displays also educate visitors about flood control and the park's natural habitat.

DESIGN FIRM
Landor Associates

PROJECT DESIGN
Courtney Reeser, Executive Creative Director
Scott Drummond, Creative Director
Jean Loo, Senior Designer
David Rockwell
David Garcia

FABRICATION
Martinelli Environmental Graphics
Princeton Welding
Archetile

PHOTOGRAPHY
Mark Johann Photography, San Francisco, Ca.

TOP LEFT: Freestanding decorative trellises identify park destinations and extend the riverwalk motif found in the mosaic panels.

BOTTOM LEFT: Two large-scale mosaic compasses evoke the river with their colors and fluid lines while providing definitive wayfinding information.

TOP RIGHT: Directional medallions guide visitors to various destinations within the park.

BOTTOM RIGHT: Square mosaic panels direct visitors to the new municipal park.

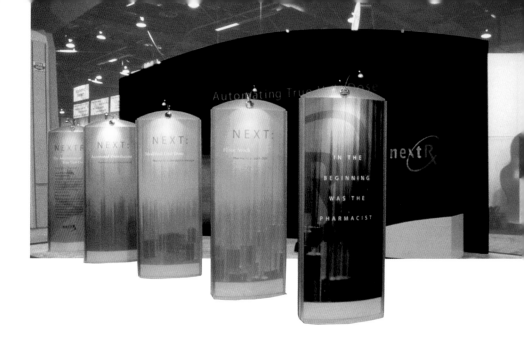

FASHIONING
CONSUMER-FRIENDLY SPACES

by Phil Engelke and Thom McKay

Time was, signs were a source of information. They were simple, clean directionals. They told us where to go. "Where's the telephone?" Look for a white and blue sign. "How do I get out of here?" The exit is just beneath that red sign. A gilded shoe told us where we could get shod. Signs served a very utilitarian, practical purpose. They helped us get around, find our way, point out certain dictums (No Smoking) and conveyed naked facts (Wet Paint). Signage was a craft, not a science. Signs were a means, not an end.

Sometime around the First World War and the height of big urban advertising, signs came to represent something else. Spectacle. Sponsorship. New technology... and a whole lot of neon. The commercial bulwark of Madison Avenue took over. The world was changing, and the importance (or, at least, the presence) of the almighty brand was being felt everywhere. A new highway system unfolded across the great heartland, garishly punctuated by billboards extolling the virtues of soap, colas, and ointments that promised wondrous things. Think, too, of Times Square and Piccadilly Circus between the World Wars and the image of bigger-than-life advertisements pulsing and throbbing with the prosperity of a New World order—big brands were taking control.

The message seemed clear. Signs were becoming something more than wayfinders; they crossed over to

> It is difficult to say whether anyone is actually absorbing information from these "whizzy" new signs, but one thing is clear—the medium has triumphed over the message.<

place makers—elements in the landscape that could contribute to an overall atmosphere or, when successful, sense of place. They could tell a brand's story, sell a product, convey a mood or just make the environment an exciting place to be.

Today, the design of signage is going through another subtle transformation, one that is trying to accommodate an information revolution in full tilt, the ramifications of which are difficult to gauge. Consider the cliché that we are being bombarded by vast quantities of information, some useful, some superfluous. This has always been the case, to be sure, but the one element that no longer exists is the buffer zone or filter process that allows us to distinguish between what information is fact and what is a pitchman's empty promise. Telling the ads from the facts is no longer as easy as it looks.

Consider some of the more recent magazines devoted to e-commerce or the rise of the dot-com industries (Fast Company is a good example). The ads are edgy and hip and use language that did not exist five years ago. All those clues that helped us distinguish between what was being sold and what was the unadulterated, objective view of the publication are gone. Advertising has

merged with editorial—in design as well as in content—to the point that it is now difficult to tell the two apart.

The design of signs has also gone through a similar synthesis. Using Times Square as an example once more, the reader-board signs on the new ABC Studios (the ABC Studios themselves!) and the NASDAQ wall are both examples of how the display of factual information has become spectacle, extravaganza, a showcase for next-wave technology. Even NBC's giant screen looming over the street has become a new Times Square icon. The Coke sign and news ticker, both of which have helped define Times Square for past generations, now look rather, well, passé. It is difficult to say whether anyone is actually absorbing information from these "whizzy" new signs, but one thing is clear—the medium has triumphed over the message.

Of course, these signs rely on state-of-the-art technology, something that doesn't come cheaply. Las Vegas, once the neon Mecca, has become a testing ground for LCD technology and, along with over-the-top fantasy architecture, the latest in signage extravaganzas. Lighted signs, which once shone only at night, and screens the size of tennis courts now compete quite

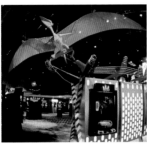

> Good signage is typically more critical to the overall retail riddle—figuring out what makes people buy —than any other aspect of retail design. It informs, directs, and inspires. <

successfully with the Nevada sun and seem to be getting bigger by the day. Indeed, finding well-crafted neon (yes, there is such a thing) has become no small feat, as real-time feeds and broadband technology have changed the way signs and billboards operate.

Today's better retail environments demand this type of hyper-kinetics albeit in smaller doses. Manufacturers such as Nike, Sony, and Swatch have always understood the power of media over message when building a brand and, ultimately, developing a loyal customer base. A triumph of style over substance? Perhaps, but that could be the point for a young consumer who is more interested in being wowed by a zoomy graphic than reading about the virtues of Gore-tex.

What all of this means is that signage now contributes as much as architecture (if not more) to the social aspects of public spaces and the commercial engine of retail and entertainment. People read signage (literally and figuratively) more readily than they read architecture—signs are more accessible, less cerebral and, therefore, more visceral. Given this, good signage is typically more critical to the overall retail riddle—figuring out what makes people buy—than any other aspect of retail design. It informs, directs, and inspires.

So it is here, in the emerging retail and entertainment environment, that sign design is reaching a new expression. Today's signs must combine all the utilitarian way-finding aspects of the past (You Are Here) with brand expression (Just Do It™) and a multi-media overlay (from scratch-n-sniff and plasma-screens to gobos and video-tronics). They must balance media and message. And they must do so in a way that contributes to the overall sense of place without overwhelming the environment or the architecture.

Are today's designers up to the challenge? We shall see.

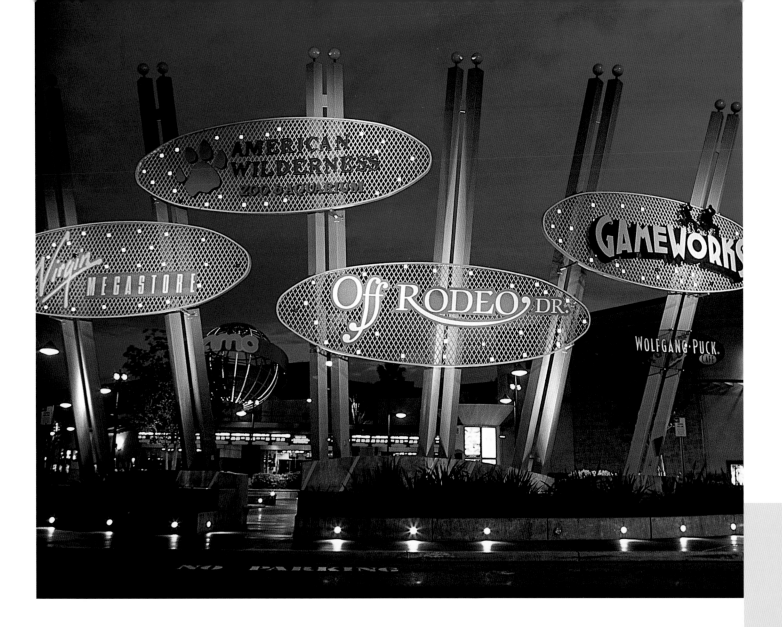

Phil Engelke and Thom McKay are co-directors of ID8, the entertainment and environmental graphic design division of RTKL. They have designed signs and retail/entertainment environments in some wonderful and not-so-wonderful parts of the world.

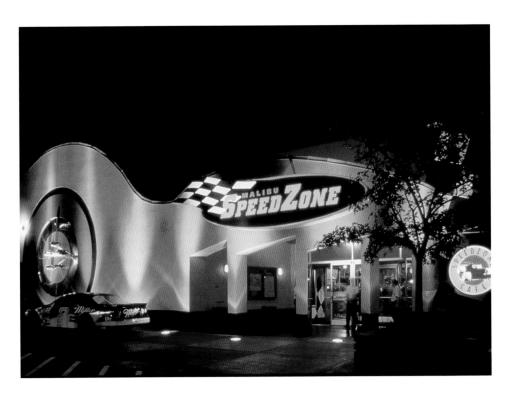

DALLAS, TEXAS, AND PUENTE HILLS, CALIFORNIA

MALIBU SPEEDZONE

Themed recreation parks rely heavily on design to establish a strong presence and an inviting space. A clear understanding of auto racing makes Malibu SpeedZone a convincing experience.

At Malibu SpeedZone, a new type of recreation theme park based on auto racing, the various design components derive their design from racing iconography. ID8, the entertainment and thematic design division of RTKL Associates, Inc., completed the prototype architectural, graphic, and interior design for the parks, the first of which opened in 1997 in Texas and California.

Every pattern, color, and form in the SpeedZone emphasizes the racing experience, from the checkered-flag pattern on the floor to the wavy-roofed shade structures scattered throughout the park. The clubhouse facade is designed with a highway-scaled front end of a racecar; the back of the car forms the parking lot facade. A high-tech game and redemption area, a SpeedZone

Café restaurant and bar, private function rooms, a retail sales area dubbed Parts Department, and an administration area are located on either side of the theme park. A giant mural of speeding race-cars adorns an upper wall encircling the bar and is repeated at billboard scale on the building exterior to become the signature image of the park.

Individual identities were created for each of four racing venues: Indy-style Grand Prix racing, top-eliminator dragster, Slick Trax bumper go-carts, and the bank-turn Turbo Track. A collaborative design-team effort resulted in simple yet bold and creative solutions to multiple design and scheduling challenges. To meet the aggressive schedule, the parts kit was designed and built in six months with inexpensive and readily available technology.

DESIGN FIRM
i.D.8, A Brainchild of RTKL

PROJECT DESIGN

Jeff Gunning,
vice president-in-charge, (AIA)

Randy McCown, project manager

Andra Newsom,
interior design/theming

Mark Askew, graphic design

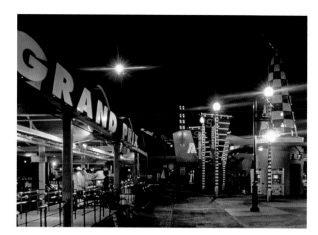

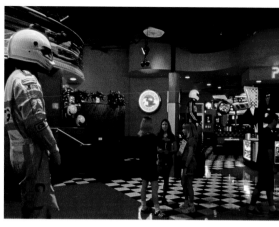

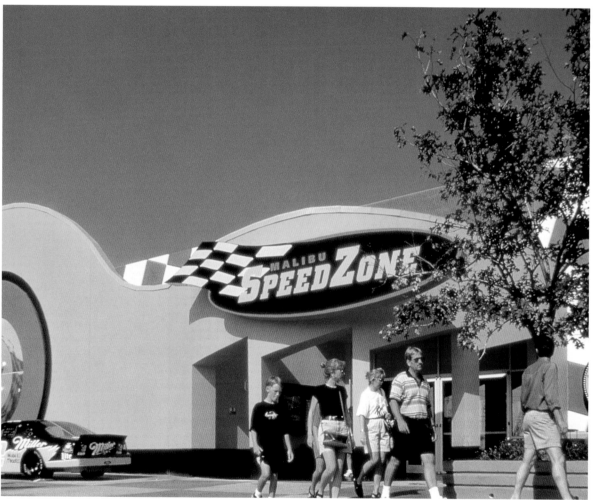

TOP LEFT AND RIGHT: In the interior, an explosion of color, light, and motion gives visitors a taste of the racing atmosphere.

BOTTOM: The bold race car facade of the SpeedZone entrance makes a strong statement on the highway frontage.

THIS PAGE: Clearly visible from the major commuter freeway that carries traffic into downtown Seattle, the REI graphics reach thousands of potential customers each day.

SEATTLE, WASHINGTON

REI TOWER

Changing signage captures customers' attention while dynamic imagery promotes a lifestyle appealing to REI's market.

REI, one of the first recreational outfitters, contracted Koryn Rolstad Studios/ Bannerworks Inc. to produce art panels to hang from a 60-foot-tall, glass-encased, climbing tower that tops their flagship store on the edge of Seattle's city center. The banners featured on this installation are changed twice per year and reflect appropriate seasonal activities. Printing on the banners is done in a 14 dpi process on vinyl coated mesh. The banners are sewn, grommets are added, and then the banners are installed along cables on the tower structure.

To support the panels, KRS worked with the building's architects to design a steel-frame-and-cable-rigging system that was welded to the steel structure of the tower. The panels are made in three separate layers and installed side-by-side on two sides of the tower, each visible from the pedestrian and vehicular traffic below. KRS developed several configurations for the 15-by-28-foot panels, which are easy to redesign and install. This keeps the panel idea fresh and allows the

marketing department to use the concept in a variety of ways over time.

The designers and the REI marketing staff have designed a continually evolving identity program utilizing visual images of people engaged in such activities as skiing, hiking, mountain climbing, biking, and kayaking while sporting stylish athletic wear and gear available inside the store. These graphic images have become the artwork that identifies the REI flagship store. They have become a familiar part of the cityscape culture without marring the bold natural views of mountains and tree lines for which Seattle is known.

This program is a striking example of the power of strong graphic presentations to create and define corporate identity. Without a word of text or even a logo, REI has managed to mount an advertising campaign on site and to link its store in the minds of viewers with eye-catching images of active, outdoor, recreation.

DESIGN FIRM
REI Marketing, in conjunction with Koryn Rolstad Studios/ Bannerworks Inc.

PROJECT DESIGN
Koryn Rolstad
Adam Ernst

PHOTOGRAPHY
James Frederick Housel

TOP RIGHT: Computer-enhanced photographs were digitally printed onto a vinyl-coated polyester mesh background and on opaque fabric for the foreground imagery in an appliqué method to produce REI's striking banners.

MIDDLE RIGHT: The vivid photographs are suspended with stainless steel cables over REI's glass climbing tower.

BOTTOM RIGHT: Since the images can be changed with the season, the display retains a freshness that suggests the active lifestyle that REI promotes.

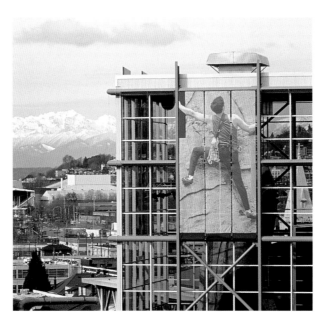

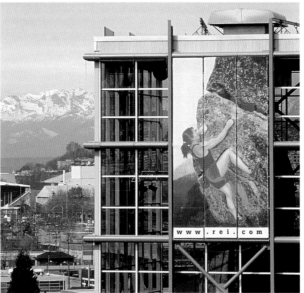

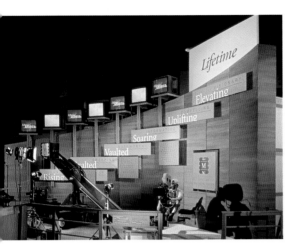

ANAHEIM, CALIFORNIA

LIFETIME TELEVISION

"Know your audience." This dictum is critical to effective marketing and design. At the Western Cable Show in Anaheim, trade booth sets reflected a lifestyle and personality with which Lifetime's market would identify.

When Lifetime Movie Network called on Lorenc + Yoo Design to produce a 40-by-40-foot trade show booth to launch the Lifetime Movie Network (LMN) at the Western Cable Show, the clients anticipated an exhibit that would go beyond the ordinary plastic veneer/plywood backdrop for company hype. Lifetime requested a space that would appeal to women ages eighteen to forty-nine, the LMN target audience. In keeping with the Lifetime mission to create "a sense of place akin to a viewing destination, a media avenue women can count on to entertain, inform, and educate," the designers created a space that evoked the warmth, intelligence, and concerns of women.

The booth and all of its furnishings were custom designed. Seven lighted honey oak columns with posters about Lifetime and the LMN concept lined the booth perimeter. Divided into sections like a mini TV studio, the display included an upswept, curving, cherry wood wall mounted with graphic messages and monitors. The wall served as a backdrop for the main feature of the exhibit—a Panavision camera and boom crane that allowed visitors to ascend fourteen feet into the air to see the living-room film set and the spatial definition. The set included an entire convention hall. The "living room," complete with oriental rug for atmosphere and entertainment unit well stocked with Lifetime cassettes, Kit boxes, lights, and bounce scrims provided comfortable seating for visitors, added to the studio setting, and provided additional opportunities to display Lifetime logos.

Behind the camera set, visitors could enter a boat-shaped, shoji-enclosed conference room for private talks or some cappuccino. The ambience of the entire environment conveyed Lifetime's goal—to be perceived as an informative, but familiar resource, like a good neighbor in the media world.

DESIGN FIRM
Lorenc + Yoo Design

PROJECT DESIGN
Jan Lorenc
Chung Youl Yoo
Steve McCall
Gary Flesher
David Park

GRAPHIC DESIGN
Rory Myers

FABRICATION
MDM Scenery Works,
Atlanta, Georgia
Ken McGraw
Designers Workshop, Inc.,
Atlanta, Georiga
Len Seal

PHOTOGRAPHY
Rion Rizzo, Creative Sources Photography

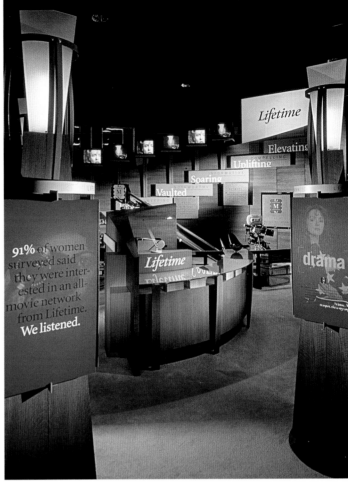

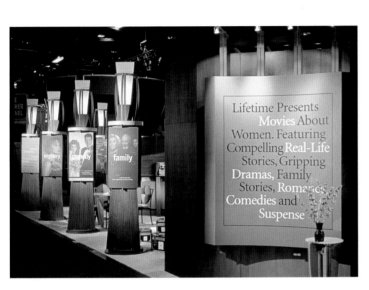

TOP LEFT: Poster obelisks topped with light lenses accentuated the rear of the exhibit providing orange and blue-gray graphics with green accents.

TOP RIGHT: The view into the exhibit between lit kiosks displaying posters offers a welcome respite from the usual trade show atmosphere.

BOTTOM: The reception area with its glass-topped cappuccino counter encourages visitors to stay a while and absorb the Lifetime message.

CARNEGIE FABRICS SHOWROOM

Graphics interwoven with the products displayed in the Carnegie Fabrics Showroom reflect the textures and soft, sophisticated color palette of the fabrics.

Because of the small size of the 1996 show, the designers chose to focus on just two new products, rather than the complete Carnegie line. This allowed them to create an elegant presentation for the Xorel Chair™ by Brian Kane and Vertical Reality Fabrics by Beverly Thomas and Laura Guido-Clark.

The panel-display system made for an easy reconfiguration of the room. The system was a spring-loaded, 1950s-like, bookcase/pole lamp combination. The fabric display system had interchangeable panels that allowed for flat panel insertions, as well as box file inserts for fabric panels. The "patent leather" floor and pea green walls, along with the style of the fixtures, lent itself to a Gucci-meets-Mies experience. A quote from essayist and philosopher Ralph Waldo Emerson wraps the room along the wall. This running text is a unifying element.

DESIGN FIRM
Gensler

PROJECT DESIGN
John Bricker
Micko Oda

FABRICATION
Halo, New York City, N.Y. (lighting)
Precision Engraving, Opiague, N.Y. (signage manufacturing)
Frank O. Carlson, Chicago, Ill. (vinyl graphics)
Mobil Cable Systems, New York City, N.Y. (Furniture System)

PHOTOGRAPHY
Chris Barret, Chicago, Ill.

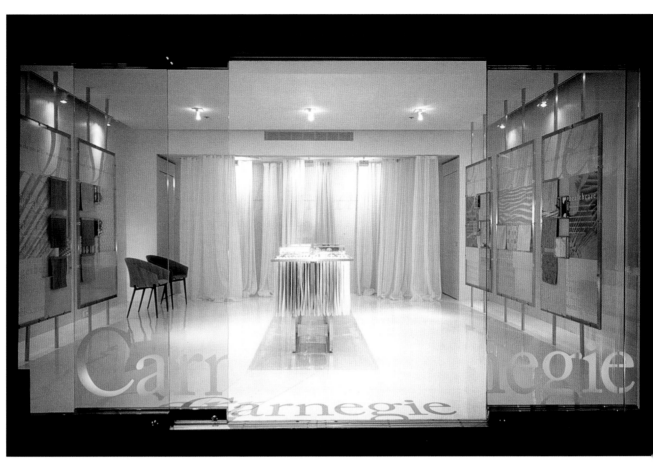

OPPOSITE PAGE: Each wall of the showroom featured a display that expressed the designer's inspirations for the line.

TOP: In the center of Carnegie's showroom a "buffet" of textile samples allows visitors to browse the collection.

BOTTOM: Translucent scrim panels blocked the main view into the showroom, serving as projection surfaces for Carnegie branding and enticing visitors to walk around the wall to see the new chair.

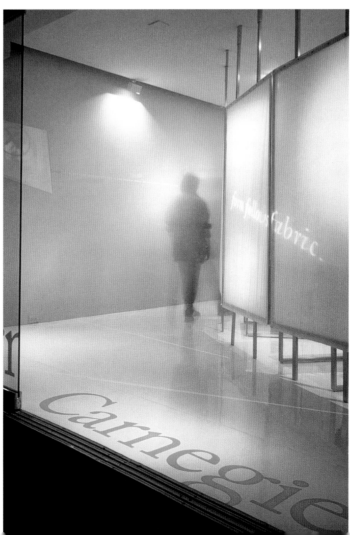

VOLKSWAGEN DESIGN 2001 CAR SHOW EXHIBIT

The VW exhibit went far beyond the car-parked-on-carpet display to convey the German values of design, engineering, and fun in the VW brand.

Volkswagen asked Mauk Design to develop a modular exhibit program for its North American car show circuit that would communicate Volkswagen's brand essences in an uncluttered environment. Show attendees were encouraged to stimulate their senses in the Volkswagen esthetic through sound and video in the Immersion Theatre, a specially designed space with simple, curved walls on which footage of the new Volkswagen gave visitors a taste of the car in action.

To enhance the simulation, Volkswagen included the rush of wind and interactive feel boxes that appealed to the sense of touch in the Cabrio section of the theater. All parts of the exhibit, but especially the interactive feel boxes and the theater itself, were designed with the physically challenged and child attendees in mind. Benches, play stations, and video displays were placed at intervals around the exhibit to encourage visitors to pause and reflect on the product and to absorb the marketing message

With its visually arresting design, strong message, and playful attractions, the exhibit provided an engaging and compelling introduction to the product. The display was innovative, appealing to the rational as well as to the sensual and emotional.

It went beyond the kicking-the-tires kind of experience by enhancing the level of interaction for the attendees. Mauk Design accomplished this without spending a fortune, using low-tech interactive components, simple video, clean shapes, and straightforward finishes.

DESIGN FIRM
Mauk Design

PROJECT DESIGN
Mitchell Mauk
Adam Brodsley
Laurence Raines
Michael Minn

FABRICATION
Exhibit Works

PHOTOGRAPHY
Andy Caulfield

OPPOSITE PAGE: The Immersion Theater provides visitors the experience of VW's branding message and was used to help launch the new Beetle.

TOP LEFT: The video wall rests on a stock aluminum scaffold system that has been polished and is fitted with chrome alloy wheels. The exhibit made extensive use of found, used, stock, and off-the-shelf components to reduce costs and eliminate unecessary custom fabrication.

TOP RIGHT: Graphic panel display cases feature lifestyle hardware such as carbon-fiber mountain bike wheels to express VW's youth-oriented brand essence.

BOTTOM LEFT AND RIGHT: To demonstrate highlights and shadows of the metallic car colors, painted bowling balls are mounted on bearings, allowing them to be spun. A color and fabric selection wall is interactive, allowing attendees to slide fabric samples along a rail to match with exterior colors.

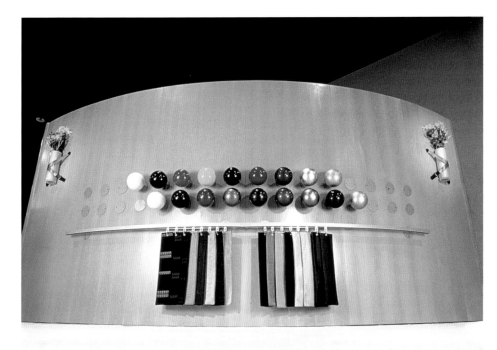

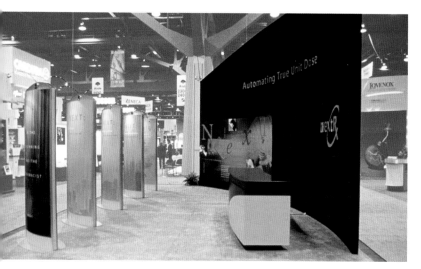

NEXTRx TRADE SHOW EXHIBIT

Hornall Anderson Design Works, Inc. used stark simplicity of design to advantage in garnering attention for this up-and-coming company.

After adopting a new name, NextRx needed an entirely new identity system, including a trade show exhibit booth, to introduce their new product to the pharmaceutical industry. This innovative product was a fully automated system that enabled central replenishment at unprecedented rates of speed and precision while maintaining complete pharmacist oversight of drugs and dosages. Since their system was still in the prototype phase, NextRx depended on the booth design to convey their presence as a serious new player in the industry and to reflect the scope of their ventures.

After Hornall Anderson's research results confirmed that the use of black, a non-traditional color in the medical industry, would serve as a bold statement, their designers chose a black backdrop for the display. This dramatic yet uncomplicated use of black grabbed the attention of passersby, especially within the context of a tradeshow where black was barely in evidence. The booth itself served as a three-dimensional brochure. The client's corporate-brochure graphics incorporated into the actual design and structure of the booth lent the exhibit a distinctive appearance. Individual kiosks displayed key pages in sequence to mimic the corporate brochure, which was distributed at the trade show to introduce the client's new name, identity, and product.

Plastic laminate-faced wall panels with applied digital graphics and dimensional typography and logos made up half the exhibit. Five aluminum-framed kiosks with digital graphics and a reception counter featuring a black-and-natural maple-veneer facing and a synthetic countertop completed the exhibit. The booth was styled to expand to a structure, 30-foot-by-40-foot, containing a product display and two conference rooms.

Through the simple use of color and configuration, this tradeshow booth attracted attention and piqued people's interest in learning more about NextRx's product.

DESIGN FIRM
**Hornall-Anderson Design
Works, Inc.**

PROJECT DESIGN
**Cliff Chung
Alan Florsheim**

FABRICATION
Commercial Displayers

PHOTOGRAPHY
Cliff Chung

TOP LEFT: The reception counter is striking with its black and natural maple veneer and made even more so by the dramatically lit NextRx logo.

TOP RIGHT: Enlarged graphic displays of key pages from the corporate brochure highlight the NextRx name, identity, and product.

BOTTOM: Illuminated aluminum-framed kiosks with digital graphics helped explain the client's automated pharmaceutical-replenishment system.

K2 SKIS TRADE SHOW EXHIBIT

Hornall-Anderson designed this tradeshow exhibit as a metaphor for the basic ski experience.

Those in the ski industry expect an exhibit to last about five years yet retain flexibility in displaying their product. As a result, the design cannot be too trendy, but at the same time it must be configured to incorporate additions that make it appear fresh and contemporary.

In creating an exhibit that would represent K2 Corporation as one of the top ski manufacturers in design, technology, and innovation, Hornall-Anderson realized a tradeshow exhibit design which illustrated the power of simple graphics: the product itself became the graphic. The exhibit design served as a metaphor for the basic ski experience. The ski displays were hung on a steel-trussed chairlift that extended from a central point to various locations on the simulated-mountain wall. The beauty of this design lies in its flexibility of use: the panels and displays could be moved or changed easily. It could accommodate nearly any configuration of space while maintaining the congruity of the ski groupings. The industrial nature of the exhibit and the detailed fastening represented the client's technology-driven philosophy.

DESIGN FIRM
Hornall-Anderson Design Works, Inc.

PROJECT DESIGN
Cliff Chung
Jack Anderson

OPPOSITE PAGE: The dynamic K2 logo, enlarged on a portable scrim, clearly stamps the product name on the exhibit. The K2 logo is repeated in place of the stars on a representation of the American flag; red ski shapes replace the red stripes.

TOP: The spare design, dramatic lighting, and movement in the exhibit give it a sense of energy that meshes with the sense of ski adventure. Panels of skis in motion suggest the excitement of the slopes while the ingenuity of the display underscore's K2's credentials as craftsmen.

BOTTOM: Detail of the product. Banks of gleaming skis create a vivid design element and showcase their appeal.

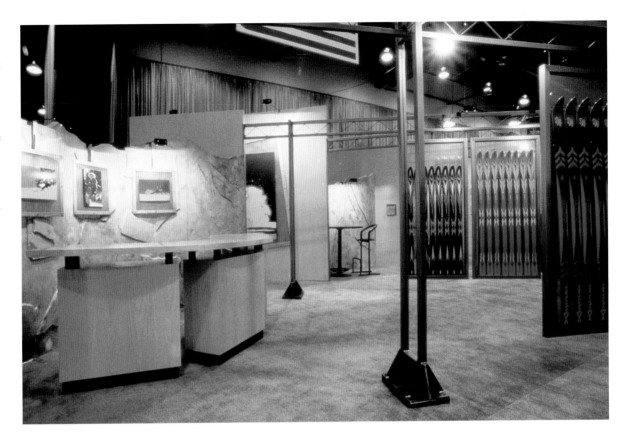

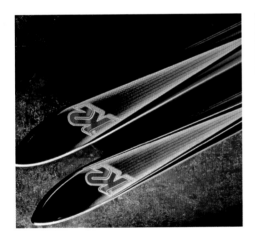
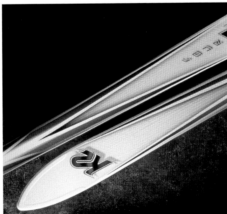
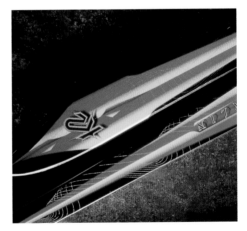

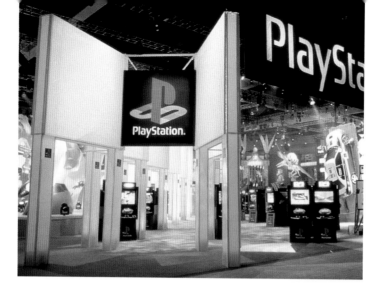

SONY PLAYSTATION E3 '99 EXHIBIT

How does a corporate giant in the video-game industry stand out at the loudest, cheesiest trade show on the planet? The designers at Mauk Design envisioned the exhibit as a cityscape in which radically different game-feature areas were held together with a high-tech visual glue.

Sony Computer Entertainment sought the graphic wizardry of Mauk Design to grab attention at the E3 video-game trade show in Los Angeles in 1999, where the company planned to introduce its new PlayStation II. Because E3 is the only significant international video game trade show all year, Sony put close to one hundred percent of its trade show effort behind the PlayStation II exhibit.

The challenge was to create an entire world of PlayStation games in a 44,000-square-foot exhibit and to guide 100,000 visitors in and to the games they wished to see. Use of the city street metaphor made access to the interior of the exhibit actually easier than passage through the show aisles. Elevated catwalks allowed overhead transit to other areas of the exhibit while showcasing new games along the railings. A large entry portal consisting of five 25-foot inflated characters framed the main entrance and accentuated the pyramid containing the PlayStation II prototype. In keeping with the overriding concept, It's About the Games, the themed areas focused on a dozen new feature games as well as four hundred available titles

The floating balloon characters made the PlayStation's entrance visible from hundreds of feet away. The exhibit was mobbed from the beginning of the show to the end. It provided an experience unlike anything else on the show floor, and it chronicled PlayStation's exciting vision of the future of video games.

DESIGN FIRM
Mauk Design

PROJECT DESIGN
Mitchell Mauk
Adam Brodsley
Laurence Raines

FABRICATION
Pinnacle Exhibits

PHOTOGRAPHY
Andy Caulfield

OPPOSITE PAGE: At the corner of the booth, a strong branding statement appears against a clean backdrop, hinting at the fun inside. The clear corridor off the corner leads to the heart of the exhibit.

TOP LEFT: This monumental pyramid was featured in front of the exhibit to preview the upcoming PlayStation II gaming platform. Monitors displayed startlingly real video images produced by the PlayStation II prototype. In the top glass case, the new size and vertical factor were unveiled for the first time.

TOP MIDDLE: A forty-foot pterodactyl tears off the corner of the DinoCrisis game kiosk.

TOP RIGHT: Three real cars (to underscore the game's authenticity) were attached to three different road surfaces to publicize the GT2 driving game. The cars were mounted vertically on a structural steel grid.

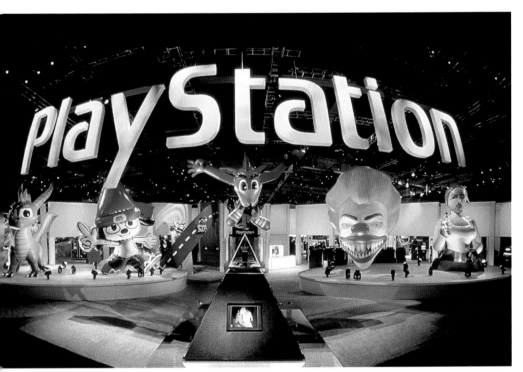

BOTTOM LEFT: Twenty-five-foot-tall character balloons captured attention and signaled a unique experience at the E3 '99 PlayStation entrance.

BOTTOM RIGHT: After ascending the grand staircase, show attendees flowed through the Final Fantasy VII entrance portal. The 8-foot feathers and silverleaf stone were inspired by this futuristic role-playing game.

SPOKANE REGIONAL BUSINESS CENTER

Anderson Mraz Design and Kirkwood Rodell Associates conducted thorough research and listened to the varied voices in the community to reach design decisions that now provide the Spokane region with a business center that welcomes, invites, and informs its myriad visitors.

In the fall of 1997, the Spokane Area Chamber of Commerce selected Anderson Mraz Design as lead designer and project manager for the Spokane Regional Business Center (SRBC), a project dedicated to showcasing the region and promoting business, tourism, and industry. The assignment included design of the center's logo, brand identity elements, and facility signage, including donor recognition. Interpretive space planning would lead to the best use of the $2 million budget for design and construction of a 6,500-foot main floor and a 6,000-foot adjoining exterior courtyard to tell the story of why the region is an extraordinary place to live, work, and play.

Research began with an in-depth review of the area's history, focusing on the character of its people, the many outstanding features of its geography, and the significant events that shaped the region. The design team also conducted in-person interviews with dozens of regional citizens, to discover the benefits of living in the Inland Northwest, and with community leaders and area visionaries, to glean their expectations for the SRBC. The culmination of this three-month research was the Project Design Program, an extensive document that clarified the region's story and helped determine the images, words, and media that would be used to capture the region's spirit and sense of place.

Four themes were selected, representing the region's four seasons. The interior space was easily divided into four zones. The themes—Living, Working, Learning, and Growing—illustrated the region's quality of life, commerce and industry, system of education, and infrastructure. Each theme was presented through several 39-inch-square photo panels; a self-activated film presentation with original music score; and a sensor-activated, interactive touch-screen kiosk. The four areas were individually color-coded and identified by signs and graphics. Their placement along the primary streetscape windows easily involved passersby in the experience day and night.

The Spokane Regional Business Center, with its high-tech conference center, grand foyer, and Internet-based resource center, as well as its adjacent courtyard used for public and private events, clearly represents the multi-faceted area that it serves.

DESIGN FIRM
Anderson Mraz Design, Inc.

PROJECT DESIGN
**Anderson Mraz Design, Inc.
with Kirkwood Rodell
Associates, P.S.**

SIGNAGE FABRICATION
**Archwajet
F.O.Berg
Letters Unlimited
Metallic Arts
Mraz Fabrication
Powder Tech
R&R Custom Color Lab
Ken Spiering
Techline Spokane
Vic B. Linden & Sons Sign
Advertising, Inc.
Wilson Tool & Manufacturing**

PHOTOGRAPHY
J. Craig Sweat Photographer

OPPOSITE PAGE: The Spirit of Place wall includes a regional map with several communities highlighted.

TOP LEFT: One of five primary donors receives recognition above the resource center signage. Brushed aluminum letters, bands, and mounting hardware accentuate the donor signs.

BOTTOM LEFT: Ten regional pioneers are featured throughout the interior; standards are made of powder-coated steel and feature porcelain-enameled renderings of each pioneer.

TOP RIGHT: A wayfinding totem near the secondary entrance helps visitors locate the center's resources.

BOTTOM RIGHT: The main entry to the SRBC includes an information host station that incorporates wayfinding signage, shown on the left side.

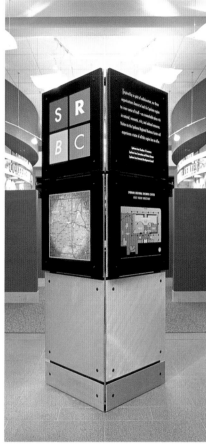

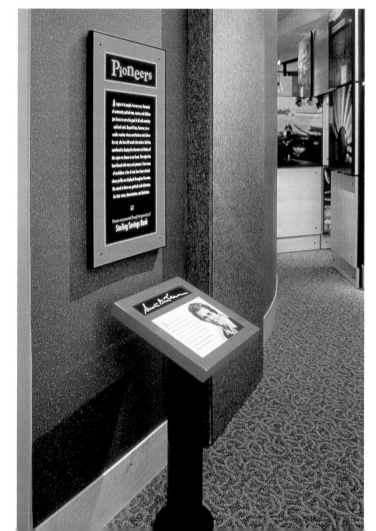

GAIA SHOPPING MALL

Gaia Mall's water imagery, along with a natural color scheme, serves as a unifying design element throughout the mall.

RTKL's conceptual design package for this new shopping mall contains a wide variety of graphic and signage elements to organize, add personality, and create a recognizable identity within the surrounding setting. The package includes exterior signage and graphics, wayfinding and directional signs, logos, colors, and floor designs and handrail patterns.

The center's distinctively simple logo was inspired by the barcos rabelos whose cargoes of port wine are traditionally shipped down the Douro River to Vila Nova de Gaia. The logo appears on the roof and sign tops throughout the

project to perpetuate a consistent identity. RTKL also developed distinctive themes, each based on the influence of the local river on mall.

The two-level complex is configured into three distinctive legs. One leg uses a wavy line for the logo and as a feature of the handrail design; fish-like patterns serve as parts of the floor, tiled columns, and tenant blade signs design. Another features light sconces evocative of the billowing sails of the town's classic riverboats. The third leg uses wine barrels and bottles to recall the influence of the area's wine and shipping industries.

DESIGN FIRM
i.D.8, A Brainchild of RTKL

PROJECT DESIGN
Phillips Engelke
Ann Dudrow
Frank Christian
Charlie Greenawalt

DESIGN ARCHITECTS
Jośe Quintela
Todd Lungren,
Mark Lauterbach

PHOTOGRAPHY
Whitcomb/RTKL

OPPOSITE PAGE: The inlaid terrazzo floor serves as a landmark for visitors.

BOTTOM LEFT: The Portuguese wine-boat logo clearly indicates the mall's entrance. As a logo design, it makes a bold statement on the entry tower.

The logo sails ornament is also used at the bulkhead at center court in the Gaia Shopping Mall and as windvanes on the mall's connector bridge.

TOP RIGHT: Retail-tenant blade signs reflect the natural color scheme used throughout the mall.

BOTTOM RIGHT: With a wavy line running through the type, the logo at the primary entrance establishes the mall's link with the river.

THIS PAGE: More's City offers specialty retail and boutique-style shopping, family entertainment, an assortment of restaurants, and an open grocery marketplace all under one roof.

YOKOSUKA, JAPAN

MORE'S CITY

In designing for large spaces, the concept of "rooms" or "zones" helps define space and organize information. At More's City retail and entertainment complex, an identity for the complex as a whole was developed, as well as secondary level identities for each of the six zones established by the architects. Graphic elements based on these identities characterize each zone.

Because the new More's City retail and entertainment complex in Yokosuka, Japan is located in an area known for the natural beauty of its bay, the mall design is intended to evoke a town atmosphere in harmony with the natural environment.

For the More's City retail/entertainment complex, the project developer, Yokohama Okadaya Company, Ltd., and the project interior-design firm, RIC Design, selected Kiku Obata & Company to develop the main identity and six retail area, or zone, identities; directory maps; and directional signage concepts for the complex. The six specialty retail zones include More's Street, the Magical Tower, Misaki Ichiba, Restaurant Park, Yokosuka Planet, and Parking Garden.

After developing some initial design concepts, Kiku Obata & Company realized that the American definitions of 'fun, relaxing, and energetic' did not necessarily translate into the Japanese visualization of these concepts. The firm also discovered that the Japanese perception of Americana and cities in the United States was based largely on information and images gleaned from television and the media. Understanding this, the designers submitted a wide range of concepts, including various approaches to colors and shapes, to get an idea of what the client liked and to establish an appropriate direction. It became evident that the client was most drawn to progressive concepts with fluid, organic shapes and trendy colors.

DESIGN FIRM
Kiku Obata & Company

PROJECT DESIGN
Kiku Obata
Nao Etsuki
Rich Nelson
Teresa Norton-Young
Joe Floresca
Scott Gericke
Liz Sullivan
Jeff Rifkin

PHOTOGRAPHY
Nacasa & Partners, Japan

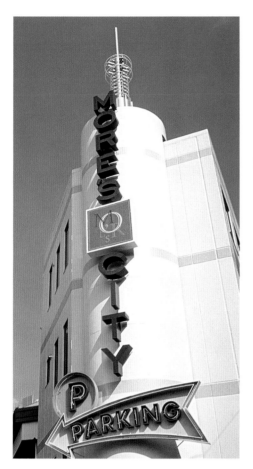

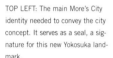

TOP LEFT: The main More's City identity needed to convey the city concept. It serves as a seal, a signature for this new Yokosuka landmark.

TOP RIGHT: Each of the areas, or zones, has its own identity to simulate the idea of being in different parts of a city. Vividly colored banners contribute to the sense of place and energize the space.

BOTTOM LEFT: Since More's City has nine floors (plus a basement level) but is divided into six zones, the directory maps display an elevation view of the development as opposed to a plan view typical of most wayfinding directories. Each zone is color coded on the directory.

BOTTOM RIGHT: The final zone designs for More's City appeal to a wide audience and create the feeling of being in an enclosed city with distinctly different areas.

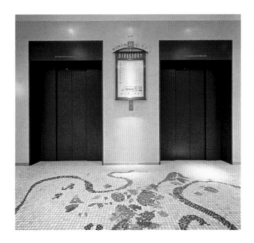

CANAL CITY HAKATA

Ways for organizing space and incorporating signage and graphic elements can differ from culture to culture. At Canal City Hakata, natural elements appropriately used as design motifs reflect the idea of bringing the outdoors in, a theme that is also found in traditional Japanese architecture.

Collaborating with the Jerde Partnership and an international team of designers, Selbert Perkins Design developed the communications master plan for Canal City Hakata, a 2.5-million-square foot, mixed-use urban project that includes retail stores, entertainment centers, hotels, and offices. The comprehensive master plan included logo, print and environmental communications, public art, and merchandise design.

Monumental sculptures symbolizing the sun, moon, stars, Earth, and sea orient visitors within the site and guide them on a walk through the "universe." Design features include all exterior/interior identification and wayfinding components, a merchandise program, print communications, dramatic sculptures, and gateways.

DESIGN FIRMS
Selbert Perkins Design (art and environmental communications)
The Jerde Partnership, (architecture)
EDAW (landscape architecture)
Wet (water features)
Kaplan Lighting (lighting)

PROJECT DESIGN
Robin Perkins
Clifford Selbert

PHOTOGRAPHY
Clifford Selbert

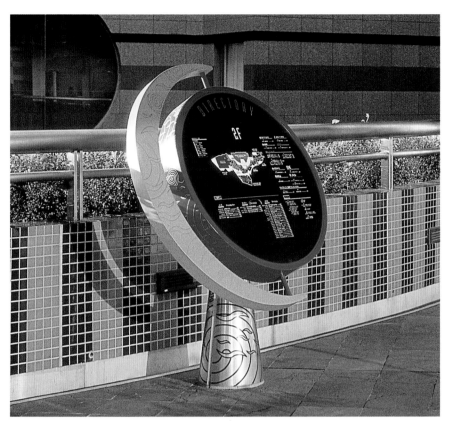

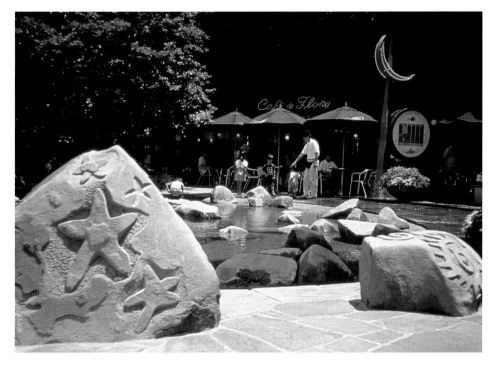

OPPOSITE PAGE: The dramatic north entry to Canal City seamlessly integrates architecture, landscape, lighting and graphics, and intermodal transport to create a dynamic entry experience.

BOTTOM LEFT AND RIGHT: The traditional Japanese design elements of stone and water are used extensively in the interior courtyard to create pleasant walkways and idyllic stopping points in the large mixed-use development.

TOP LEFT: The tenant directory integrates the project identity and patterns for the five zones within Canal City: Sun Plaza, Moon Walk, Earth Court, Sea Court, and Star Court.

TOP RIGHT: A logo store and a series of market carts sell original Canal City souvenirs and merchandise, which include apparel, paper products, jewelry, and food.

GRAPEVINE, TEXAS

GRAPEVINE MILLS

Inside the Grapevine Mills shopping megaplex, sets, theatrical in size, house the retail shops. These theatrical backdrops set the stage for an explosive fantasyland based on the lore and legends of the region.

The result of a joint venture of retail giants, this 1.8-million-square-foot retail/ entertainment complex is the largest such development to be built in the United States in many years. The super-regional mall includes fifteen anchor stores, more than two hundred specialty stores, a multiscreen cinema, and a one-thousand-seat food court. With more than 4.5 million people residing within a one-hour drive, Grapevine Mills is a lively resident and tourist destination that welcomes.

In keeping with the project's scale, RTKL adopted a bold approach in its themed architecture and environmental graphics. From a 40-by-65-foot Texas state flag to huge bluebonnets, tornadoes, vineyards, radio towers, roller coasters, and football icons, Grapevine's stylized entrances offer location references and a playfully exaggerated flavor of the Lone Star State.

Inside, Grapevine Mills' stores are grouped into neighborhoods. Unique storefronts and carts line the shopping avenues, while colorful graphics, video, animation, and lighting keep visitors entertained and informed. Sprinkled throughout these neighborhoods are courtyard oases, characterized by high ceilings, trees, plants, and animation features.

DESIGN FIRM
i.D.8, A Brainchild of RTKL

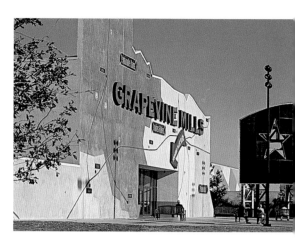

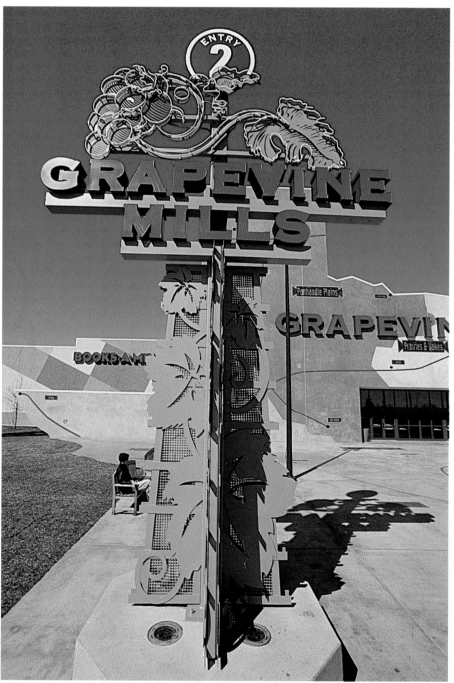

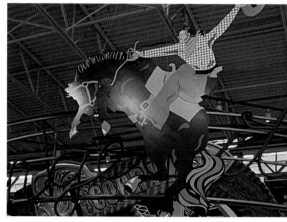

TOP LEFT: Bold colors, unmistakable Texas style and familiar state icons mark the entrance signage to Grapevine Mills.

BOTTOM LEFT: The stylized grapevine motif is characteristic of the imagery used throughout the mall.

TOP RIGHT: The massive state flag of Texas brands an exterior entrance to the giant complex.

BOTTOM RIGHT: Images of the Old West help sustain Grapevine Mills' distinctive identity, distinguishing it from "just another mall."

TOP LEFT: Two dimensional graphics portraying grapes on a vine are echoed by nearby, sculptural lighting fixtures of a similar shape.

TOP RIGHT: The playful graphics serve two purposes—they entertain and provide wayfinding clues throughout the vast complex.

BOTTOM: Inside, oversized graphics and dramatic lighting give the space a dynamic energy.

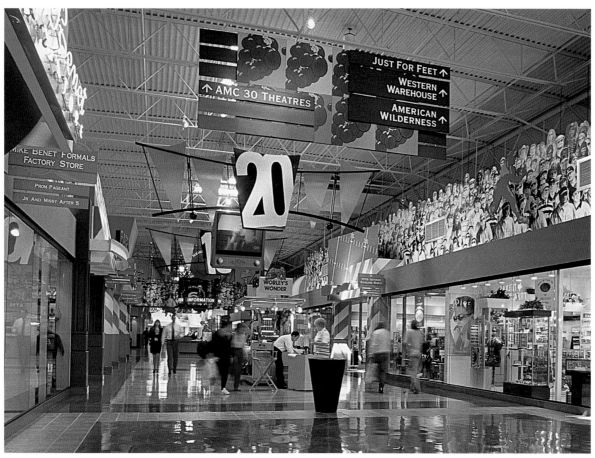

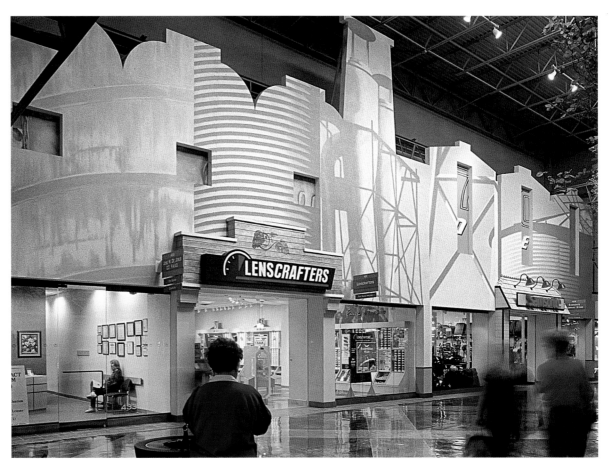

ABOVE: Retail stores are grouped in neighborhoods that provide visitors with another means of understanding the layout of the project.

BOTTOM LEFT: Clear identity signage including a "street number" lets shoppers zero in on the store they are seekng.

BOTTOM MIDDLE: Mall signage is integrated with retail shops' signage.

BOTTOM RIGHT: A variety of bold graphics and design elements enliven the large food court.

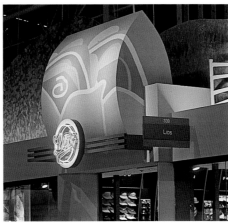

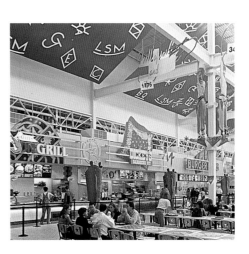

ONTARIO MILLS

Supermalls are increasingly popular and bring new meaning to the development of sign systems. At Ontario Mills, separate regions of the mall, with easily distinguishable visual elements, keep the scale of the mall from being overwhelming to shoppers and visitors.

THIS PAGE: The large sign at the main entry to Ontario Mills suggests the warm palette of southern California updated to a pleasingly modern venue.

This new 1.7 million-square-foot outlet mall is the world's largest. Working with Fiola Carli Archuletta Architects, CommArts was responsible for the overall project design, character, interior architecture, thematic development, and signage/graphics. The architectural design of the four major building entries reflects the history of southern California and especially Ontario. The project includes nearly two hundred storefronts arranged in a racetrack layout. Four distinct interior courtyards filled with natural light punctuate Main Street. Each features different plant species and water features for an outdoor experience. Storefronts along this Main Street have portal entries unique to each tenant.

DESIGN FIRM
CommArts, Inc.

PROJECT DESIGN
Henry Beer
Paul Mack
Bryan Grong
John Ward
Taku Shimizu
Kelan Smith
Jim Bainchak
Jim Redington
Kristian Kluver

FABRICATION
Barth Brothers
Architectural Fabrications
Raymond
Robert Englekirk Engineers
Preserved Treescapes International
Jon Richards Co.
Colour Concepts Inc.
JK Design Group
Cies Sexton
Thomas Mnich, AIA

PHOTOGRAPHY
Larry A. Falke

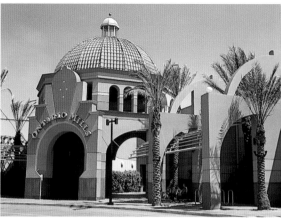

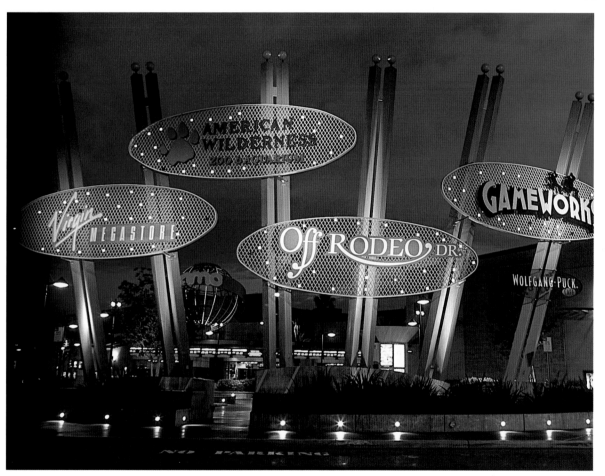

TOP LEFT: Parking-lot directional signs offer clear and easily readable wayfinding for visitors to the mall.

TOP RIGHT: The front entry to the massive mall references the Mission style architecture of Southern California.

BOTTOM: Tenant blade signs at night blur the distinction between entertainment and shopping, an indication of how the line between these two activities is gradually dissolving in American culture.

TOP LEFT: For this food
court, one big graphic gets
across the whole idea.

TOP RIGHT: Natural light
and abundant vegetation
signal one of the four
interior courtyards

TOP: The familiar information-arch guides visitors to the directory, which provides graphic and textual wayfinding.

BOTTOM: An information-center kiosk brims with useful materials for mall visitors.

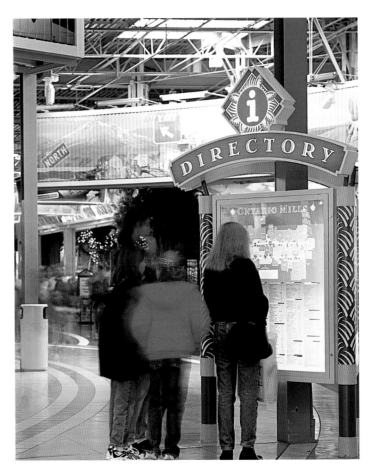

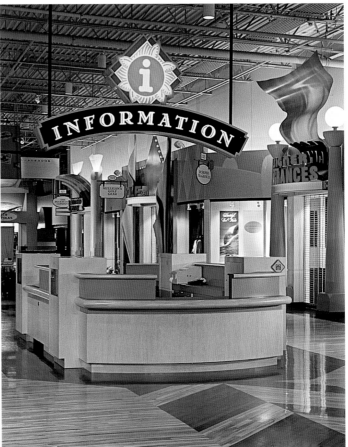

THE YALE BOOKSTORE

Customers at the Yale Bookstore identify strongly with the school, its close community, and its proud history.

Graphics that capture the personalities and places associated with Yale bring faculty, students, and others who are

part of this community together into a bookstore that celebrates who their tradition.

Customers at the Yale Bookstore identify strongly with the school, its close community, and its proud history. Graphics that capture the Yale personality, in all of its aspects, brings faculty, students, and the community together in a bookstore that celebrates their tradition.

The Yale Bookstore, housed in an Eero Saarinen building, reflects a new trend in university bookstores. The store showcases the personality and history of the university, incorporates many kinds of merchandising, and also satisfies the community's need for a premier academic bookstore. Clients, Yale University and Barnes and Noble College Bookstores, asked the design firm of McGinty, with Antunovich Associates, Architects, to create graphics, specialty fixtures, and murals that would capture Yale's image and accomplishments for the faculty, students, and campus visitors who frequent the store.

To give the store a character unlike any other, McGinty emblazoned the arcade entrance to the bookstore with the unique shields of Yale College and the university's graduate and professional schools such as the law school and school of medicine. Inside, famous graduates are featured on blade signs lining the main book area. Archival sports memorabilia, murals, and drawings from the Saarinen archive of his Yale buildings adorn the stairwells.

The bookstore's mural and wall program provide an opportunity to celebrate the work of graduates and professors. A collage of watercolors by a member of the faculty marks the café area. Framed covers from the humor magazine, along with cartoons by such famous alumni as Gary Trudeau, Robert Osborne, and Sandra Boynton decorate the walls inside the café.

Specialty fixtures and signs add character to individual departments such as the market and children's area. The Yale bulldog mascot welcomes kids in the children's department with his oversized Yale bowl, dog-biscuit table and chairs, and entry tower.

DESIGN FIRM
McGinty

PROJECT DESIGN
Ted McGinty
Idie McGinty
Liz Sullivan
Beth Wallisch
Terry Bliss
Al Sarks
Elisha Cooper (artist)
Joe Antunovich
George Sorich
Stephen Long
Antunovich Associates Architects

FABRICATION
Engraphix Architectural Signage
Ariston/Allen Shanosky
SignLite
Ken Lieberman

PHOTOGRAPHY
Jon Miller,
Hedrick Blessing, Ltd.

OPPOSITE PAGE: The Yale Bulldog mascot welcomes kids into the children's department. On the classical porch, the "Whiffenpups" singing group, a kids version of Yale's famous Whiffenpoofs, sings a special version of a traditional fight song.

TOP LEFT: A structural sign allows for prominent signage while maintaining a view through to the back of the store.

BOTTOM LEFT: The sports mural enlivening the stairwell features student athletes and archival sports memorabilia.

TOP RIGHT: A mural featuring some of Yale's best-known architectural landmarks embellishes the bookstore's cafe.

BOTTOM RIGHT: A view of the bookstore shows the blade signs featuring famous Yale graduates and the cafe mural beyond.

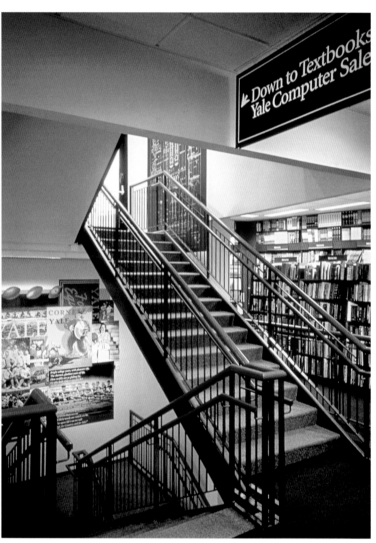

directory

50–51,
90–95,
104–107,
132–135,
174–175

Kiku Obata & Company
5585 Pershing Ave Suite 240
St. Louis MO 63112
Tel: 314 361 3110
Fax: 314 361 4716
Website: www.kikuobata.com
Email: obata@kikuobata.com

20–21,
100–101,
156–157

Koryn Rolstad Studios/Bannerworks, Inc.
2610 Western Avenue
Seattle WA 98121-1376
Tel: 206 448 1003
Fax: 206 448 1204
Website: www.krstudios.com
Email: bannerworks@Krstudios.com

60–63,
148–149

Landor Associates
Klamath House
1001 Front Street
San Francisco CA 94111
Tel: 888 2 Landor / 415 365 1700
Fax: 415 365 3190
Website: www.landor.com
Email: more_info@landor.com

22–23

**Lee Skolnick Architecture +
Design Partnership**
7 West 22 Street
New York, NY 10010
Tel: 212 989 2624
Fax: 212 727 1702

70–75,
158–159

Lorenc + Yoo Design
109 VIckery Street
Roswwell GA 30075-4926
Tel: 770 645 2828
Fax: 770 998 2452
Website: www.lorencyoodesign.com
Email: jan@lorencyoodesign.com

162–163,
168–169

Mauk Design
39 Stillman Street
San Francisco CA 94107
Tel: 415 243 9277
Fax: 415 243 9278
Website: www.maukdesign.com
Email: info@maukdesign.com

186–187

McGinty
4860 Sterling Drive
Boulder CO 80301
Tel: 303 402 9233
Fax: 303 402 9234
Email: idie@boulder.net

30–31

Parks Canada
220 Fourth Ave SE
Calgary Alberta T2G 4X3
Tel: 403 292 4753
Fax: 403 292 4242
Website: parkscanada.pch.gc.ca
Email: parks_webmaster@pch.gc.ca

80–81

Pentagram
204 Fifth Avenue
New York NY 10010
Tel: 212 683 7000
Fax: 212 532 0181
Website: www.pentagram.com
Email: info@pentagram.com

58–59,
114–115,
128–131,
176–177

Selbert Perkins Design
2067 Massachusetts Ave
Cambridge MA 02140
Tel: 617 497 6605
Fax: 617 661 5772
Website: www.selbertperkins.com

124–125

Susan Maxman & Partners, Architects
1600 Walnut Street Second Floor
Philadelphia PA 19103
Tel: 215 985 4410
Fax: 215 985 4430
Website: www.maxmanpartners.com
Email: smp@maxmanpartners.com

52–53,
88–89

Sussman/Prejza & Co., Inc.
8520 Warner Drive
Culver City CA 90232
Tel: 310 836 3939
Fax: 310 836 3980
Website: www.sussmanprejza.com

126–127

The J. Paul Getty Museum
1200 Getty Center Drive
Los Angeles CA 90049-1687
Web: www.getty.edu

44–45,
86–87,
96–99,
138–139

Two Twelve Associates
90 West St. 23rd FL
New York NY 10006
Tel: 212 233 3535
Fax: 212 233 3536
Website: www.twotwelve.com
Email: info@twotwelve.com

34–37,
76–79

W P a, Inc.
911 Western Ave Suite 380
Seattle WA 98104
Tel: 206 233 0550
Fax: 206 233 0663

about the authors

James Grayson Trulove is a publisher, editor, and author in the fields of graphic design, architecture, landscape architecture and art. His most recent books include *New Design: Berlin, Museum Architecture: Designing A Destination, The New American Garden, The New American Cottage, Ten Landscapes: Raymond Jungles,* and *Ten Landscapes: Shunmyo Masuno.* Trulove is a former publisher and editor-in-chief of *Graphis* magazine and a recipient of the Loeb Fellowship from Harvard University's Graduate School of Design. He resides in Washington, D.C. and New York.

Connie Sprague is a writer and editor in Northern Virginia. She has won numerous awards from the Virginia Press Association for her columns and critical writings, which appear in *The Fauquier Citizen* newspaper. She is co-author of *Porches and Other Outdoor Spaces*, which explores the mystique of the porch in American architecture. She resides in Warrenton, Virginia.

Steel Colony has a background in broadcast journalism and has often had difficulty finding his way in major cities around the world. He is a resident of Marshall, Virginia.

DATE DUE